**Michael
Gillette
Drawn in
Stereo**

ROCK ON!

Michael
Gillette

X

AMMO

Studio Wall.
2015.

Table of Contents

(Previous Spread)
Right On.
2005.

(Left)
Morrissey.
2014.

Introduction

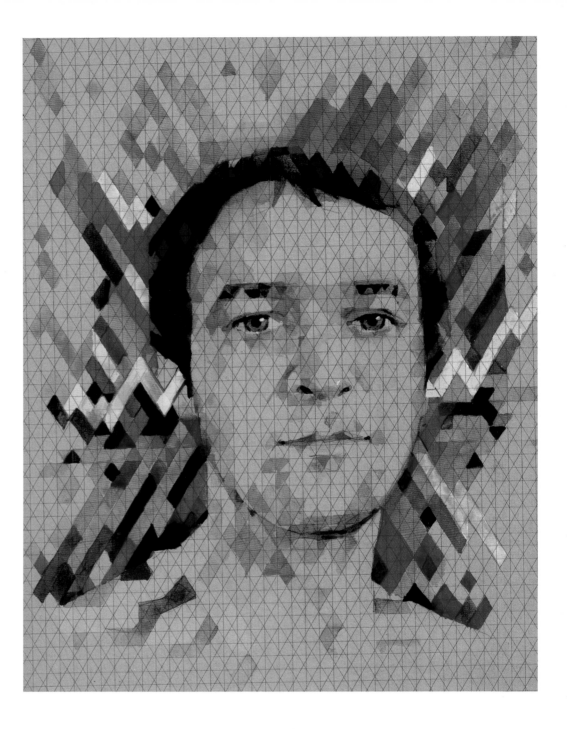

Self-Portait.
2015.

By the time this book reaches your delightful eyes, I will have had 45 revolutions around the sun. Within it are the fruits of a quarter of a century of work. I say *work*, but really the only toil I've done was in a bookshop at the start of my career, and that involved using every fiber of my concentration to move the clock hands to closing time.

Art wasn't my first career choice; I wanted to be a pop star—no, really. I always enjoyed drawing and figured art school was the best place to kill time whilst my carriage to the stars was readied. Soon enough, though, I realized the world's ears could do without me. Thankfully, I'd already bought some paints.

The energy which music stirs I use as inspirational fuel for the journey, and a compass for direction. It has served me well and led to all kinds of interesting places and people. Wherever I put my heart, the rest seems to shimmy along soon enough!

My first love was The Beatles. The manner in which they moved between styles was innate. "Helter Skelter," "Yellow Submarine": same source. If I'm inspired by a folk song, it's going to look different than if I'm listening to a man machine.

Arranged in chapters, my work may appear to fall into distinct periods, but I can be working in one mode in the morning and an entirely different manner in the afternoon. I don't bother to distinguish anymore, I just let the work come out like an eclectic playlist.

I spent the '90s in record shops, amassing a collection of vinyl I'd soon enough leave behind in Britain. Now, that whole collection can fit in the corner of a cloud! The delivery may change but the song remains the same. Life needs a backbeat, and that rhythm needs visuals; so, I'll carry on sharpening the pencils and keep my ears wide open.

Michael Gillette
San Francisco, 2015

Why do I love Michael Gillette's work so much? Let me count the ways. Firstly, there's the fundamental beauty of the images he makes. In these days of computer-crafted imagery, it's deeply refreshing to see a primarily analogue aesthetic take centre stage for a change. Instead of the ubiquitous vectors and flat colours of much of today's illustration (for which I may be partly responsible—so sue me!), he gives us a dazzlingly diverse painterly blend of deep textures, hand-drawn scrawls, and cartoon-like imagineering. He conjures rich worlds of psychedelia and humour that light up my pleasure centres with alarming regularity. Then there's the depth of the content: the man just doesn't seem to ever run out of ideas. There's nothing wrong with prettification, but Michael's work goes way beyond that. He has something to say, something complex and emotive. The *Little Angels* portraits are the best-known example, but there's a big idea behind most of the work here, whether it's a commission or (more often) a self-initiated piece, an emotive visual expression extracted from the depths of his psyche.

However, I think the main reason I love Michael Gillette's work is that I recognise and honour the personal obsession with music that is made visible throughout his canon. I watch in awe as his desperate need to achieve the impossible, to visualise the intangible essence of all that he loves in the history of popular music, drives him to create the astounding imagery in this book. This love seeps through every brush stroke, line, and pixel. The intimate relationship he has with the specific musical artifacts he has bonded with is something we can all relate to, but Michael has managed to (partly) tame this madness and set it to some use, specifically to create this remarkable body of work. Like many of his favourite artists, most notably his beloved Beatles, this obsession has sent him on an endless quest of re-invention, while at the same time managing to keep a consistent thread of personality running through every iteration. And it's a pretty amazing range,

folks: most illustrators would be satisfied with discovering just one of these aesthetics and milking it dry until it has become a cliché. Michael seems to throw off styles before the ink has dried, relentlessly moving on to the next big thing. He recognises, I think, that despite bearing this cross of reinvention which stops him being truly satisfied with his work, he is privileged to be in the middle of an incredible creative flow, and has a wider duty to let it take him where it must. So like his and my favourite musicians, Michael is, in essence, a tortured artist, driven to create, to communicate, to blow our minds and then move on. Twenty-seven is a long time ago for him now, so I doubt there will ever be a schoolboy self-portrait of Michael hanging next to Biggie, Amy, and Kurt, but he shares their spirit. Paint on you crazy diamond! Can't wait to see what's next.

Fred Deakin
London, 2015

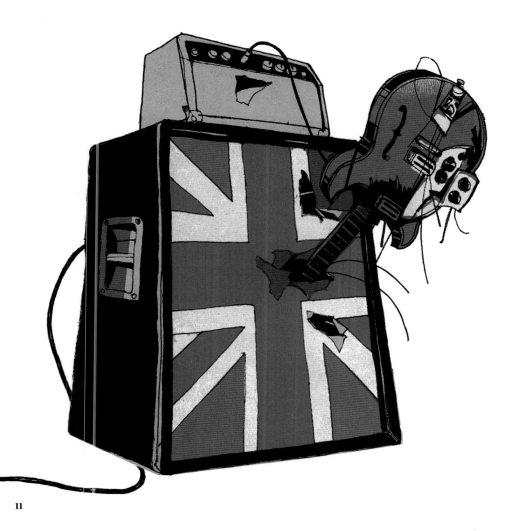

A conversation with artist Justine Frischmann in Marin, California, 2014.

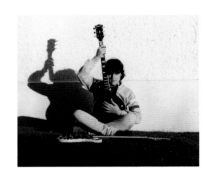

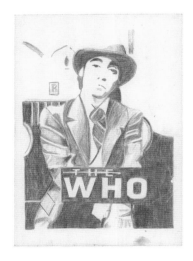

Justine: When did you decide that you wanted to be an artist?
Michael: My mum was an art teacher so art was in the air, but it was discovering music that really kicked things off. The BBC played all the Beatles films Christmas 1979; I remember watching *Magical Mystery Tour* in my Cub Scout uniform [thinking] "What is this?" By the end of the season it was as if I'd been reprogrammed; I never wanted to wear a uniform again! I'd seen another way to be. That's when I started to play the guitar. Art and Music started to hold hands, become all important.

J: It was probably unusual to have a Beatles thing in the eighties when you were a teenager?
M: They felt more vital than what was going on at the time. I was just obsessed with them. They were a blueprint to life, a great cultural gateway. I discovered so much through them.

J: What else really stuck with you?
M: Well, the San Francisco poster scene—I got a Rick Griffin monograph when I was a kid. I really loved that book; it gave me my first idea of San Francisco. I now live in the neighbourhood where he had his '60s pinnacle—the attraction was that strong!

J: How old were you when you came across the book?
M: Probably about thirteen—that time when your mind is fresh cement and those images just trampled all over it. I decided, around that age, I'd go to a London art school, be in a band, and that would take care of me.

J: It seems that your work has a nostalgic edge.
M: It comes from those early primal inspirations; they were all '60s rooted. I am a recovering nostalgic I would say. I see now that the goal is to be absolutely present in this moment in time. I didn't like the '80s much. It started out well but by '85, it had got so awful. Jingly-jangly indie was the alternative and it was attempting to be 1966! There were a lot of us turning our backs on the '80s. I was living in Minehead by then.

J: Where is Minehead?
M: In Somerset. The middle of nowhere. At sixteen, my family moved from Swansea to a seaside retirement town, with a Woolworths selling the Top 40. A real backwater, it gave me a gnawing feeling of being out of the action. Before that, in Swansea, I was well into my teenage weekend routine: visiting record shops and going to music stores to try out guitars.

J: In the early '80s there were Adam and the Ants and Duran Duran. I loved them both. And by the mid '80s, there were the Smiths and the Pixies, so there was stuff going on in the '80s that was good.
M: There's always good stuff going on; it had just come adrift from the mainstream at a time when I had very little access to an alternative. The Smiths were like a lifeboat, right? And they still sound great. I adore Morrissey, and Johnny Marr is one of my favorite guitar players, so imaginative and tasteful. I didn't like Duran Duran mind.

J: I know—it's the early stuff I like.
M: Of Duran Duran? Before they recorded?

J: Before they were born ... ? [*Laughter*]
M: Somebody put my name in a *Smash Hits* in 1985 saying, "Young, trendy dude into Wham!, Duran Duran, write to ... "

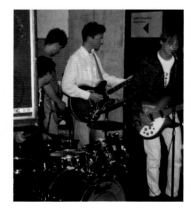

(Top)
Michael Gillette,
Swansea.
1983.

(Middle)
Keith Moon.
1983.

(Bottom)
Michael Gillette (center)
Somerset College
of Arts & Technology.
1988.

J: As a wind-up?
M: Yeah, and I got thousands of letters from girls. Poor postman.

J: So, you were in Minehead, and there's nothing but the Top 40 on the radio; you managed to get yourself to London at that point?
M: I did foundation in Taunton—still in Somerset—which was great. There were loads of bands there. PJ Harvey came out of that scene. I thought, "Wow, I'm going to London and it's going to really kick off."

J: So you managed to get into London, to Kingston, to do …?
M: Graphics; well, it had a sort of split graphics/illustration course. I didn't really know what graphic design was, and finding out was a rude shock! I went into complete stasis and didn't do anything.

J: What was it?
M: Cutting up type and making slick, horrid '80s packaging—by hand! I can't do anything without a grotty thumbprint in the middle of it. It was tedious.

J: Did you think you were going to be designing posters?
M: Yes. I went on a pilgrimage to see Vaughan Oliver at 4AD in my first year at Kingston. He broke me out of my slump. I went back to school and made collaged pictures with type all over them. I've always made pictures with type. I didn't fit into graphics or illustration; I was in no-man's-land. Then, towards the end of the second year, the band started to fall apart; my enthusiasm for being in a group died.

J: What were you called?
M: We were called The Figurines. We were like a poor man's Pixies—The Poxies. [*laughs*] I was playing the bass by that point—next stop the spoons! The reality of gigging in London; we kept being booked by the Bull & Gate in Kentish Town where the toilet door had no lock and opened out.

J: Yeah, I remember that. Onto the stage?
M: That would have been quite an entrance! Even if we were playing to one man and his dog, which actually happened, I would get terrible stage fright. I realised I wasn't going to be a musician—utter shock—because I was like, "Hang on a moment …"

J: That's the whole point.
M: Yes.

J: That's the way out.
M: Yeah.

13

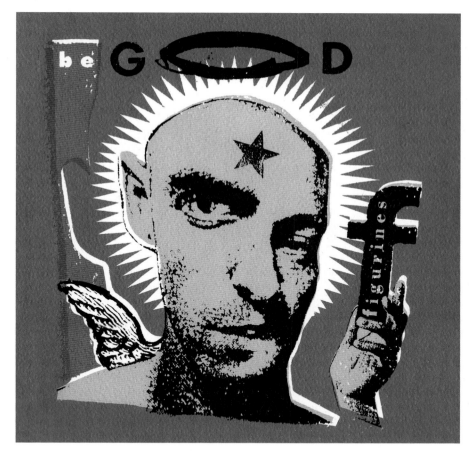

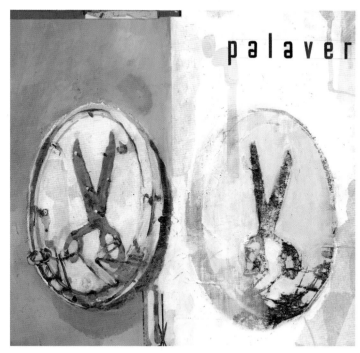

(Top)
Figurines sleeve,
Kingston Polytechnic.
1990.

(Bottom)
Palaver sleeve,
Kingston Polytechnic.
1991.

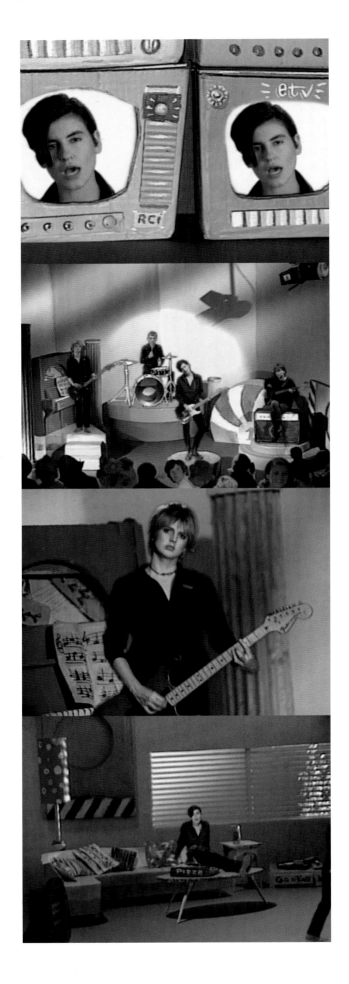

(Right)
Elastica.
"Connection" video.
1994.

(Opposite, Top)
Saint Etienne,
So Tough sleeve.
1992.

(Opposite, Bottom)
YellOasis.
Q magazine.
1999.

J: The escape …
M: Tom, Dick, and Harry tunnels collapsed. [laughs] I admitted to myself that I had more potential as an artist.

J: So at that point you felt, "I better get good"?
M: By that time I'd woken up. I'd made a choice to go to art school; making art made me happy, so make art! I felt I was better off creating my own projects with enthusiasm, tapping back into what I loved: music. I carried on regardless of what was said at college; it really is the most important lesson I learned. I got put on probation for making a sleeve instead of the assignment set, so I had to go and see the head of the course once every couple of months and take him everything I'd done. But I knew it was virtually impossible to get kicked out of art college, especially if you were actually making art!

J: And he liked your work?
M: Maybe; he picked me to go on a Russian exchange in '91; I was probably the only applicant who he'd actually met! So that's what my last year was all about.

J: Oh wow. I didn't know that. How long were you in Russia?
M: About five weeks.

J: Where in Russia?
M: Moscow mostly and Lviv in the Ukraine—for a week.

J: What were you doing?
M: That's a good question! Drinking, mainly, yeah. They like to keep the spirits up! The art college didn't have any electricity! And it was freezing! The coup had just happened and the Soviet Union was crumbling all around us, Lenin statues being pulled down, chaos! It was really unfathomable. I'd ask people to explain and they'd say, "We don't know! It wasn't like this last week." The exchange ate up a whole term in one way or another so I figured I'd best go to the Royal College of Art and hone my unsalable skills!

J: For an MA?
M: Yeah, by that time, I was doing illustration; well, that's where I was sitting anyway, but I didn't even get an interview. I met one of my tutors a while back and she said I was unteachable. Probably for the best.

J: What were you making?

M: My thesis was a book about the Russia trip; it was very lo-fi graphics with my own unemployable images! I qualified off a cliff in '92; we had a degree show in London and I got no interest whatsoever.

J: Do you feel like at that point you had a vision of what it could be that was sustaining.

M: No.

J: I don't know though because it seems like there's a unifying vision, a kind of mainstream nostalgia, a sweetness that ... it's a vision of—I'm going to say beauty because that seems to be the best word even though it's loaded, but it's just this kind of view that's pulled you along. I feel like it was visible in your work the first time I saw it in the '90s, and it's still there.

M: Well, thanks for spotting it!

J: Well, I just wondered if that's the thing that ultimately pulls you along.

M: I do love making my work, and I'm happy for it to be beautiful amongst other things. I've been lucky enough to carry on making it, you know, very blessed. I need to make art, fundamentally as a therapy. It's meditative. There were people at college who had way more talent than me, but they were happy doing something else. I wasn't. So that has spurred me to keep creating. I need to do it: financially, emotionally, you name it.

J: I think there is a real gift when you get that vision of a certain thing, and I feel like I've experienced that as well. There's a certain sound or a certain look of something that just makes you happy.

M: Yeah.

J: And it just keeps you coming back for more. Even if you just have no idea what's going on in your life, and it's all a complete mess and a disaster, there's still that thing, and it just keeps you going.

M: Yeah, it's a very strong relationship. It's like licking a toad, right? It's a very brief high that's potent enough to make me want to look for more toads! It's what keeps me in on a sunny day and why I'm probably not going to be trekking in the Himalayas at this point; I'll probably be in a darkened room trying to lick a toad again of my conjuring.

J: It's the toad that was gifted to you at some point.

M: Yeah, my gifted toad. [*laughs*]

J: So—go on.

M: I mean, I loved playing in a band. I know that feeling in a band, too, but it was so much harder to conjure because you had to maneuver around other people for it to happen.

J: Yeah, it's true. It seems way more complex. The politics of it ...

M: Yeah, but then you miss what other people can bring. I like figuring it out myself though; I never quite know what I'm doing until I've done it! So, after graduation I got some work with Saint Etienne.

J: That was straight out of Kingston?

M: Yes, two weeks after the show. When I was in Russia, their first album really clicked with me. It was retro futuristic. I felt a kinship; they had lots of pop culture reference, real fans, but they weren't slick. They'd written their home address on the back of the sleeve, so I went to Tufnell Park and stuck a package of art through their door, and went back to Kingston and waited! "Come on then ..." I didn't have a plan B! A week or two later I had to move home, and nothing had happened, so I went up to their record company (Heavenly in Covent Garden),—and "ding-dong," "Err, I sent a package to Saint Etienne." And they said, "Oh yeah, come on in. They talked about you." A miracle. A couple of days later, I met them in a cafe in Soho and they gave me a job. They gave me £2000 and the confidence to carry on.

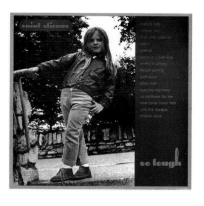

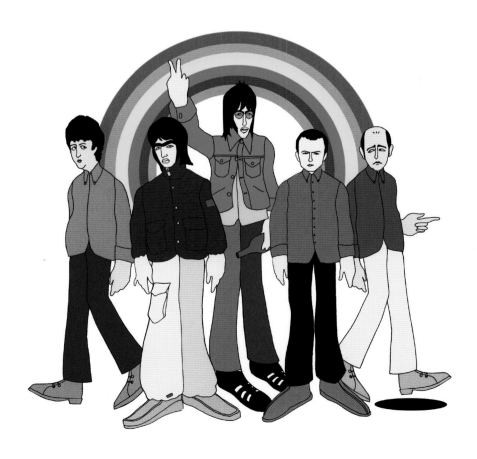

Pop Tarts,
Select magazine.
The panel ran for
50 editions between
1993 and 1997.

J: So tell me what happened exactly with Saint Etienne. You ended up doing an album cover for them, or singles?

M: I was going to do an album cover, but I didn't have the skills, so I ended up doing their logo and some paintings for the inner sleeve. They used the logo on *Top of the Pops*; I was so excited! But I really wanted to do the cover. I look back, and I didn't have the technical ability to do what I wanted. I knew I'd have to improve—and fast—if I was to survive.

J: And it's great that you could actually see that without trying to impose something on them that wasn't right.

M: Oh I'm sure I tried to impose it on them! [*laughs*] I'm sure there was quite a bit of imposing! The most important thing was: It gave me some kudos and the money to come back to London—that's when I moved in with the Aphex Twin. London life started.

So then I went to *Select*; one of my flatmate's brothers was the editor.

J: Oh really? I didn't know that. And the editor was …

M: Andrew Harrison. I said, "I've got this idea," which was Pop Tarts. And he said, "Ok, draw me up one and let's see." I did one and he said, "Yeah, okay. We'll do it," and he gave me fifty pence a month for the next five years. [*laughs*]

J: So what was the first *Pop Tarts panel*?

M: It was Jarvis Cocker, in a space hopper. It was that level of genius.

J: I remember that.

M: Really?

J: Yeah, it stuck with me.

M: Well, there was nobody who was doing that at the time. For good reason! You know what I mean?

J: In a way, and actually you talked about the future thinking retro; that was an interesting movement.

M: Definitely yeah. I went to see Pulp play in Islington, Christmas '92; the stage was covered in Christmas wrapping paper and Jarvis Cocker stuck his fingers through and started lobbing tangerines at the audience.

J: You mean before he appeared?

M: Yeah. You know, that was not an indie band thing, right? You shuffle on, you shuffle off, and in between …

J: You just kind of … shoe gaze; I guess Manchester happened somewhere in there. I think of the Happy Mondays being a bit more flamboyant, but there wasn't much around really and then …

M: There wasn't much wit really; I'm a stripy-top indie kid. Ride and all those kinds of bands; I loved them, but there was no humour, little glamour. *Select* soon commissioned me to do the illustration accompanying Stuart Maconie's article, which some credit as launching Britpop.

J: Who's on there? Denim, Suede …

M: Denim, Suede, Cud, Saint Etienne, the Auteurs; the players weren't quite right but it was a manifesto for a new attitude.

J: Is it pre-Blur?

M: It's probably at that point when Blur weren't being taken notice of.

From that point, it felt like I was more in the swing of things because then you had to drop your work off at the magazine; I got to know the writers. It was a scene.

J: And were you going to gigs? All the time? Tons of gigs?

M: Oh yeah. Yeah. Making up for Minehead! I started dating the editorial assistant of *Select*: free access to everything!

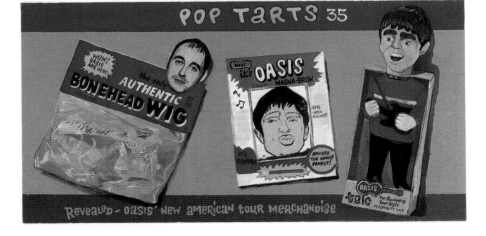

J: I remember seeing Pulp really early on, and it just seemed so entirely impossible for them not to become huge. I remember thinking what kind of world is this that Jarvis Cocker is not a star?

M: I felt maybe they'd be on *Top of the Pops* but will never be mainstream. That's why it was such a shock to see bands like Oasis. I felt, "I fought in the indie trenches for these football fellows to play Knebworth in their kagools!" I wasn't interested anymore.

J: Is that when you got out?

M: I could see it all changing. 1997 was when I first came to San Francisco. My mind was out of Britain by then.

J: Good job. You got out; I wish I'd gotten out. I was more entrenched.

M: You had a lot more involvement; still, it took me four more years to actually move.

J: Yeah, but I mean it was over by '97. It definitely was. Recently I looked back on how fast it was between driving ourselves around in a van with our equipment in the back to being in the tabloids—Blur playing Alexandra Palace; it was such a short period. It was only like a year and a half! It was crazy. It was two years max.

M: When did your first single come out?

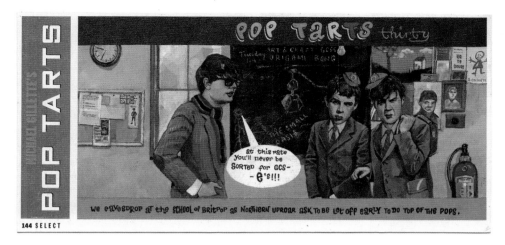

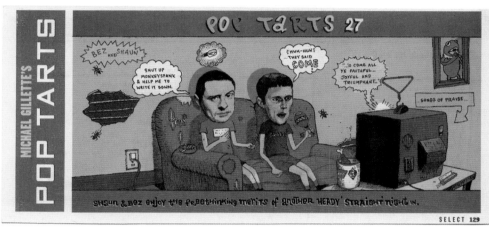

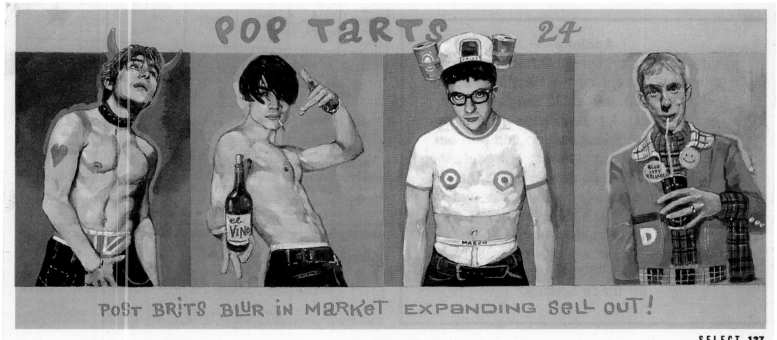

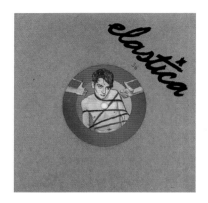

EXOTIC

54 elastica 54
CONNECTION

54 GLORIOUS NUDES
IN GLOWING COLOUR

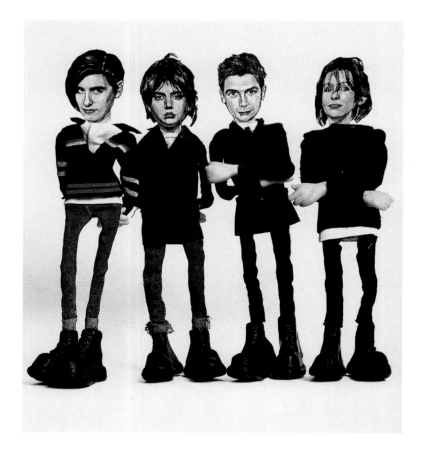

J: I think it came out in '94. April '94 or something like that. By '96 everything was kind of gross already.
M: I remember coming home to an answering phone message from you asking to do the first single artwork, and then seeing you in your Hackney rehearsal space. It went like a rocket! Blurry memories of The Good Mixer, you recording the album at Konk and then saying you were about to go on TV for the first time. Zoom …

J: It's crazy I know. You did our first two singles, and the video. I was thinking about the "Line Up" video—you did that with your mate from art school?
M: Yeah. Tom—Thomas Barnabus Edgar! He was my flatmate in Kingston. He makes *Rastamouse* now.

J: There's that really funny bit where he gets halfway and then it repeats because you totally ran out of time. It's actually incredibly ambitious; you should have had ten years making it, and you finished it in a fortnight.
M: One week's prep and a week filming! The terror of animation. We filmed at the Camden film co-op—how flipping indie '94 is that? We could only work nine to five, so we'd do what we could, [and] then come home and panic!

J: Yeah, I remember you turning up when you had a serious beard. I don't think I'd ever seen you look that rough.
M: Oh yeah, stress. We had an agreement that we wouldn't fight while we were making it.

J. You would save it up?
M: We saved it up. But we were so relieved to finish that we ended up in some bikers' bar in Archway that had karaoke, getting completely rat-arse drunk instead. Tom got up and did "Born To Be Wild," like a spider—he's 6 foot 3 [inches]—his limbs flailing all over the place. I thought we were going to get killed, but these bikers came up and said, "Your mate is fucking amazing!" Quite a night. Then the second video, "Connection," I guess you had more money by then; we hired the kit and filmed it in my studio. We didn't sleep for days on end.

Those two videos put me off making animation. Everyone sees the armies of names at the end of a Disney film. You are competing with that. Low-budget animation is cruel. I ended up working twenty-five hours a day. I'd rather join the foreign legion.

The next animation I did was for the Beastie Boys; I couldn't say no. A few years ago I did a video for My Morning Jacket because the premise was I'd direct fifteen other animators; but that fell apart and I ended up drawing it all! Brutal.

(Top Left)
Elastica,
"Stutter" 7".
1993.

(Top Right)
Elastica, "Connection"
cassingle (!).
1994.

(Bottom)
Elastica puppets
for "Line Up" video.
1994.

J: So we've hit '96, '97—you visit San Francisco for some reason, on holiday or ... ?

M: Yeah. By this time, I was getting a lot more work. I was doing book covers and lots of magazine stuff—I was working for *The Observer* every week, and by default became an illustrator. It just took off in that way. I stopped doing sleeves because I'd had some awful music industry dealings.

J: So is that when you also flirted with the possibility of fine art?

M: Well, I'd always done paintings for myself, so I got a show at the Groucho, the week the Labour party was elected '97; everybody was flush and excited and there was that feeling of ...

J: Something different.

M: We all had that misconception, "Conservatism's over! Rainbows and Unicorns, yay!" I sold sixteen out of twenty paintings. Jarvis bought three, I came home laden with cheques! A chunk of money in my hand. That's when I visited San Francisco.

J: Had you been here before?

M: No, I'd never had any money before! [laughs] It was the first time I could get further than Brighton!

J: So how long did you come to San Francisco for?

M: Not long—two weeks maybe.

J: And what did you do?

M: Walked around every step of it, completely infatuated.

J: Mecca.

M: Yeah, totally.

J: What time of the year was it?

M: October. Beautiful weather, walked around everywhere saucer-eyed; I'm thinking "Wow! This is it! I belong here." Then I got back to London and realised, "I can't live here. I'm in the wrong place." I was living in Shepherd's Bush in a relationship, but it all fell apart, and I was in a tight spot. Eventually I realised, "Well, what have I got? I've got a load of freedom—use it."

(Bottom)
The Birth of Britpop.
Select magazine.
1993.

WHO DO YOU THINK YOU ARE KIDDING, MR COBAIN?

Enough is enough! Yanks go home! And take your miserable grungewear and your self-obsessed slacker bands with you. You're already twice as cheesy as baggyism, and at least baggy was British.

We don't want plaid. We want crimplene, glamour, wit and irony. We want people who never say 'dude' or 'sidewalk' or 'Can I get a beer?' If 1992 was the American year (overweight, over-rated and over here) then it's time to bring on the Home Guard. These, Kurt, are the boys who will stop your little game: Suede, Saint Etienne, Pulp, Denim and The Auteurs. Bands with pride!

Over the page, *Select* salutes the new Best Of British, Cud name the ultimate Crimplenist soundtrack, and we save the Union Jack from the Nazis...

story by STUART MACONIE	
photos by NEIL COOPER	illustration by MICHAEL GILLETTE

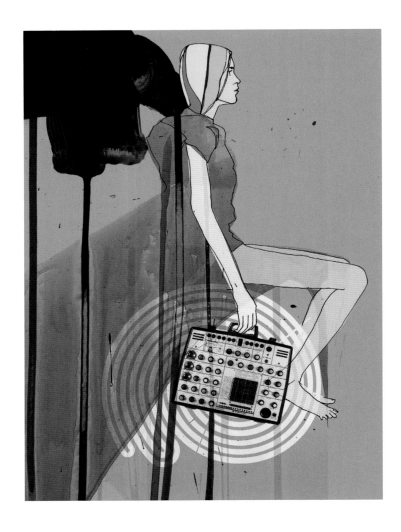

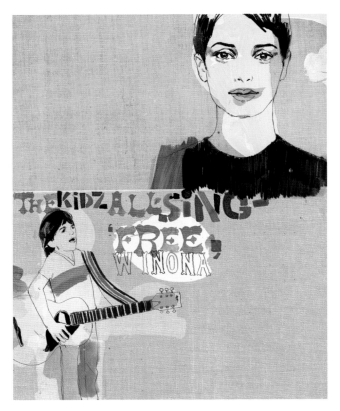

J: So you just moved here?
M: Well, it was a process; I wanted to do it legit. I didn't want to come over and have to hide. I knew it was hard enough to make a living doing art in the open! I had to get an American agent to sponsor me for a visa, and there was literally one place that I was suitable for: Art Department in New York. So I came over to visit.

I had a friend that worked for the ceramicist Jonathan Adler in Soho, and I talked to him about it. "Oh Jonathan is best friends with Stephanie Pesakoff (who ran Art Department), but if I ask him to look at your work, he'll avoid it. If we get everyone to cluck around your folder however ..." It was a coup, it worked a treat; his curiosity got the better of him and he came over, "Oh that's great. My friend Stephanie is around the corner." Result!

J: Wow. Brilliant.
M: Yeah! And then I got an interview with her, and I remember sitting in reception forever.

They also had a model agency, so I was sitting there, all these willowy girls sitting around, nicely diverting! Ages passed and then these male models started coming in and they're looking at me like, "Is this the competition?" I started to realise that this was my shot at moving to America. My mouth was so dry I ate a couple of Tic Tacs, and she came out right at that moment. I spat the Tic Tacs at her face when I introduced myself! She was like, "Your teeth!" I was mortified. I went beet red! Her little dog ate the Tic Tacs. I was still red-faced an hour and twenty blocks later!

She was sweet, however, and she liked the digital work. I'd just started doing it. "Come back next year when you have more digital work," [she said].

J: Oh really, that's interesting.
M: I'd had enough of painting anyway by then. I was worn out from it.

(Top)
Synthia.
First digital artwork.
1998.

(Bottom)
Free Winona.
2001.

J: So what do you mean by painted versus digital?

M: Well, I was painting everything in acrylic on stretched paper, with tight deadlines—done in a day, standing there with a hair dryer on the work with a courier at the door.

Arghh! I started to limit what I was doing because mistakes meant I'd be sleeping on the sofa in the studio that night. That's creatively deadening. Also, I had the same hourly rate as a sweatshop worker.

So I embraced the digital world. I'd had a Mac since '93, a Classic. Once Photoshop allowed for multiple layers, I realized, okay, it's like a screen print. It came at the right time for me. I was in the first wave of people who actually could make art that started using the computer. Before that it was more computer nerds than artists. I thought, if I feed it handcrafted work, it would look different. Immediately I got work, and I could do it twice as fast and really experiment freely.

J: So how does that work? Instead of doing all the painting on a single page, you just actually do it numerous times and do single colours or... ?

M: Well, this was the revolution—I had a freak-out during a break in Glasgow. My relationship was ending, I'd just done a *Select* job that was rejected without paying a penny. So I decided: That's it, I'm never working for them again. The stench of bridges burning was overwhelming!

When I got back to London I spent the weekend in the studio. I made loads of line drawings. Then I made lots of brush marks on coated paper. Monday morning my studio mates came in, the whole wall was covered in work: "Holy cow! What happened?"

I made an image combining one of the line drawings and the freeform marks; it was the opposite of my meticulous acrylic work. It had taken me years to lay down flat acrylic, which the computer did like that. [*clicks fingers*] Even those old beige clunkers that crashed continually were so much faster.

J: Well, so you just do a line drawing and then you tell it to fill it in?

M: That's what you saw a lot of. But I wanted the computer to synthesize my handmade work. The perfect accidental brushstroke, aligned with the perfect drawing. I couldn't do it before—you'd have to be a Zen master!

J: Oh that's interesting because one of the strengths of your work to me has always been the painted quality. It's interesting that you are able to retain that in the digital world.

M: That was my calling card. The response was, "Oh this is fresh." I'm a commercial artist and commercial art thrives on the new. So I immediately started getting lots of work. My work went from painting The Kinks to being very current. I stepped into a time machine; suddenly I was vogue-ish.

(Below)
The Kinks,
Mojo magazine.
1998.

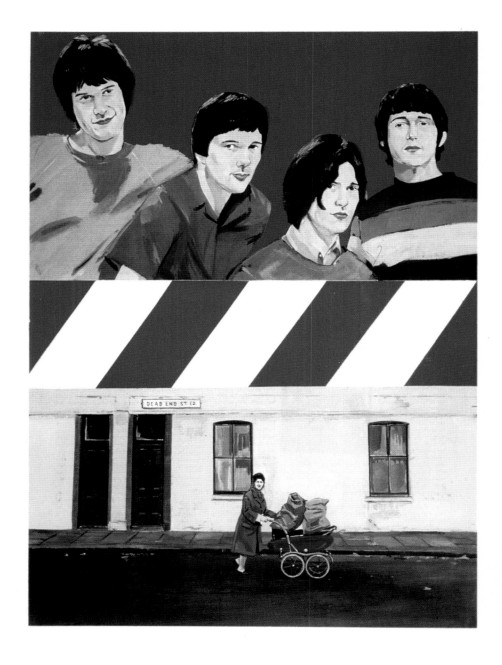

J: So what happened with Art Department?
M: I went back the next year; Stephanie remembered me. I left the Tic Tacs at home! In the interim I'd done lots of new work, so she took me on and sponsored an O-1 visa. I floated out of her office and through the streets. A few blocks later, Neil Diamond was singing "Coming to America" at an open air show, unbelievable. Then I jumped through all the hoops required to move.

J. When was that?
M: I moved on October 9th, 2001. John Lennon's birthday. Also the day that Afghanistan started to be bombed.

J: And you've been in San Francisco since?
M: Yeah. I remember the night before I came I thought, "What am I doing? This is nuts."
And then I got off the plane and, "Oh yes. I remember: home."

J: So what effect did it have on your work being here?
M: I think it was more not being in London and the openness, discovering California, and meeting Cindy (my wife). I was thirty-one. Thirty wonderful! Everything was shiny. It was really magic. My move to America was charmed.

J: So what was happening in your work?
M: I was making loads of fashionable images. I was working a lot for Levi's, *Spin* magazine too.
I did *The Little Angels*: watercolour childhood portraits of famous people who died tragically, and had a gallery show that got a lot of attention. I started doing watercolours because the digital work was becoming unsatisfying. I missed the wholly tactile experience, but I was wary of acrylic and wanted something that I could paint faster and cleaner; as I was now working at home, it was practical.
I was in an apartment behind Alamo Square. I had a killer apartment with a massive view for $1100. I moved right after 9/11—the flags were flying for me! [*laughs*] People were leaving town left and right, so, for once, places were available.

J: Really? Because of 9/11?
M: The tech bubble burst and then 9/11. All this anxiety and paranoia: "America's loss of innocence." People couldn't believe it, it was shocking, but I was so used to the Northern Ireland situation it seemed familiar to me. There seems to be more optimism here. I need it at all times, all good!

(Top)
Studio/kitchen, where the drawing below was made. 2001.

(Bottom)
View from Royal Court Apartments in Hayes Valley. 2001.

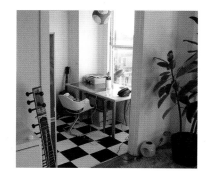

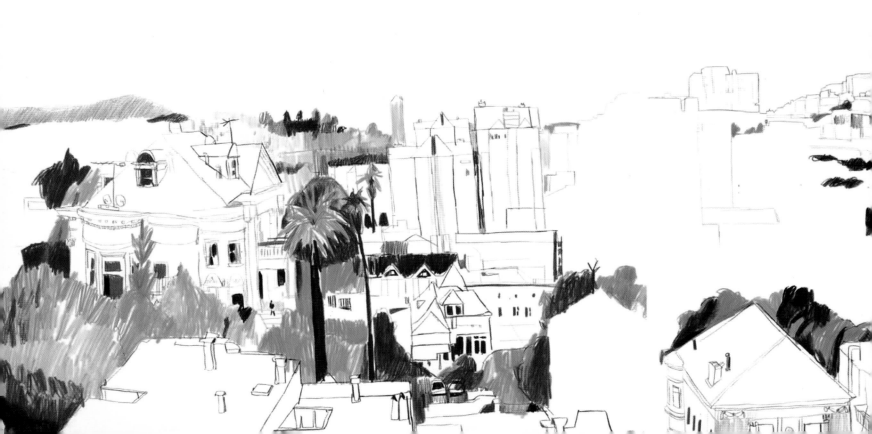

J: So how important is it to you that your work is uplifting?

M: I think that it's necessary for me to make work, and that process is uplifting to me, so maybe that shows.

I think my work has different styles, or voices, for different emotions. I'm amazed when people have a singular artistic style. Sometimes I want my work to be funny, other times deadly serious; how can it have the same delivery? Punk rock didn't yield many love songs, right?

I went through a period of time in my twenties quite angry; I've created from lots of different energy sources. Some work I look at, and I like it still, but I know that it came from a ghastly place. And maybe that was just the best of me coming out in it.

J: Like what? Which paintings?

M: Well the large acrylic paintings for sure.

J: Not from a loving place?

M: No. But interesting—I need to make work. The idea is to keep creating; like the pancreas makes a new lining every day, I'll make a new drawing. I view creativity as our natural state, and I try to honour that.

J: You know, you never really struck me as one of the artists I know who are particularly ego-driven, and maybe you just do a brilliant job of covering it up, but it doesn't really strike me that that's the motivating force. One of the things that I've always really enjoyed about your work is that it does have a hopefulness to it. The thing that it seems to have in common is this kind of charming, gentle, kind of sweetness to it.

M: Well my ego is very gratified to hear that! I'm not really sweet or fuzzy.

J: Maybe secretly fuzzy? Under your striped top?

M: I haven't achieved it.

J: You don't think you've achieved fuzziness?

M: No, Cindy will provide all the evidence. [laughs]

J: She's a native Californian?

M: Yeah, I keep having to explain: "I grew up in Wales."

I think that music takes you to an unknowable place; that's what I try to catch the coattails of in my work. I think in the early years I had, shall we say, an unexamined ego. [laughs]

Maybe one needs ego as rocket sauce to launch you out there. Over time, though, it's felt corrosive. I understand my ego as like a cloud. A cloud can liven up the sky or completely block the sun. At least I now have an understanding of it, and some tools to move it along.

I've come to understand that the way I think doesn't have to be imposed or followed by anyone else. I'm here to bring whatever I have to the world; my work is an outlet, but I am not my work. If people don't like it, that's okay with me. There are seven billion other people out there—go and check them out. It's brought me some peace of mind.

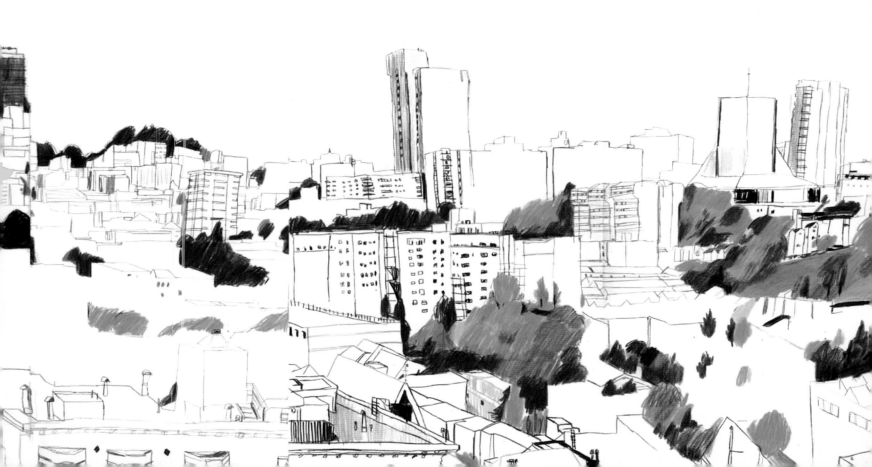

J: I don't know about you, but it's one of the reasons I got out of London, because I felt like that sort of ego trip mentality was so omnipresent. It was almost impossible not to feel competitive and feel angry when people are doing well and just all that stuff that's really not in line with who I'd like to be.

M: Yeah, it's been a relief to feel it's okay for other people to make great stuff. I can enjoy that. I can enjoy a sunset without having to make it [*laughs*]. London is a pressure cooker, a hot house. I was as guilty as anybody of all that stuff, and it's still in me. I'm so glad to have a British background—it's an amazing place on so many levels—culturally, pound for pound, it punches harder than anywhere. Look at the music that's sprung from there.

J: So what exactly did attract you to California?

M: The openness. The quality of life. It is really helpful to live out of your cultural context; I've found it's easier to quantify who I am.

J: So how do you feel your work is formed?

M: Well, it's back to the pancreas lining; how's that formed? I just keep going, you know?

J: It's just showing up, and making it work, and ignoring the voice in your head?

M: Yeah. The voice in my head just says, "Keep on keeping on."

J: But at some point it must have said, "You're not good enough."

M: All the time, yeah.

J: How long did it take to shake that off?

M: Oh, it's always there. I can never really achieve what I want. Sometimes I think I've caught something, but it pops like a bubble. I view that as a positive. There's always another chance to make something better; it's a journey. It's hard to be objective about your work. If you compare it with others, you are judging your inner flaws against others' outward successes. Whatever gifts I have, that's what I work with. I keep making the work and see where that takes me. I'm very grateful for the chance.

I think I've made a little go a long way! Any fool can make a lot go a long way, right?

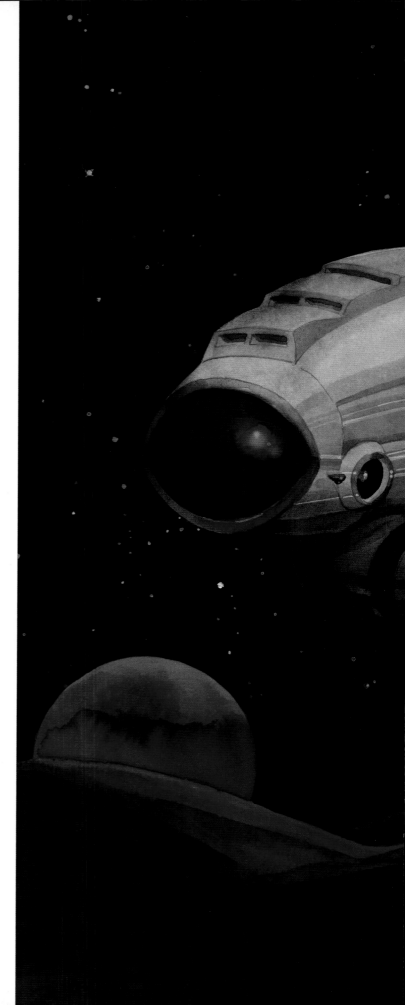

Across The Universe.
2006.

I believe The Beatles will be cloned and sent to tour the Galaxy as goodwill ambassadors.

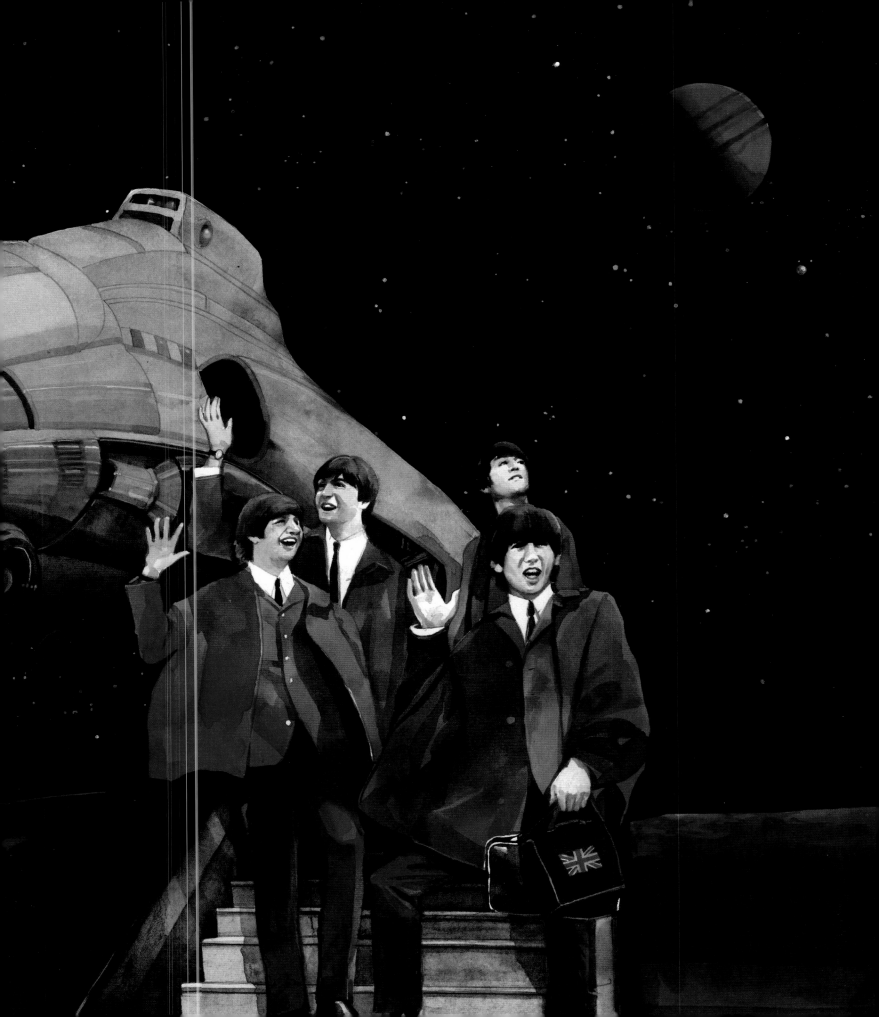

Drawing is one of human
kind's primal occupatio
right back to the cave:
Hunting, Cooking, Draw
It will always have the lu
of ancient magic! We all
it freely as kids and I've
lucky to continue to exp
I often avoid it, and to m
peril, because I feel muc
happier when I draw—a
period of focus in a worl
of chaos, like meditatio
with a visible memento.

Draw
It

Maharaja of Synthi.
Used as a sticker
for Beck's album
The Information.
2006.

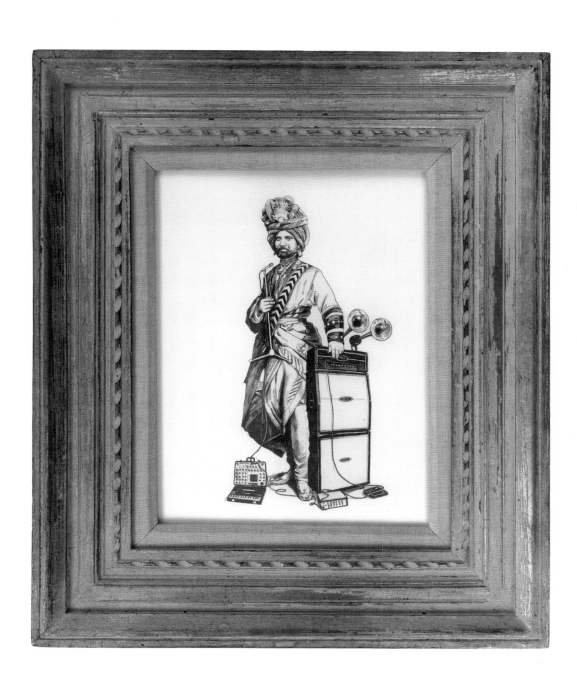

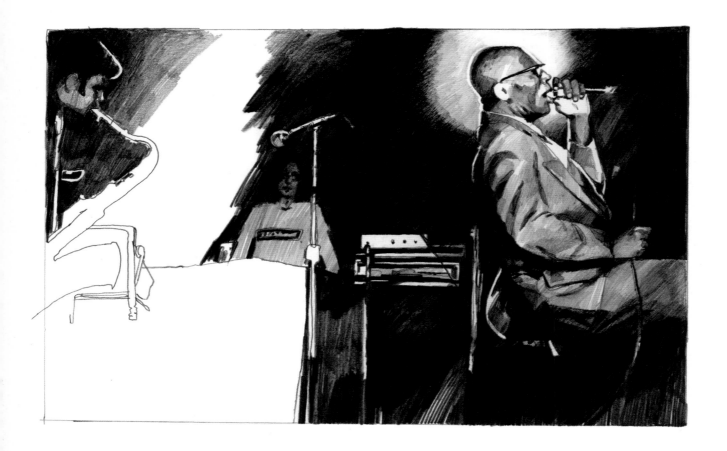

In the beginning
there was the Blues
and Jazz ...

(Above)
Howlin' Wolf.
2006.

(Right)
Miles Davis.
2012.

(Below)
The Duchess Shiva.
2006.

(Right)
Blues Giant. Used
for Beck's album,
The Information.
2006.

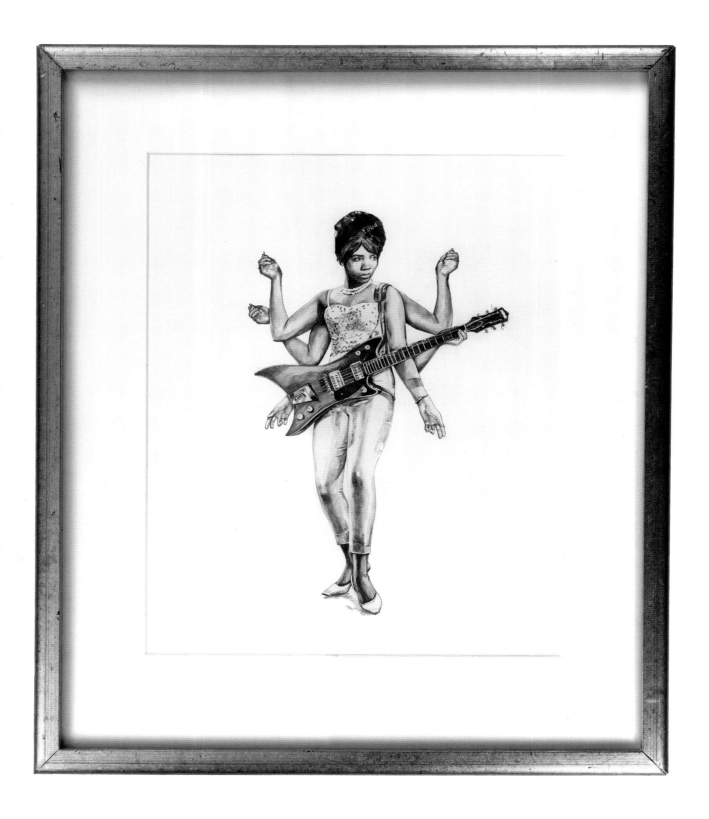

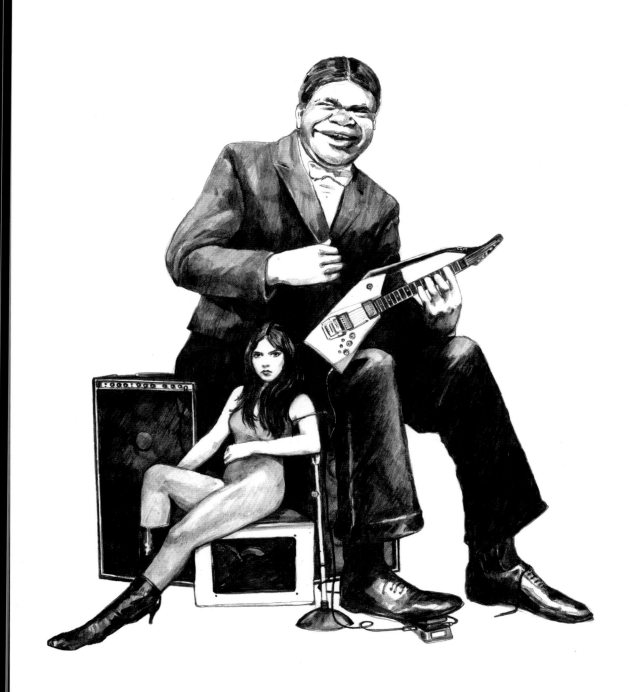

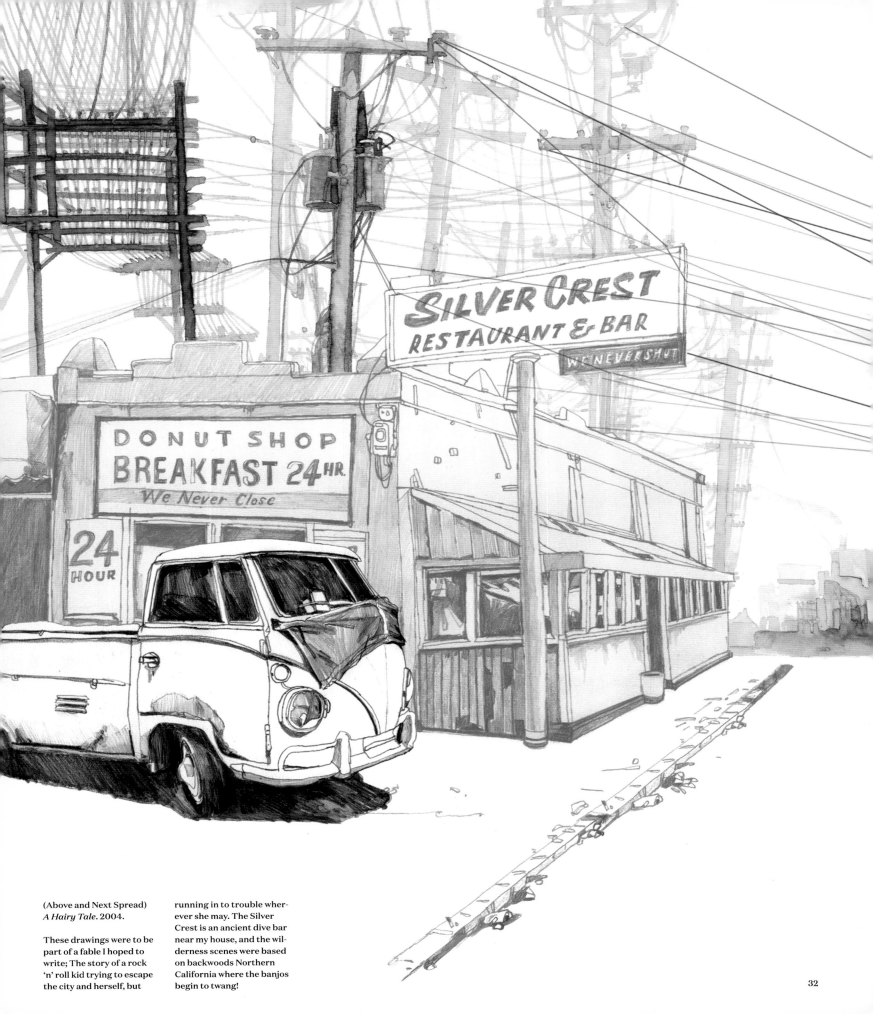

(Above and Next Spread)
A Hairy Tale. 2004.

These drawings were to be part of a fable I hoped to write; The story of a rock 'n' roll kid trying to escape the city and herself, but running in to trouble wherever she may. The Silver Crest is an ancient dive bar near my house, and the wilderness scenes were based on backwoods Northern California where the banjos begin to twang!

32

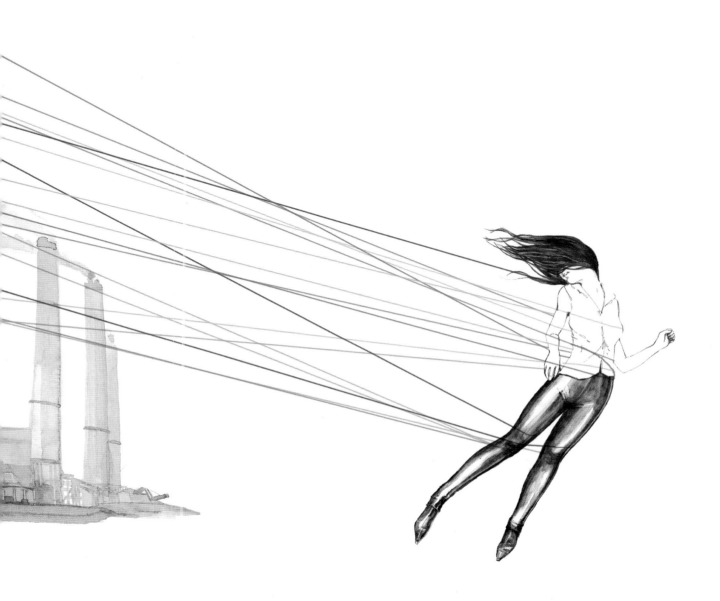

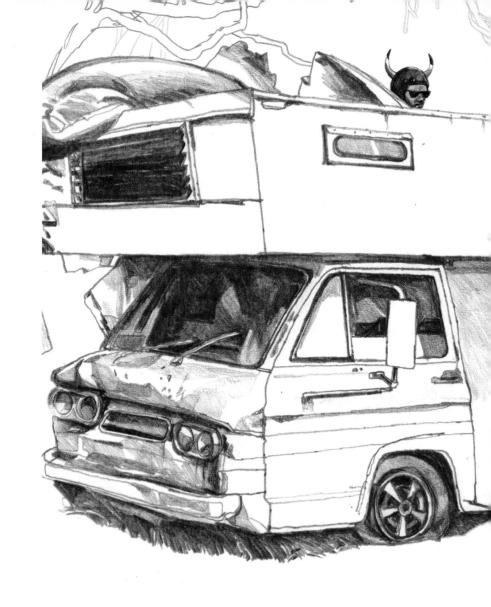

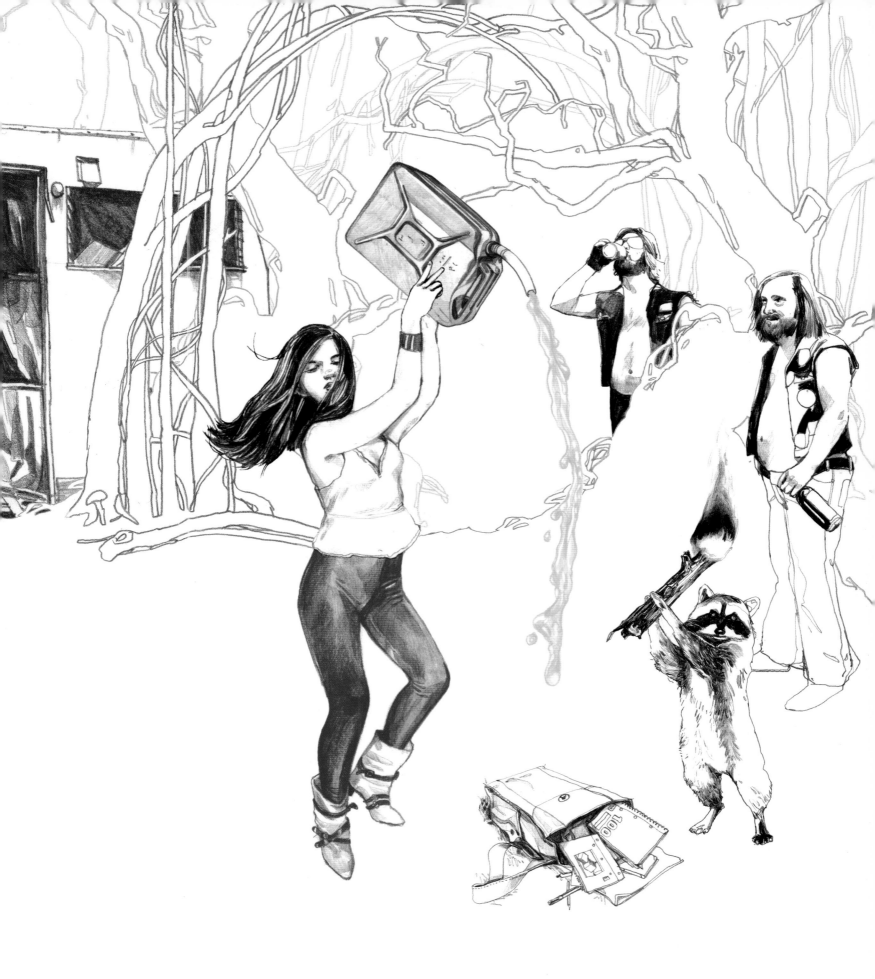

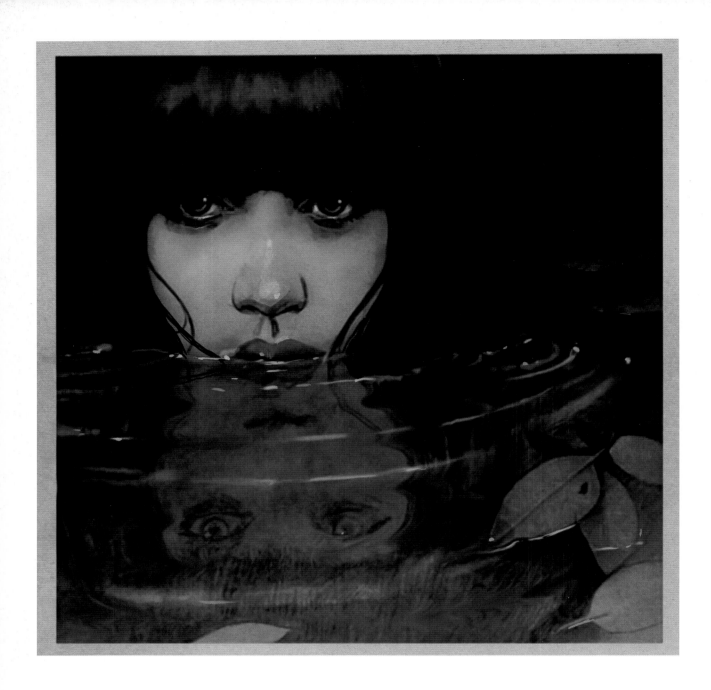

A Hairy Tale.
The Boonies.
2004.

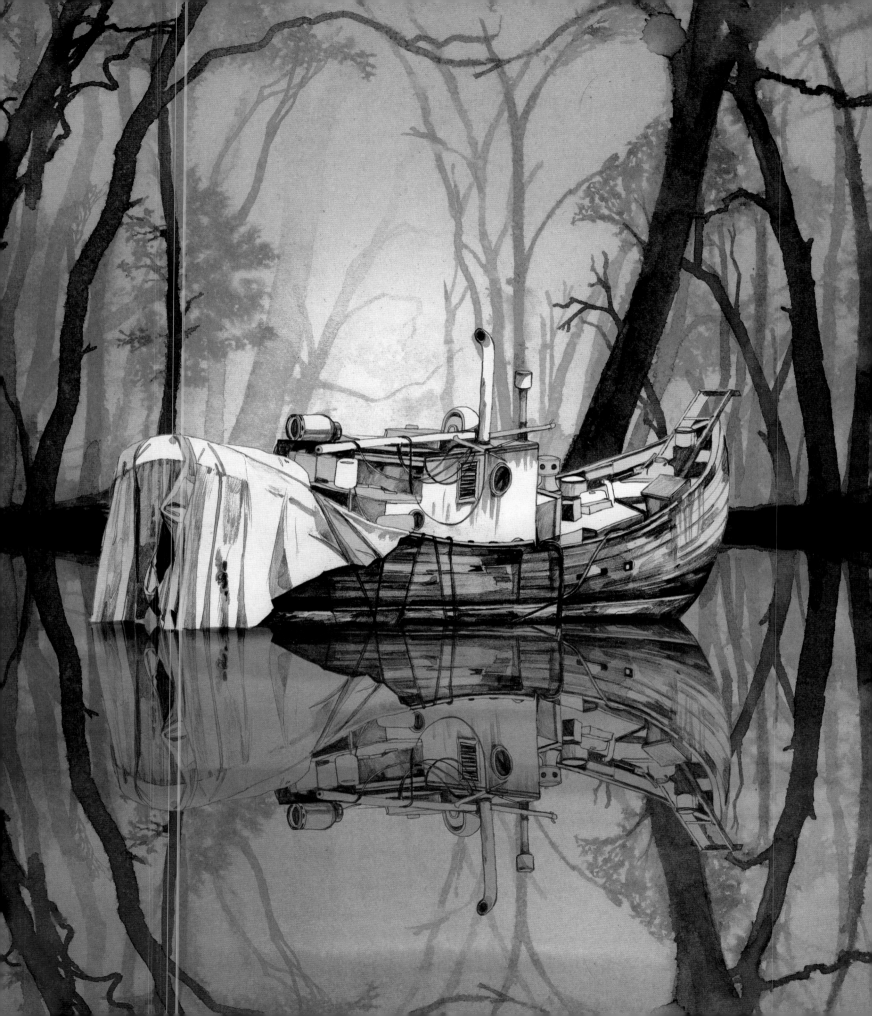

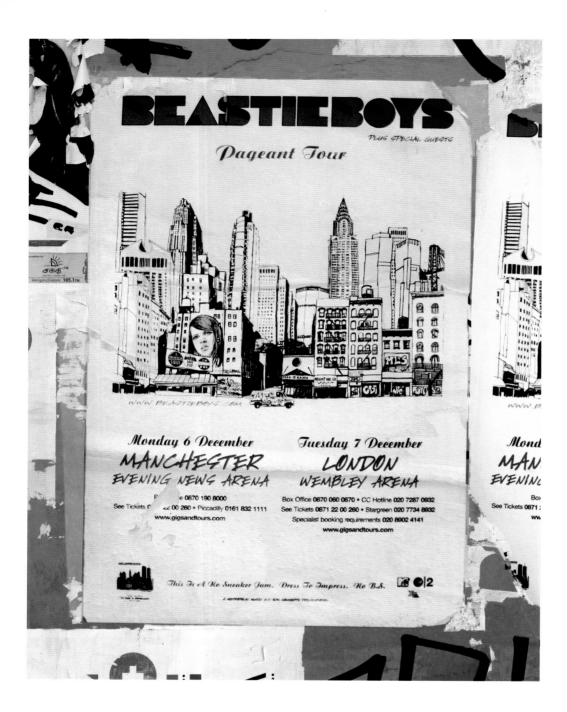

(Above and following two spreads) Beastie Boys. *To the 5 Boroughs* animation. 2004. An absolute wrist breaker! A month of drawing New York from every angle. The band used the resulting minute-long clip to promote their album and Pageant tour. An image was extracted for the accompanying posters. A real thrill to work for the masters.

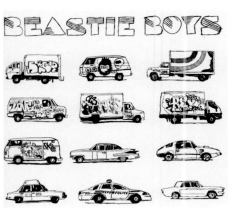

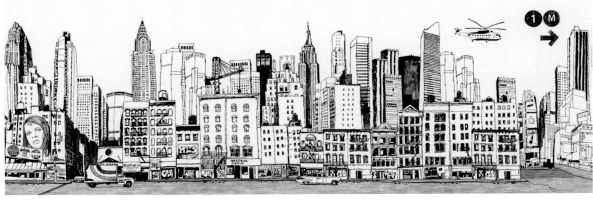

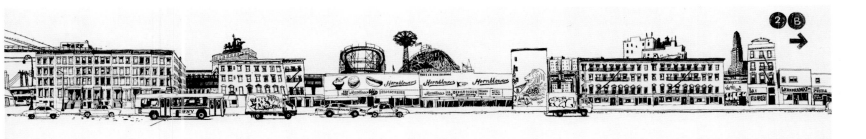

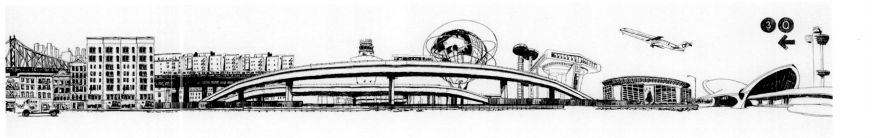

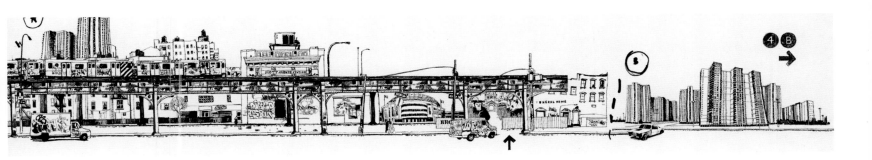

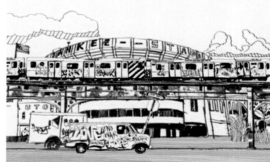
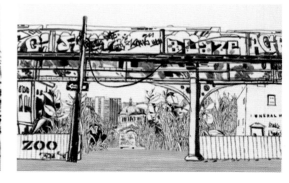

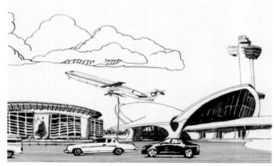
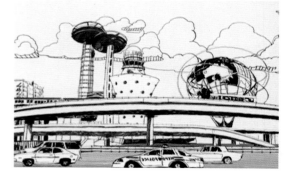
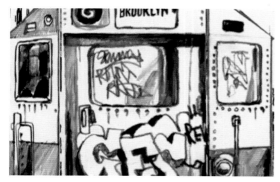
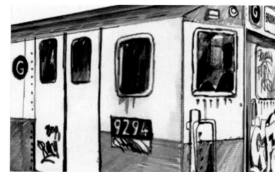
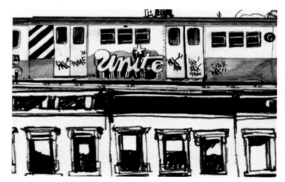
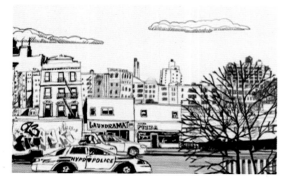
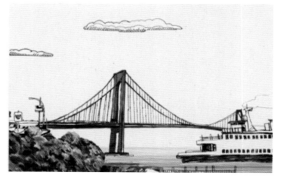
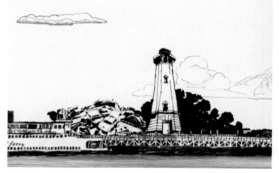
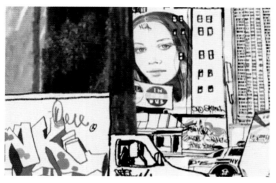
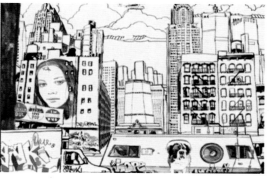
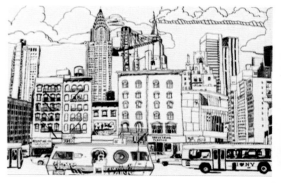

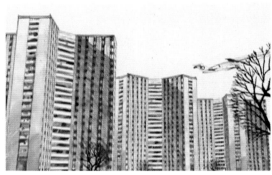

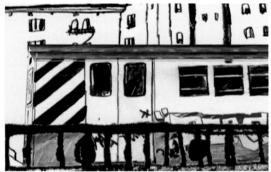
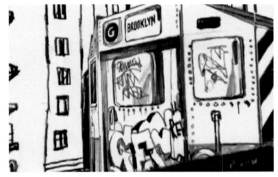
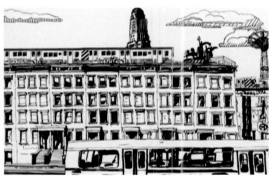
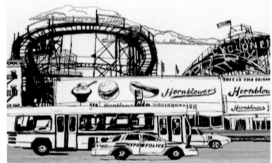
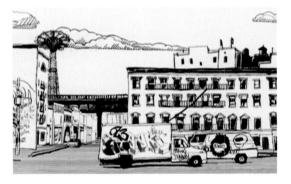
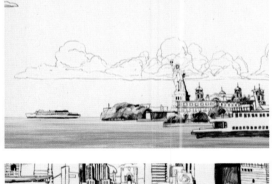
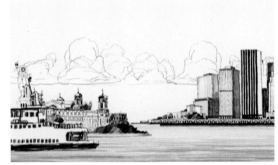
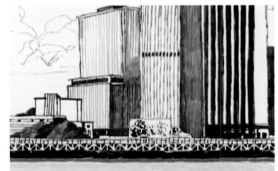
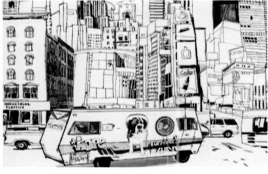
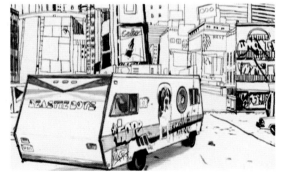
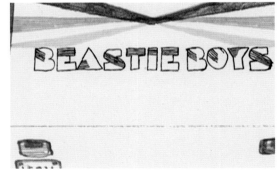

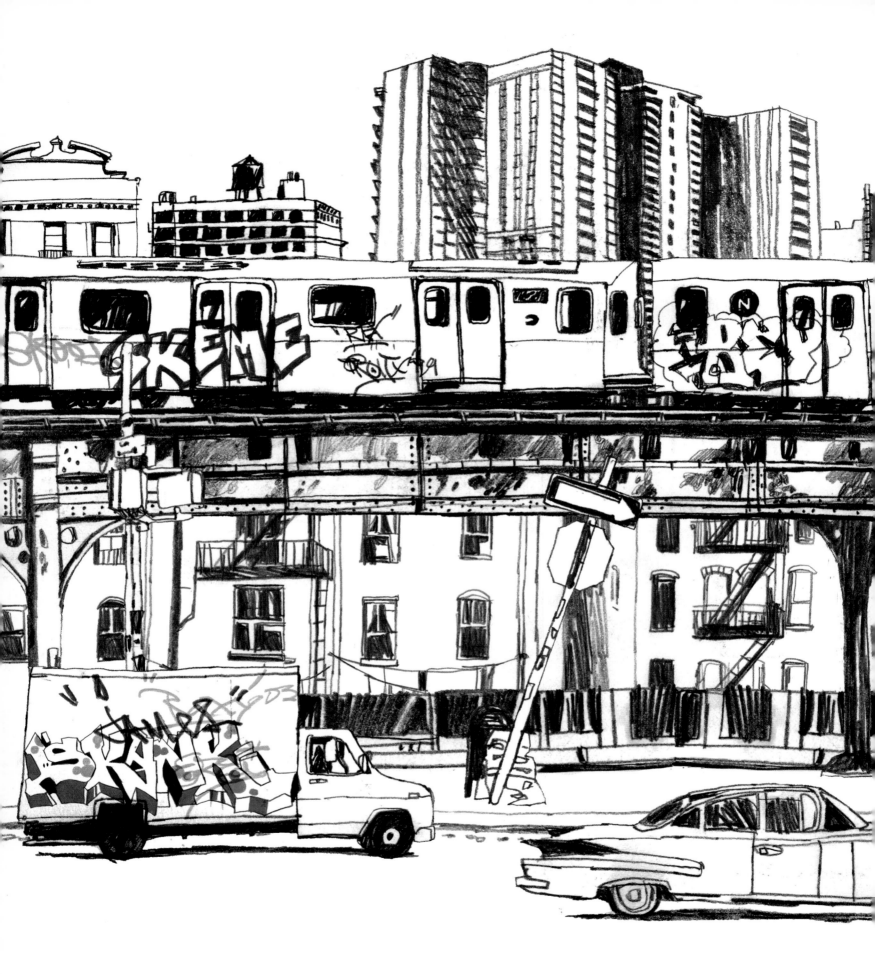

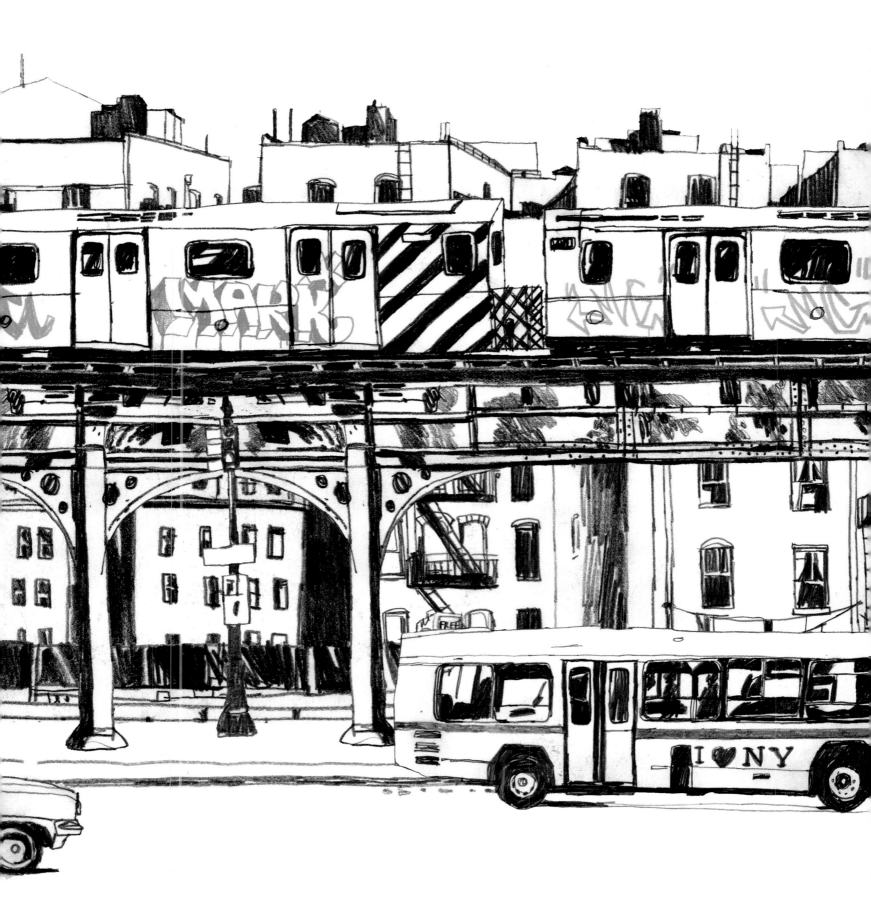

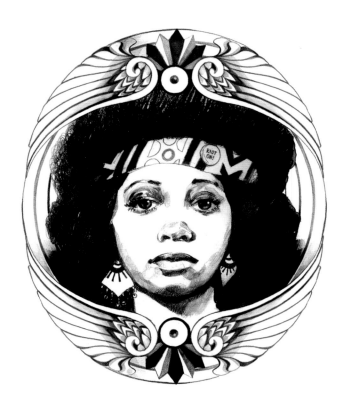

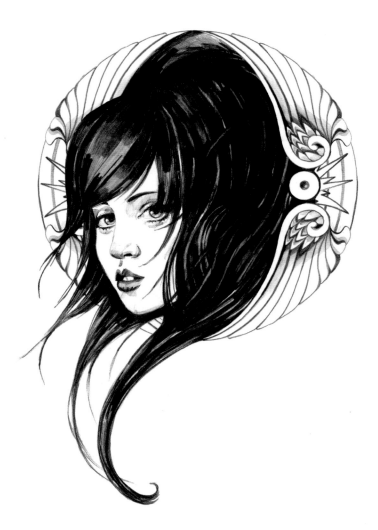

(Left)
Fullcircle.
T-shirt designs.
2005.

(Right)
The Glade,
for a solo show.
2003.

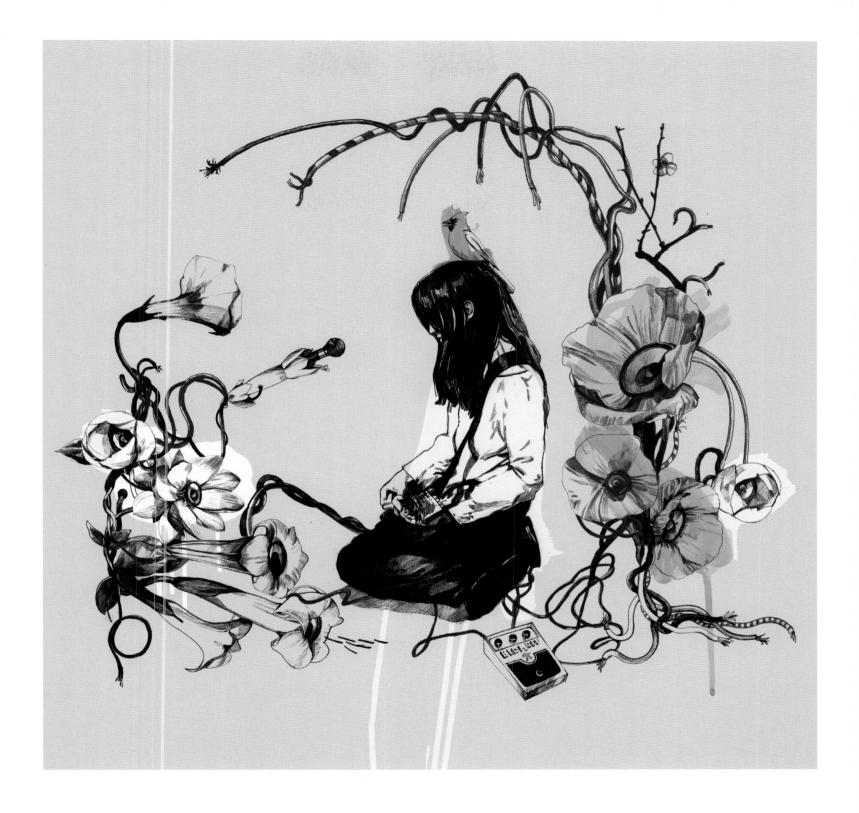

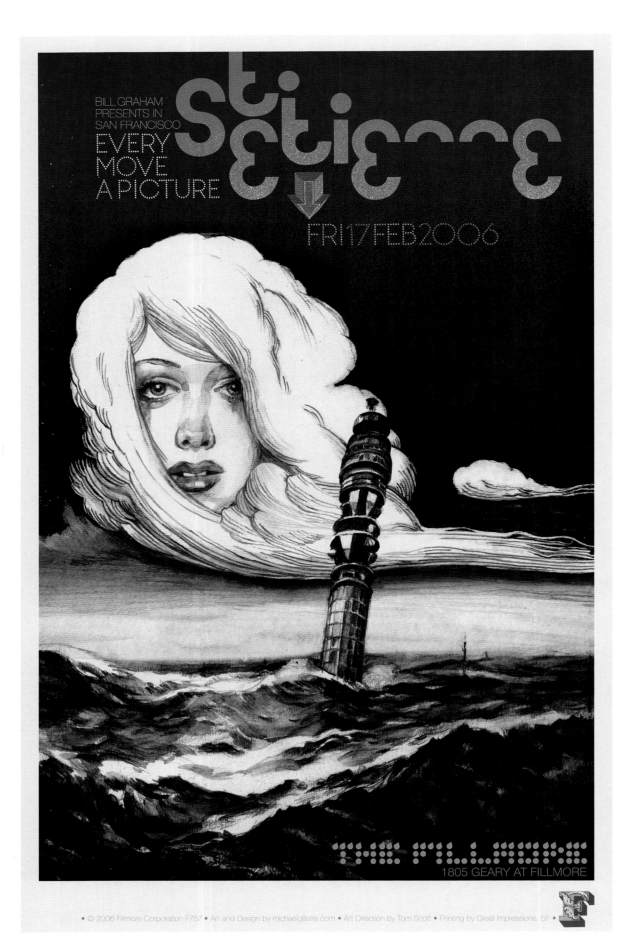

(Left)
Saint Etienne.
Fillmore poster.
2006.

(Right)
Beth Orton.
Fillmore poster
(unused).
2006.

46

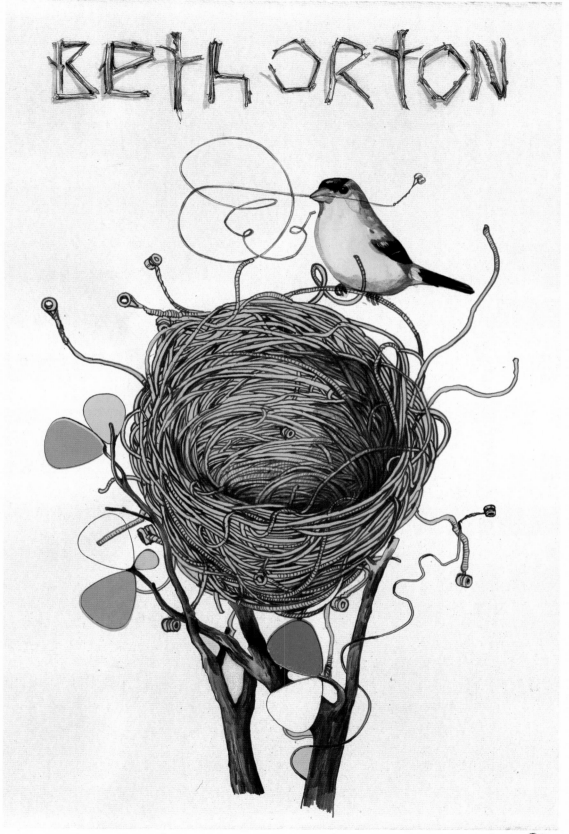

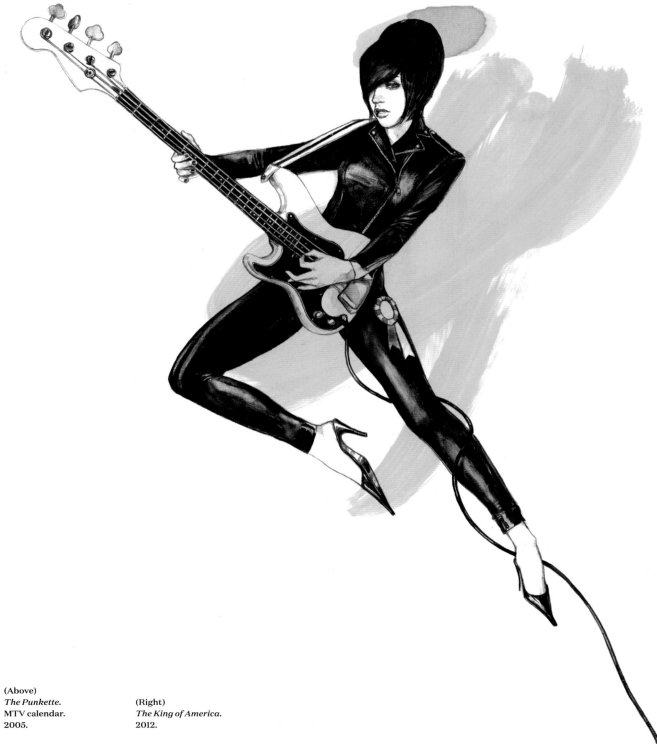

(Above)
The Punkette.
MTV calendar.
2005.

(Right)
The King of America.
2012.

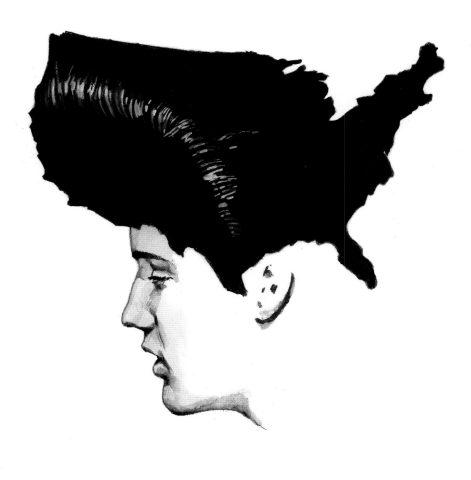

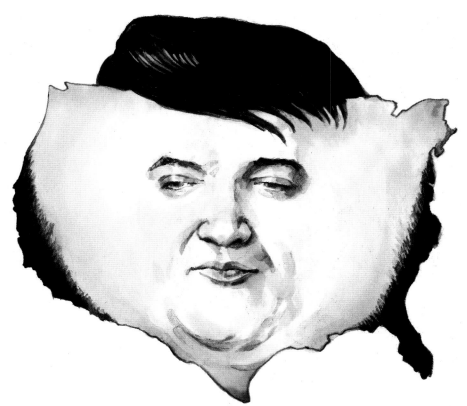

Draw It Out

Selected Ambient Words: Life With the Aphex Twin 1992-1995
by Michael Gillette

I first met the Aphex Twin on Surbiton High Street, early summer '92. I had just graduated from Kingston, along with the classmate sitting on the pavement next to him, a graphic designer we called "Nobby." Nobby's ambition was to be a robot. "Stakker Humanoid" was his 7 a.m. wake-up call. He designed the iconic Aphex logo (hand drawn in marker), which Richard bought the rights to for £500, by turns honourable and savvy.

By summer's end I was living below him on Southgate Road, then a no-man's-land between Dalston and Islington. Nobby, myself, and two college mates took the downstairs, whilst Richard lived upstairs with his delightful girlfriend Sam, a pretty Cornish flower child. Across the road was a crack den.

That first year was relatively civilized. Initially, I had no idea of the magnitude of Richard's talent; but working in my room below his home studio, it was soon unavoidable. The "Techno Mozart" by 21. I'd recently worked for Saint Etienne, and when I mentioned him, their jaws dropped. They asked if I could get him to remix them; I couldn't get him to do anything, but I did pass on the request and he obliged.

After a year on Southgate Road, we were turfed out by our landlords, deposits withheld. Filth. Damage. We decamped (sans Nobby) to nearby Stoke Newington, all thrown together in a terraced house, with Richard recording in a tiny cockpit at its heart. Here things took on a grimier cast. He was now famous and the house was abused by a stream of visitors, like a techno *Lord of the Flies*. The vibe was "3 a.m. Eternal"— always in a smoky murk, none of us had jobs to rise for.

Music poured out of him, hunched over tweaked analogue gear, a beige Mac, and a DAT machine. One such machine, which had failed, was swiftly splintered and strewn over the garden path, a taster of the chaos within.

Day and night the sound of a mammoth with its balls on fire would rip through the house at blood-curdling volume. Soon the neighbours lodged a petition. When that failed, they lobbed stones at the windows. This brought an air of siege paranoia to the place. One flatmate installed two-inch-wide iron bars on all the windows. A less fragrant of our order caught scabies, something I thought had died out with street urchins and rickets. We all itched along to the doctors to find that, miraculously, we'd avoided the pox.

The landlord, Mr. Hussain—who punctuated every sentence with "as it happens"—said nothing of the decline and kept cashing the cheques.

I made a shaky video for Elastica, which came second in some NME award. Richard's video for ON, directed by Jarvis Cocker, won. Deservedly so, as it happens.

We all made exceptions for Richard; he never did the dishes. One of the myths about him, which I believe, is that he could lucidly dream music—a total connection to creativity. The white heat.

He conjured all hues of Heaven and Hell, with an infinite sonic palette. One day, sick with food poisoning, I retched the ghosts of every meal I'd ever eaten. He recorded my heaving to add to some horrific creation.

In the wake of Dummy by Portishead he made a slew of beautiful, haunting music that sounded like a celestial ice cream truck. It went unreleased.

He wasn't hampered by any need to please others, be they famous or wealthy. At one point, mid '90s, Madonna wanted to work with him. He ignored her people; finally she phoned him to get the short answer. One of the later remixes he did for cash was a limp Lemonheads song. He didn't bother listening to the track, just pulled some random tune from his enormous stockpile. He told the record company that he'd compressed their entire song into the sound of a hi-hat! Did I mention he was a genius?

By late '95 the neighbours upped their bombardment of the house in protest at a set of ear-sores that Richard was spinning. He was gleeful of the havoc.

I left for less challenging territory. Soon after, Richard did the honorable thing and bought an old bank to live in, with a vault for a studio.

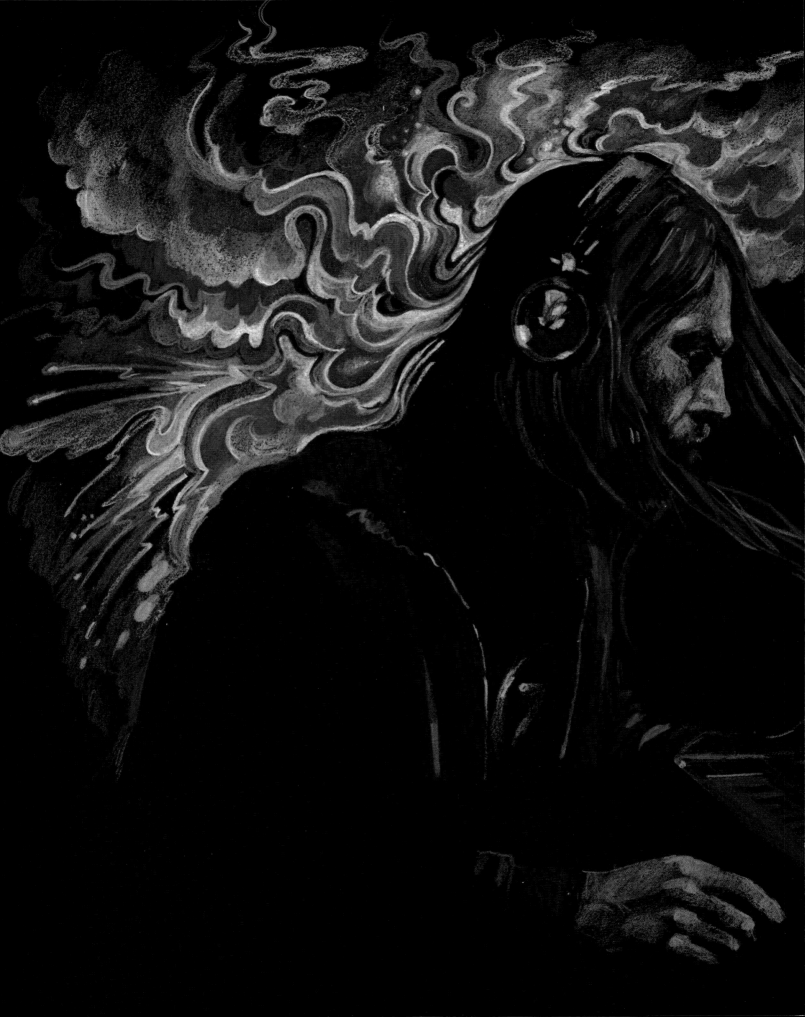

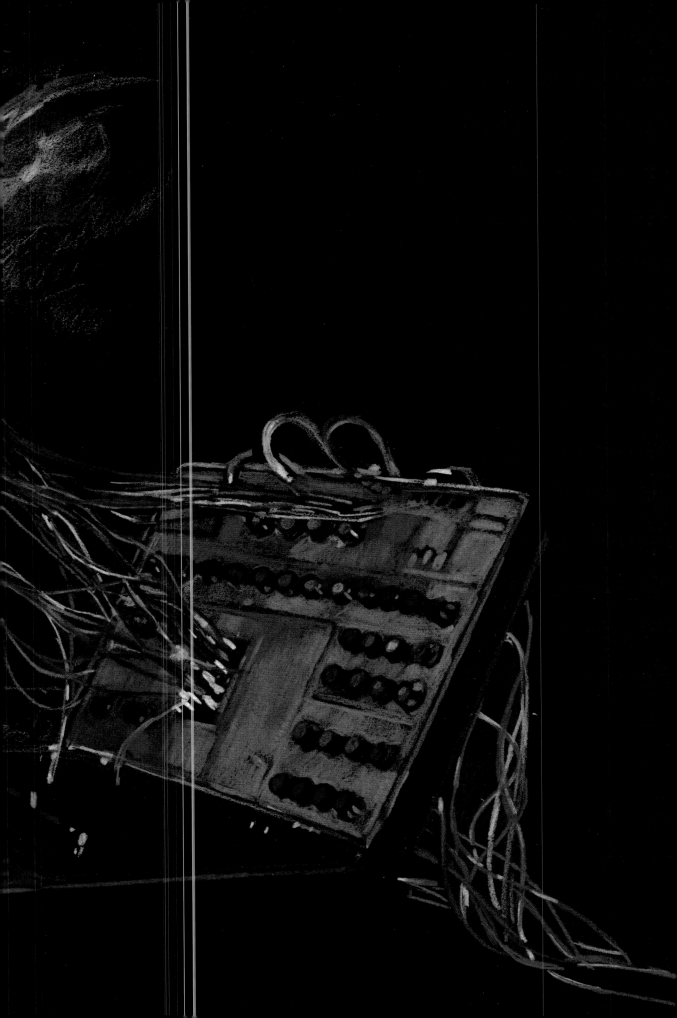

After painting in Acrylic for years, I avoided creating work which was too heavily rendered. I'd hit a wall, and wanted working methods that were looser and quicker. However, like a salmon swimming back upstream, I always return to realism. Without stylistic tics, it can have broader application. The computer speeded things up, allowing a return to collage. Photoshop's power brought fresh and unusual combinations. Sometimes an idea demands hi-fidelity

Hi-
Fi.

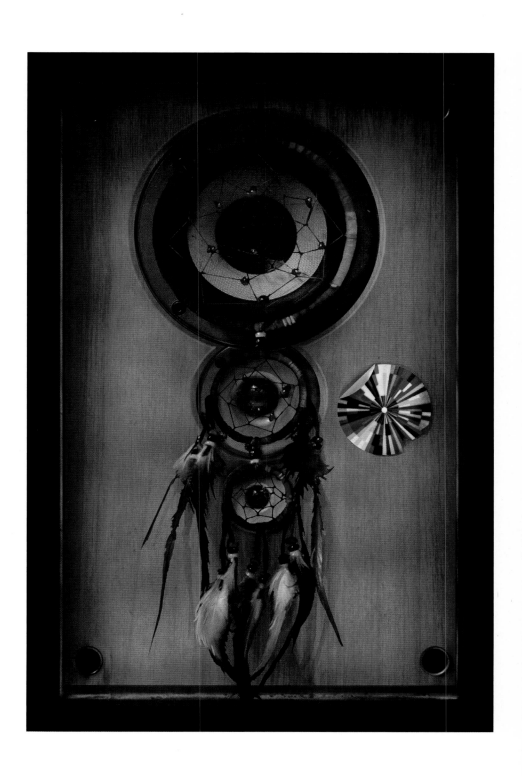

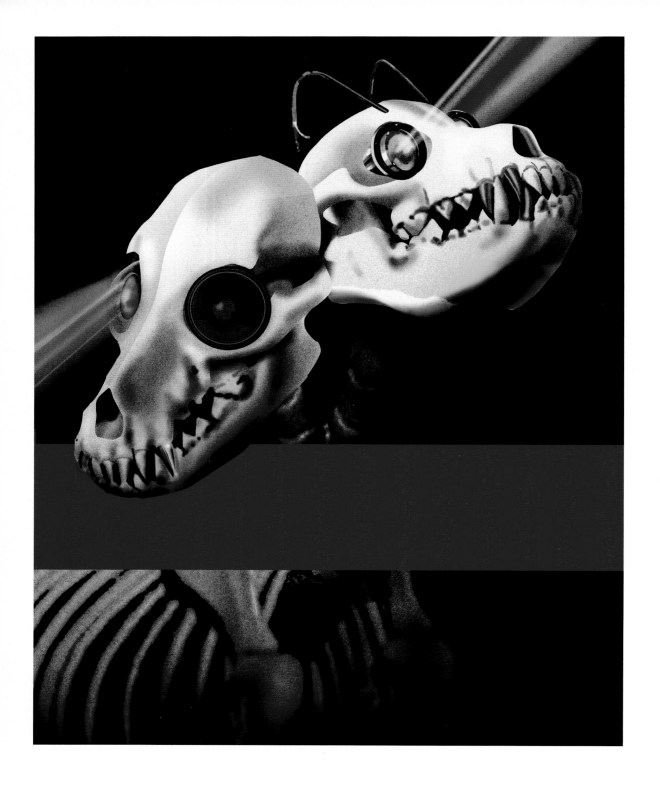

(Above)
MTV 2.
Promo poster.
2004.

(Right)
MTV. "Pimp My Ride"
promo poster.
2004.

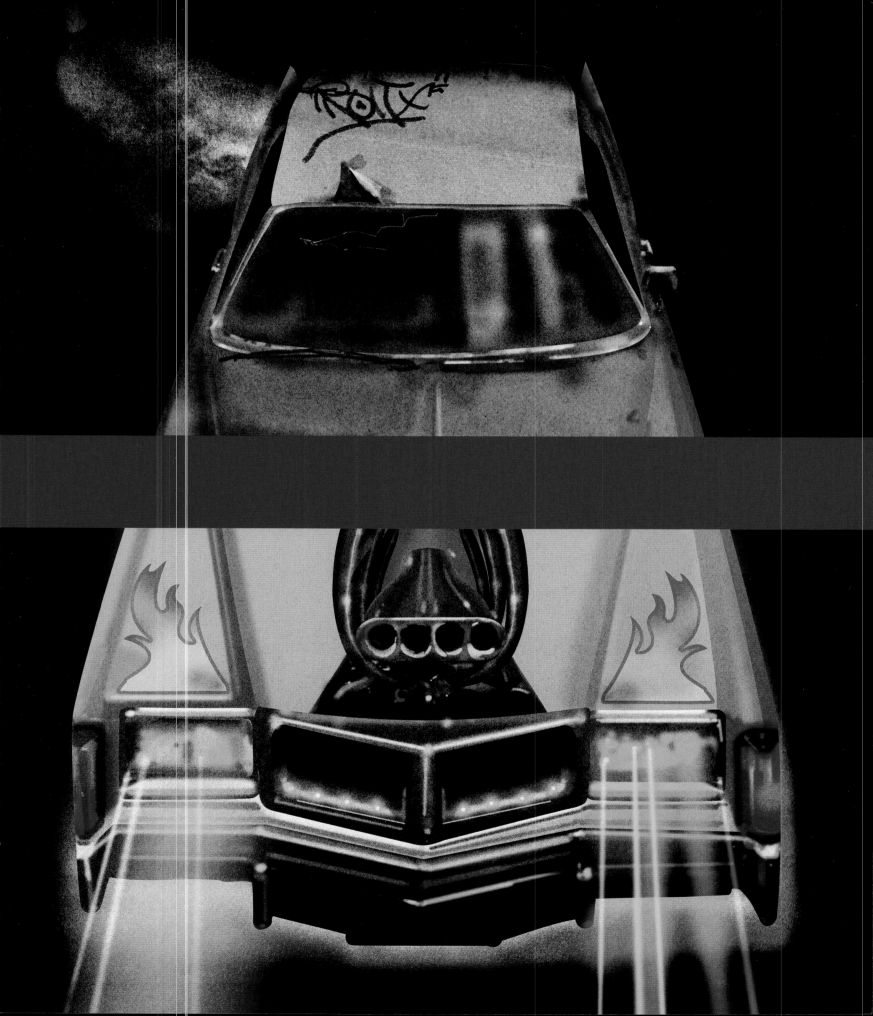

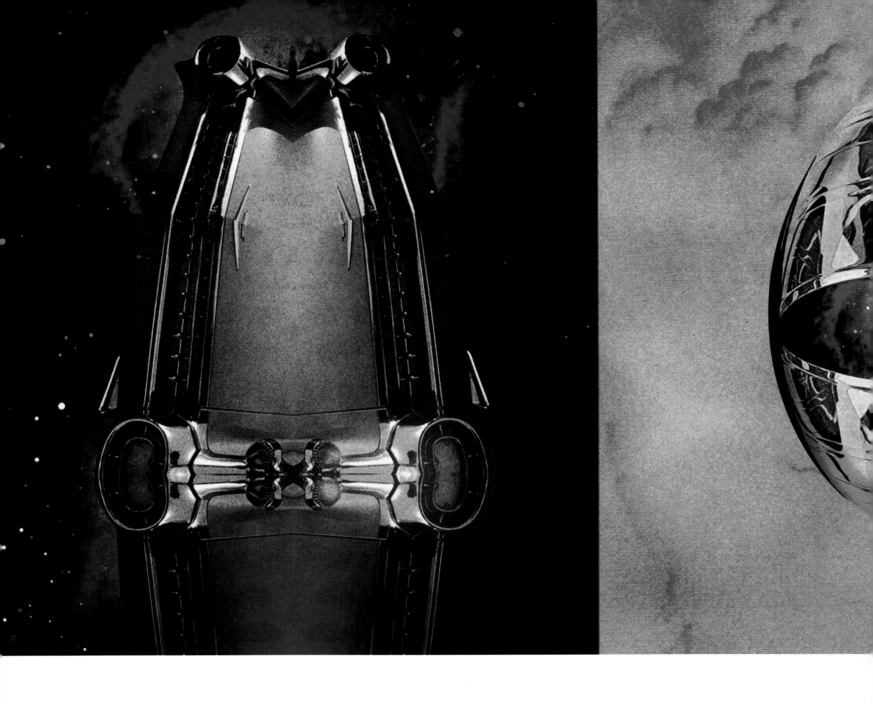

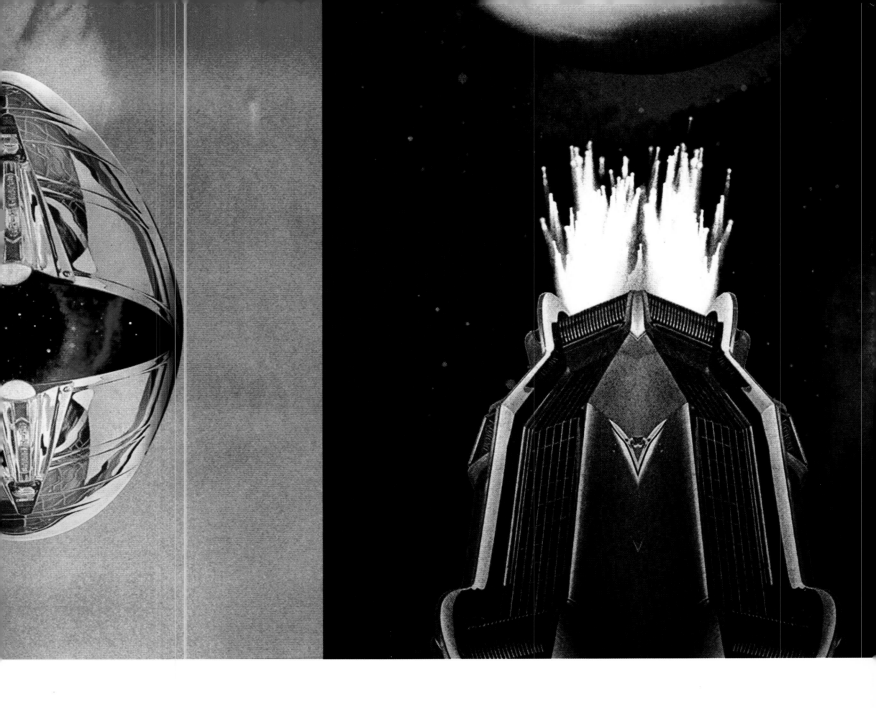

Cosmos collages.
2008.

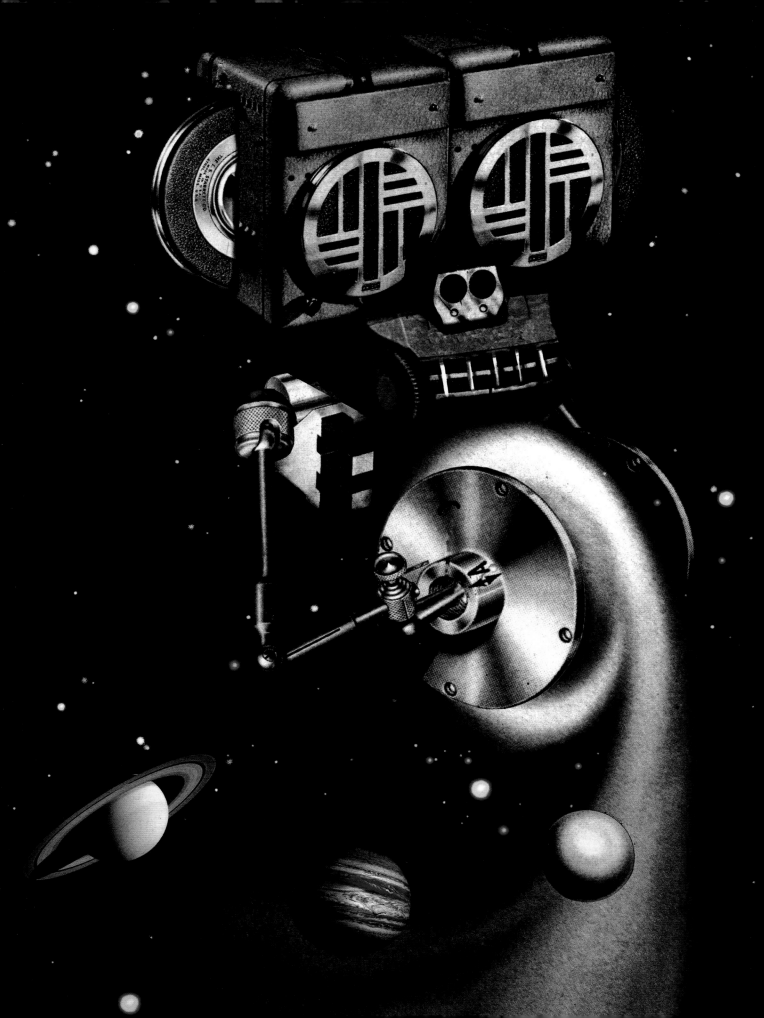

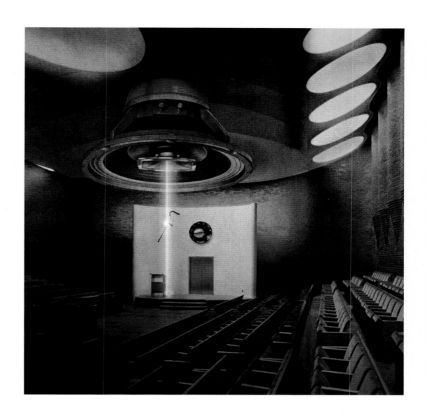

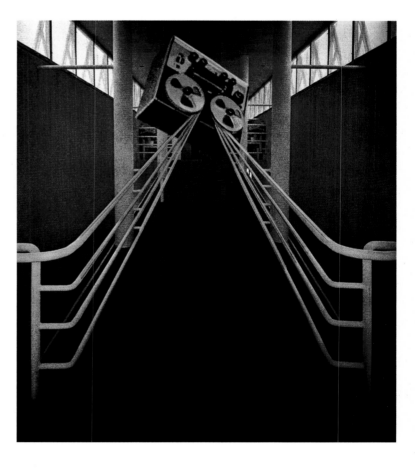

(Above, Top)
The Healer.
2007.

(Left)
*How it all
began/ended.*
2014.

(Above, Bottom)
Cold steel rail.
2007.

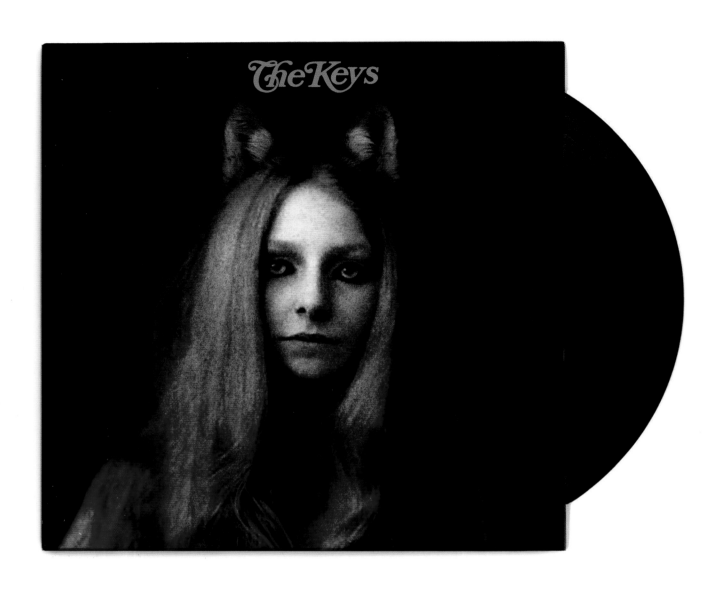

(Above)
The Keys, *Bitten By Wolves*.
See Monkey Do Monkey
Records. 2011.

(Right, Top)
Young Heart Attack.
Tommy Shots 7".
XL Recordings. 2003.

(Right, Bottom)
Young Heart Attack album,
XL Recordings. 2003.

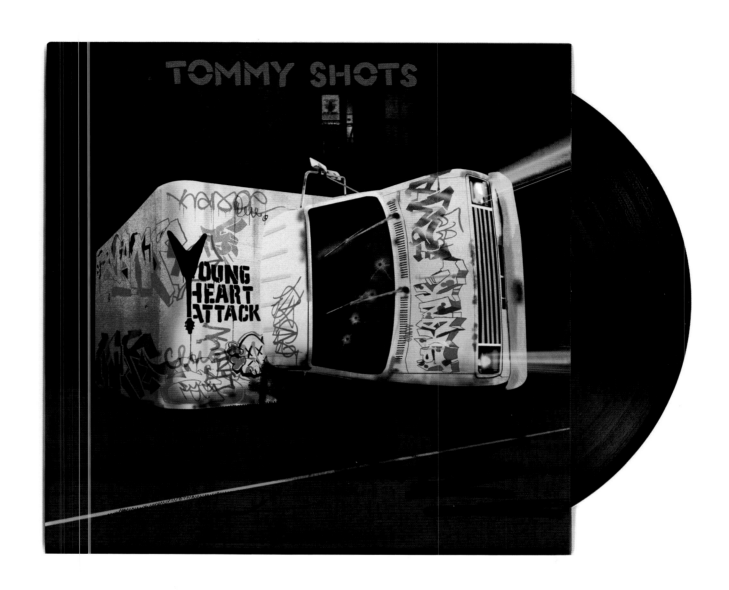

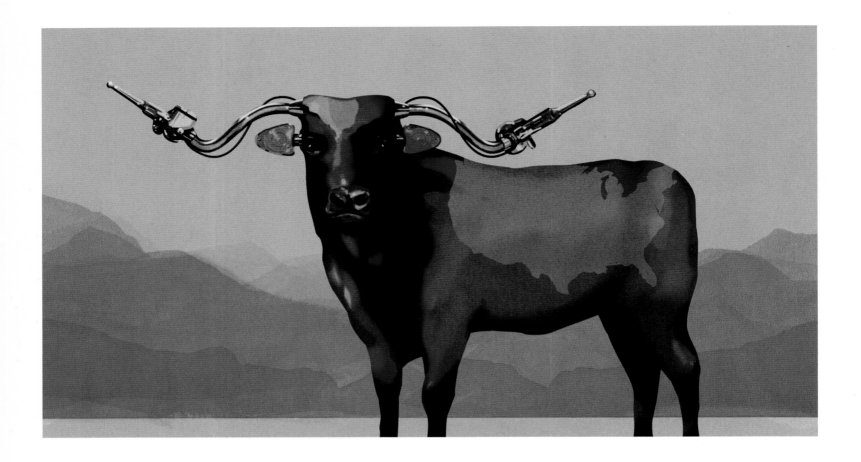

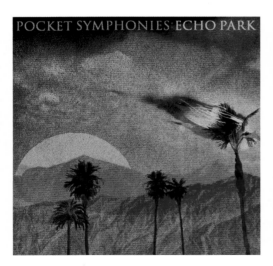

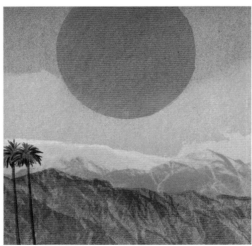

(Right)
The Monarch. 2004.

These images were
inspired by Los Angeles
and visiting the Coachella
festival. The Deercycle
started life as a drawn
T-shirt for Levi's; it was
popular so I took it further.
Rendered with a mouse!

(Above, Top)
The Longhorn. 2008.

(Above, Bottom)
Pocket Symphonies.
Echo Park sleeve
(unused). 2005.

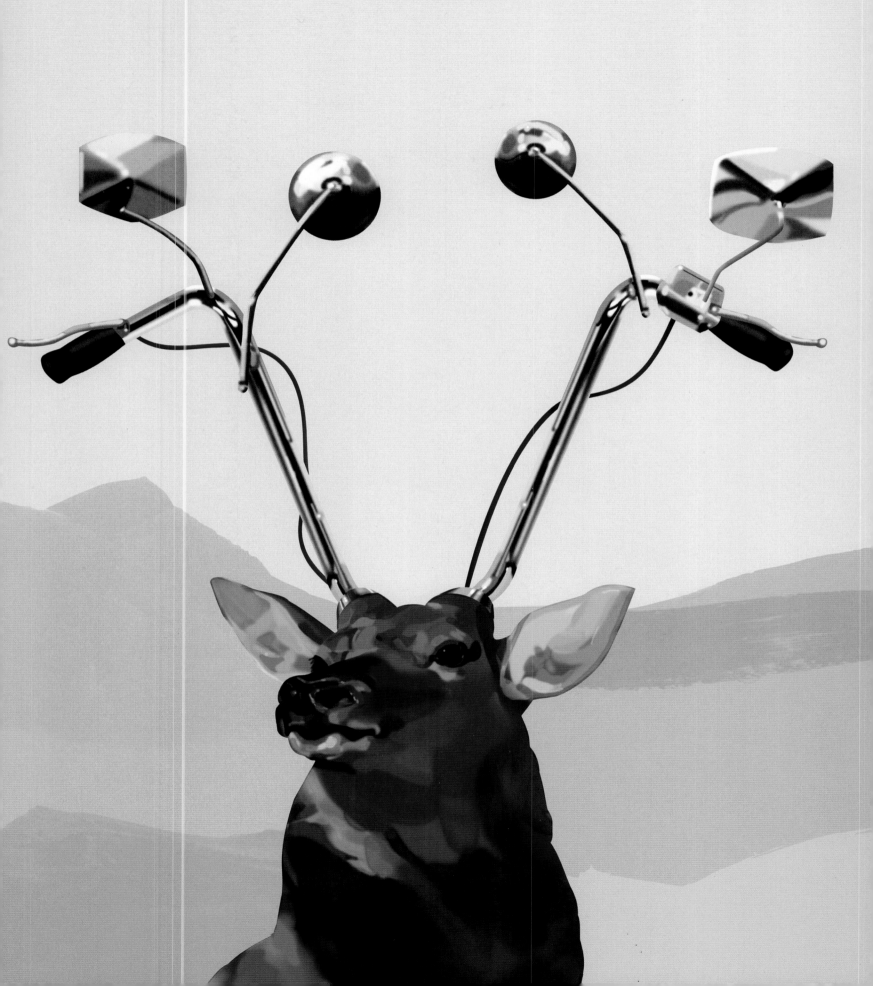

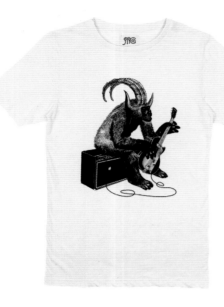

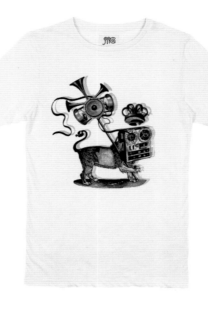

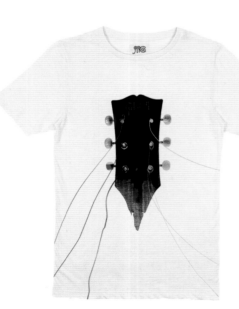

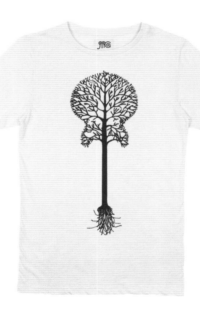

(Clockwise from Left)
Tees for Levi's
Leviathan. 2015.
Dub Lion. 2005. (Right)
Guitartree. 2005. *Denim Rocks.*
Headstock. 2013. 2015.

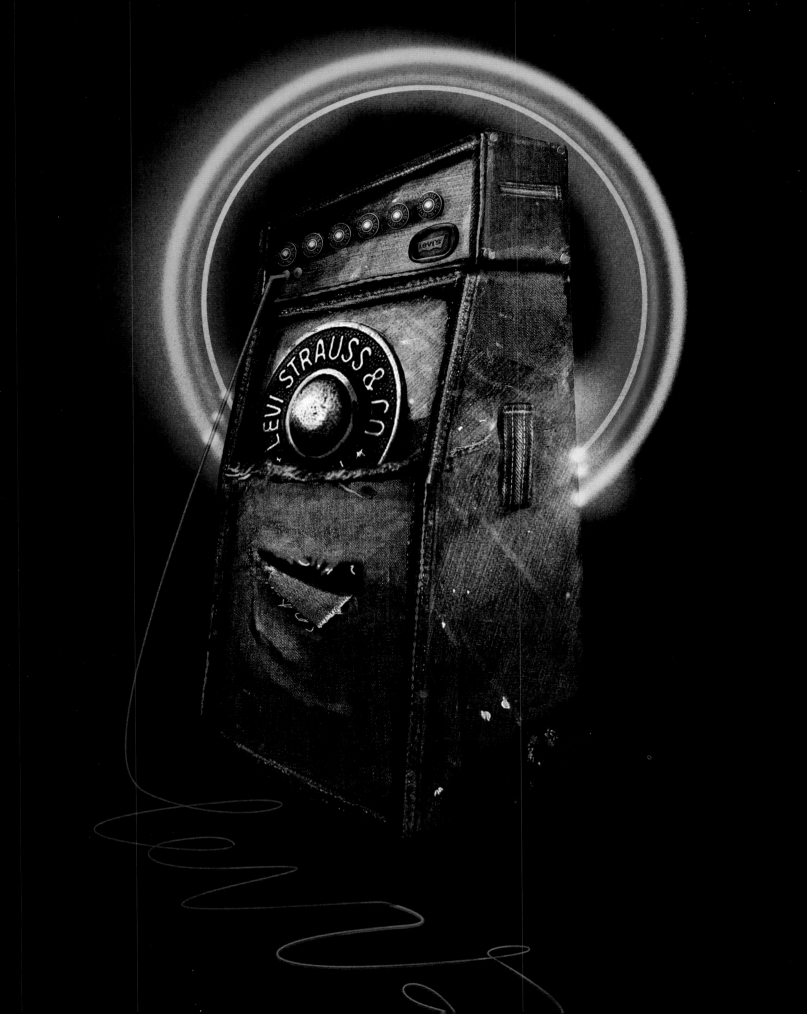

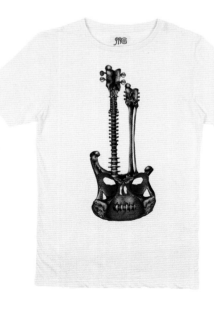

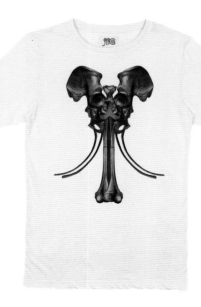

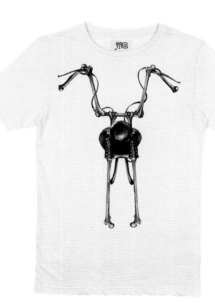

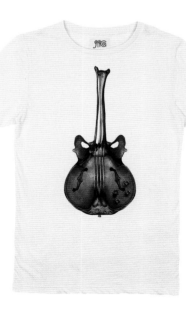

(Above)
X-ray designs (unused).
2013.

(Right)
Open Air St. Gallen poster.
2008.

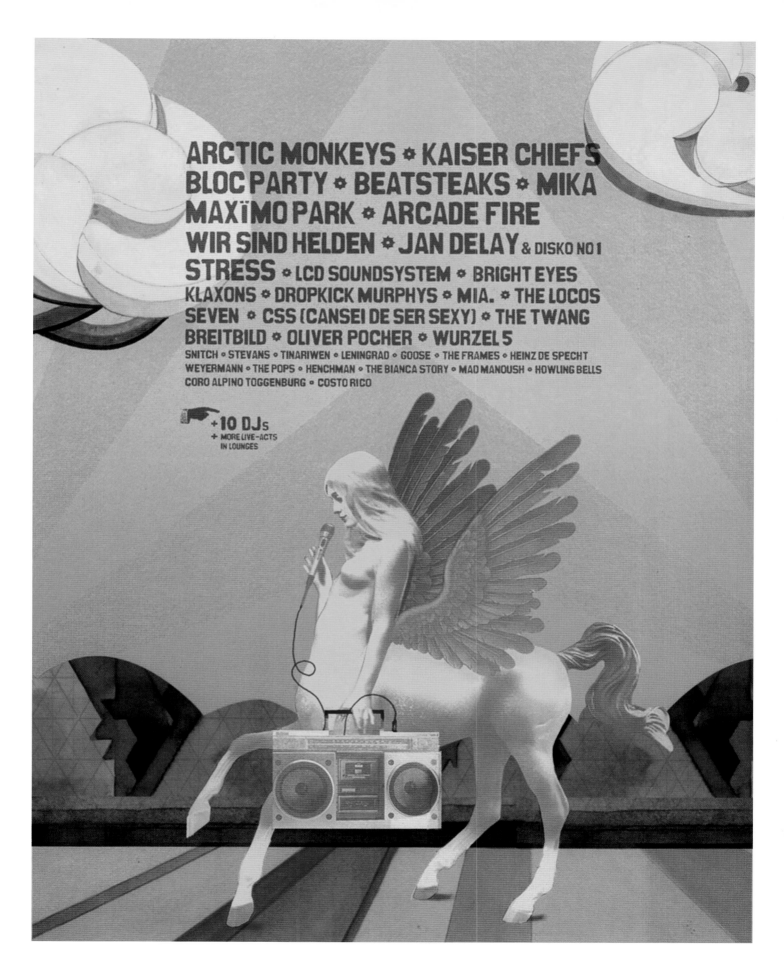

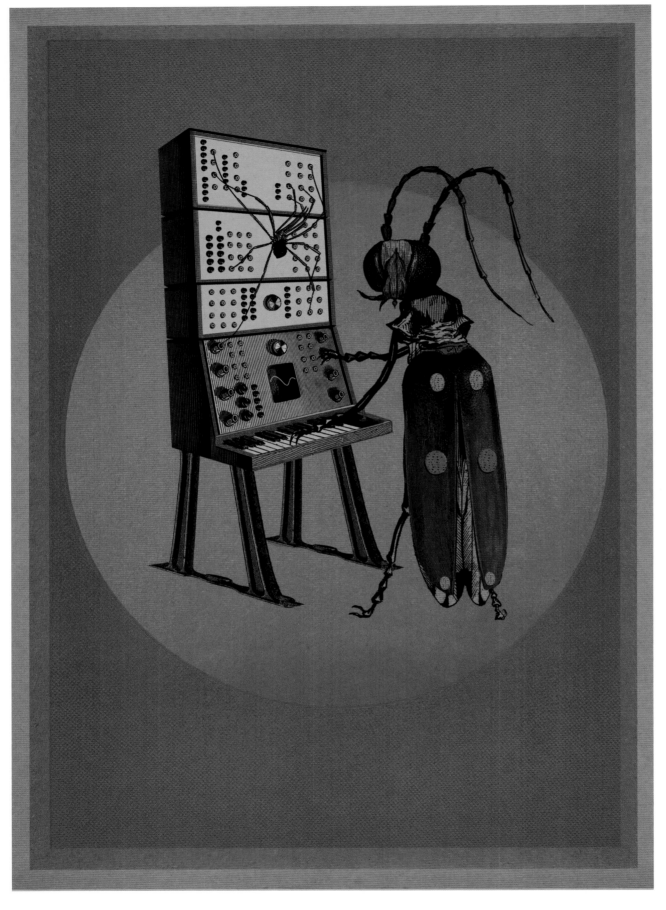

Insect Group.
2008.

I made these as I waited for my wife to go into labor with our first daughter. I donated them to the magazine *Arthur*, but alas, it folded before they could be used.

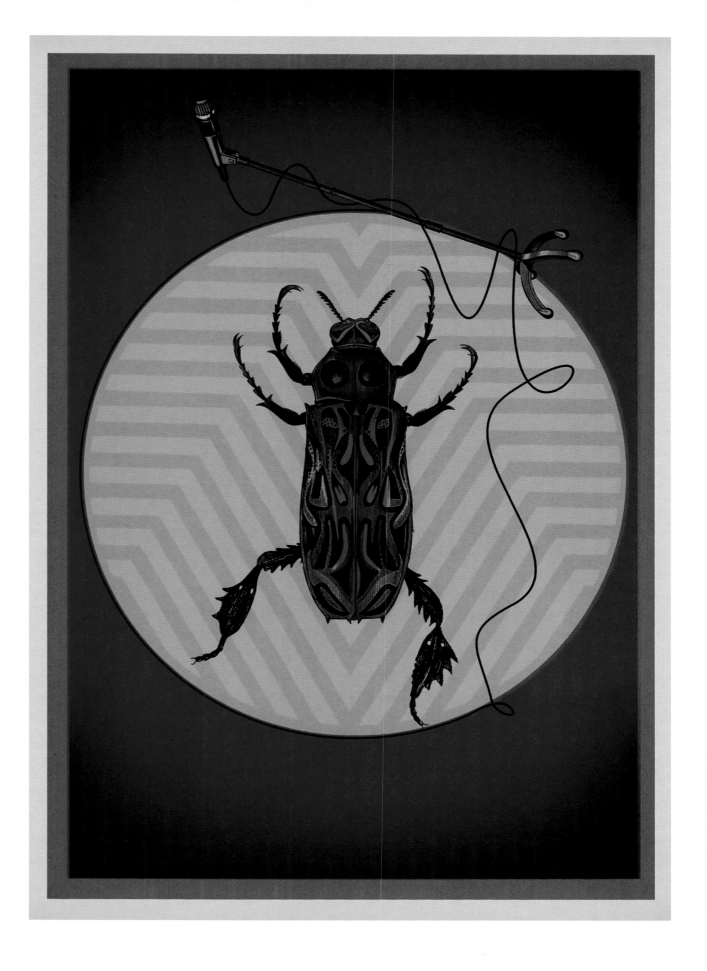

Hi-Fi

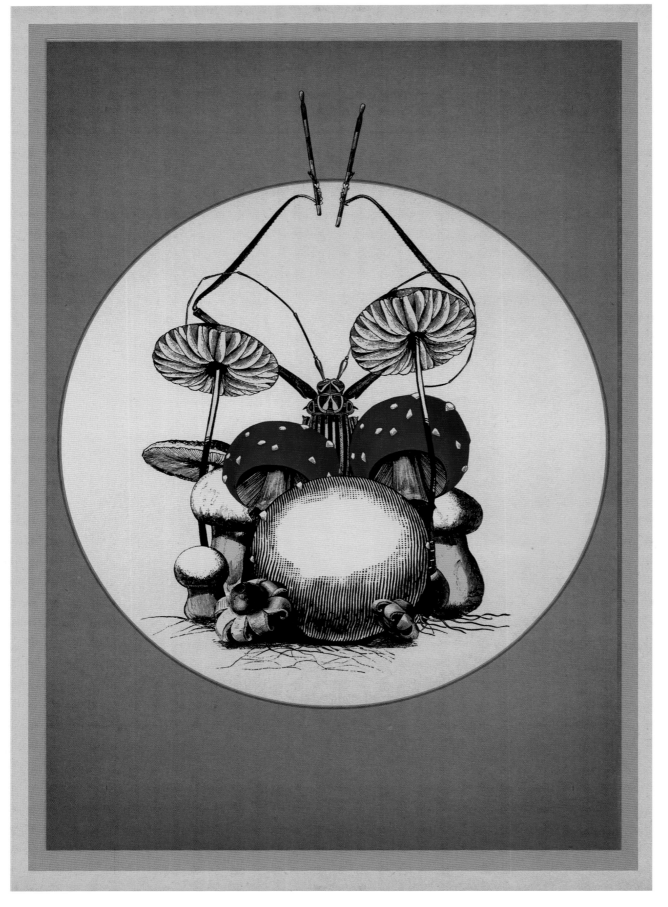

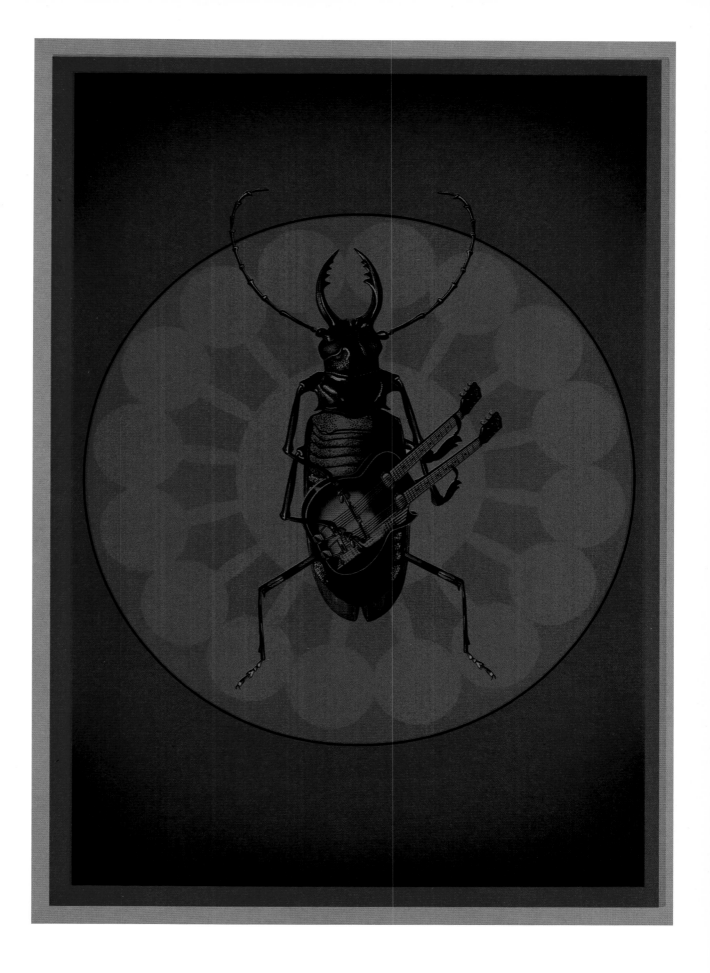

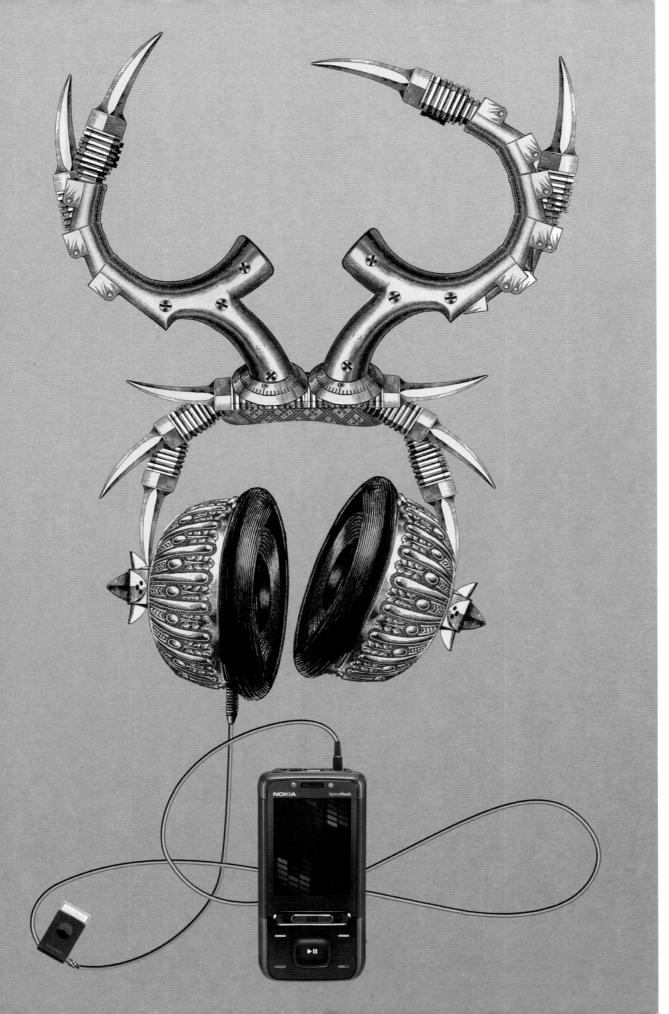

Nokia.
Music Almighty campaign.
2008.

Collaged from old etchings over a weekend. They funded a relaxed introduction to fatherhood, for which I'm eternally grateful. I've yet to own a mobile phone.

74

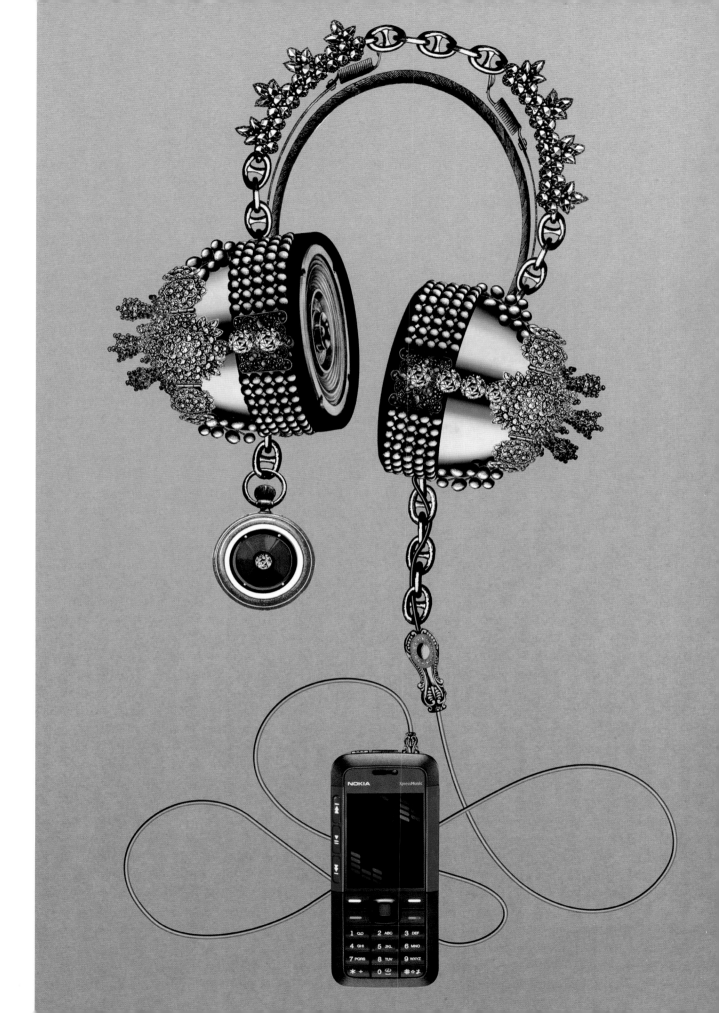

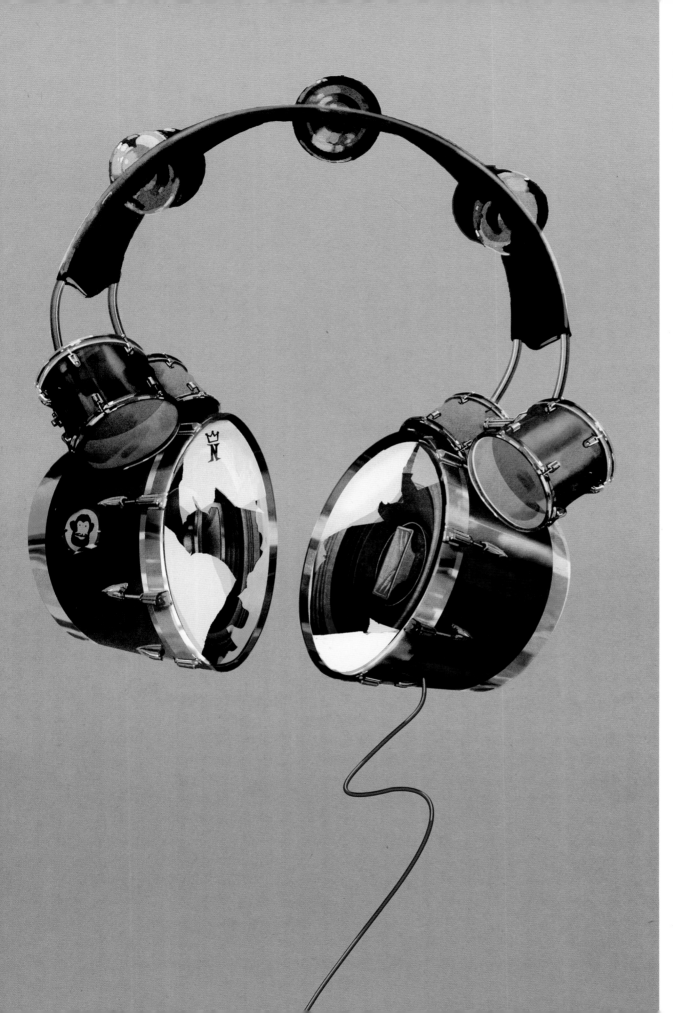

Nokia.
Unused pitch.
2008.

These were a further
treatment to be
animated. Lightning
failed to strike twice.

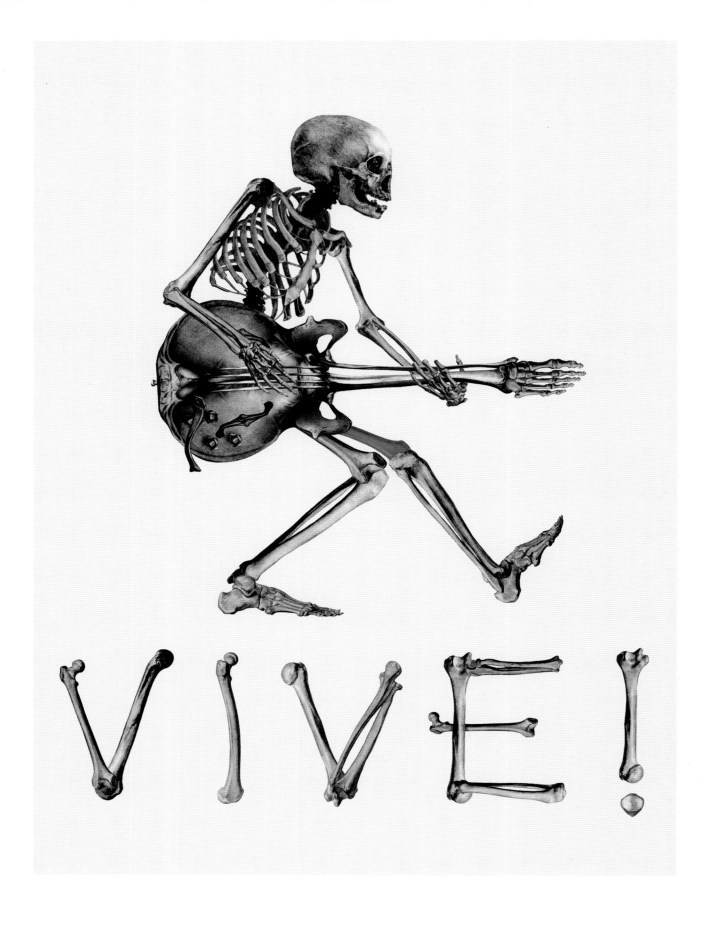

(Left)
VIVE!
Print Club London.
2014.

(Right)
*The Death of
a Disco Dancer.*
2003.

Up until the 1990s, painted movie posters ruled. Every blockbuster was heralded by handmade, often iconic art. Seemingly, the era passed when Photoshop enabled Hollywood to blandly cut craft out of the picture. Thankfully a healthy independent movie poster scene has bloomed, both for new films and rebrands of classics. Hopefully Tinseltown will soon remember that art can sell both dreams and tickets.

Inter-
mis-
sion.

Drive. Poster.
Little White Lies magazine.
2011.

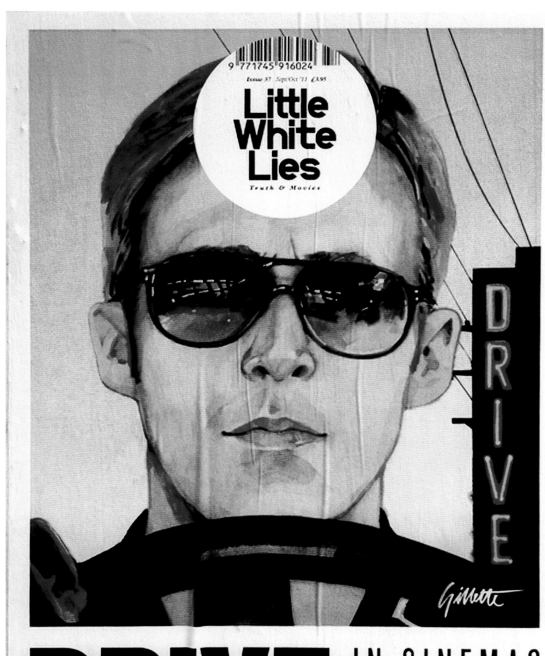

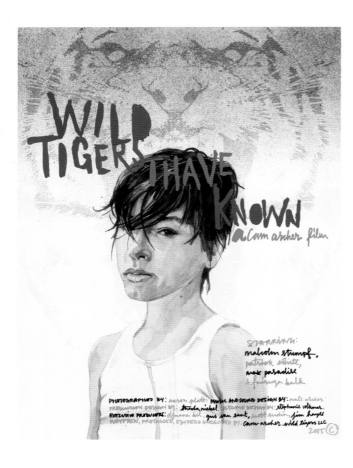

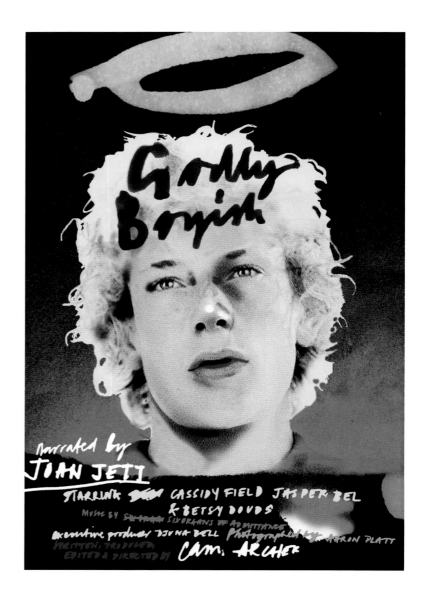

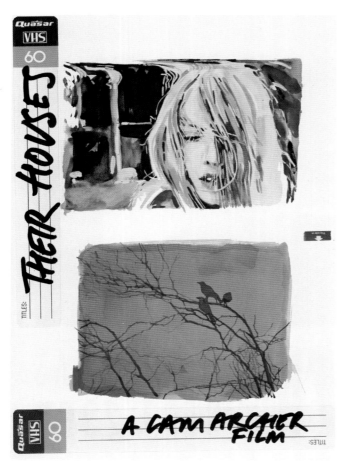

Film posters for
Director Cam Archer.

(Top Left)
*Wild Tigers I Have
Known*. 2006.

(Top Right)
Godly Boyish. 2004.

(Bottom) (Right)
Their Houses. 2011. *Shit Year*. 2010. 82

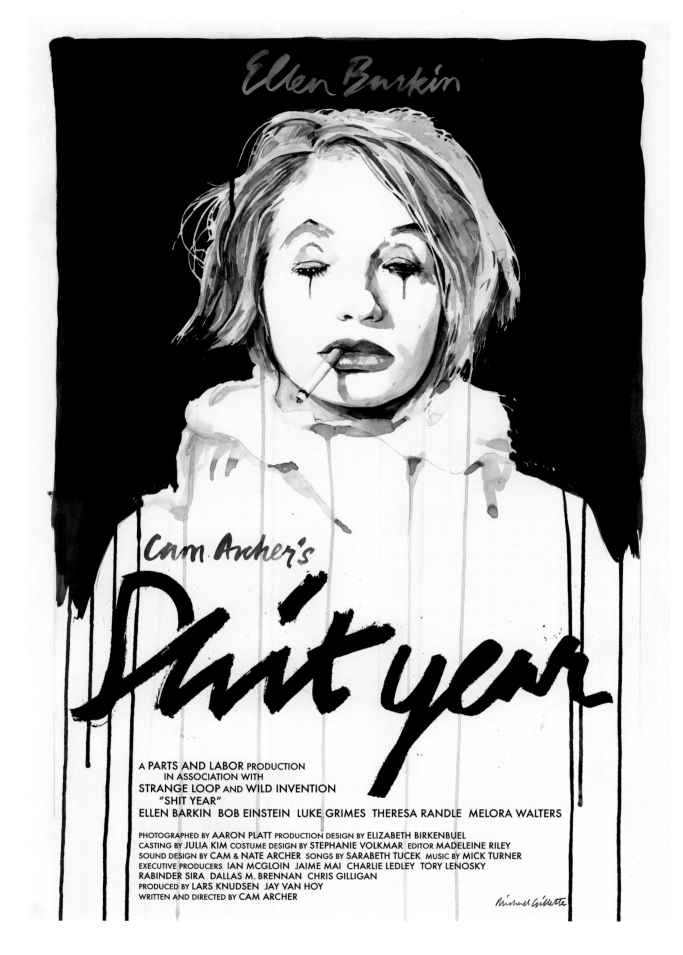

Ellen Barkin

Cam Archer's

Shit year

A PARTS AND LABOR PRODUCTION
IN ASSOCIATION WITH
STRANGE LOOP AND WILD INVENTION
"SHIT YEAR"
ELLEN BARKIN BOB EINSTEIN LUKE GRIMES THERESA RANDLE MELORA WALTERS

PHOTOGRAPHED BY AARON PLATT PRODUCTION DESIGN BY ELIZABETH BIRKENBUEL
CASTING BY JULIA KIM COSTUME DESIGN BY STEPHANIE VOLKMAR EDITOR MADELEINE RILEY
SOUND DESIGN BY CAM & NATE ARCHER SONGS BY SARABETH TUCEK MUSIC BY MICK TURNER
EXECUTIVE PRODUCERS IAN MCGLOIN JAIME MAI CHARLIE LEDLEY TORY LENOSKY
RABINDER SIRA DALLAS M. BRENNAN CHRIS GILLIGAN
PRODUCED BY LARS KNUDSEN JAY VAN HOY
WRITTEN AND DIRECTED BY CAM ARCHER

Michael Gillette

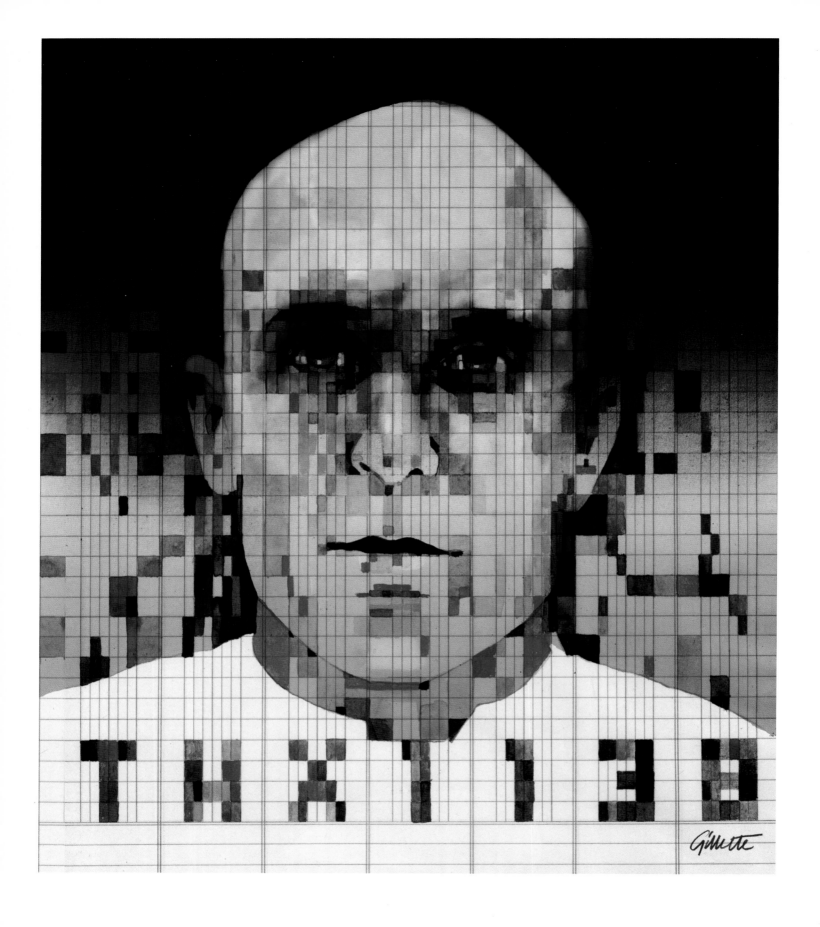

(Above)
THX1138 Redux.
Poster. 2010.

(Right)
Zoo films. Identity
for the director
James Frost. 2010.

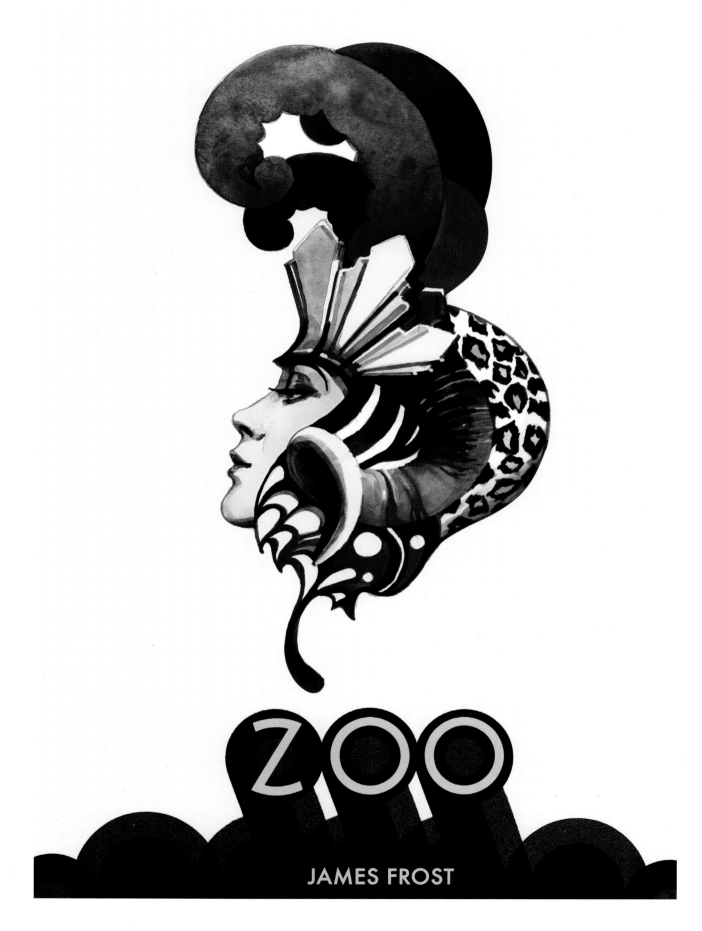

ZOO

JAMES FROST

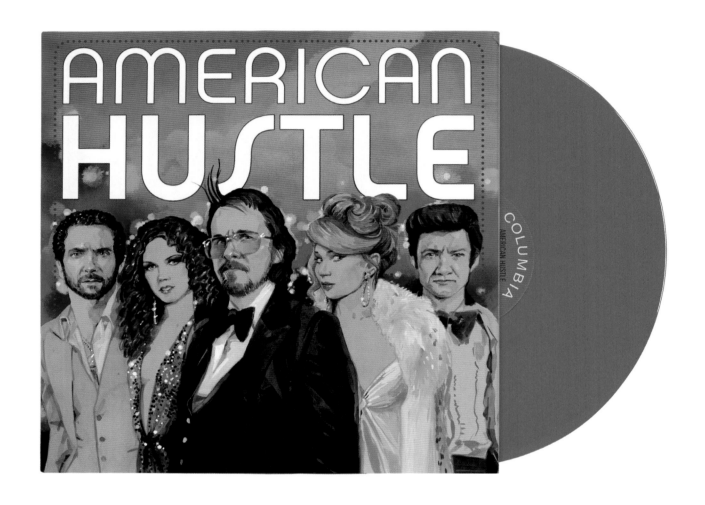

(Above)
American Hustle.
Soundtrack cover.
Sony. 2014.

(Right)
Law and Order.
The New Yorker
magazine. 2013.

86

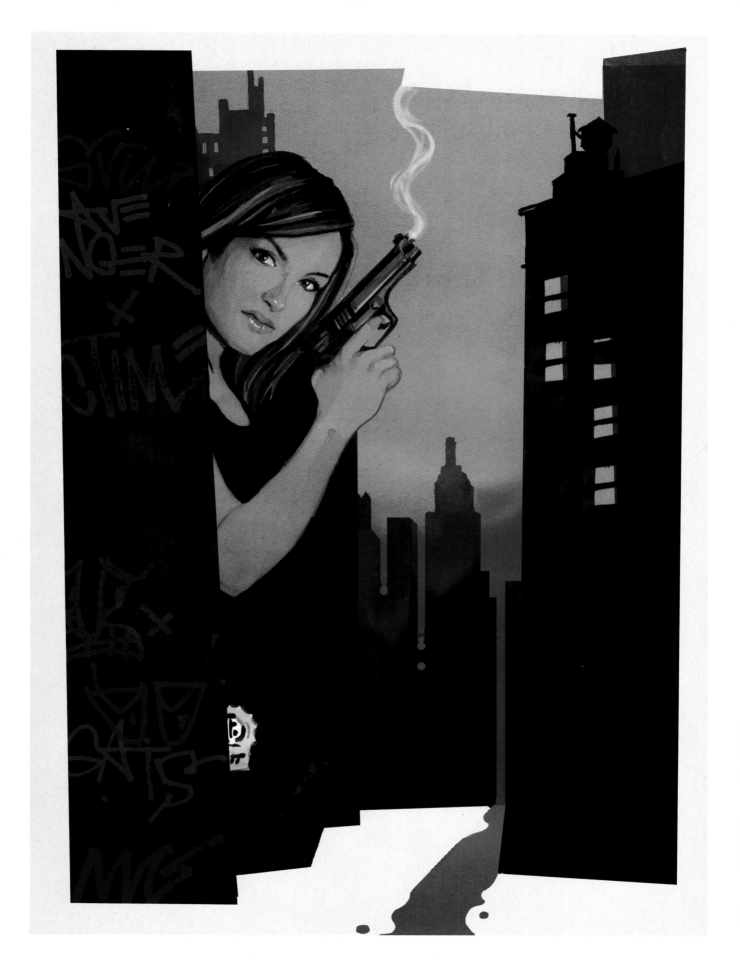

Intermission

ISSUE 25 SEPT/OCT 2009 £3.75

LITTLE WHITE LIES

Truth & Movies

An education issue

(Above)
An Education.
Little White Lies.
2009.

(Right)
Kes Redux.
Print Club London.
Poster. 2013.

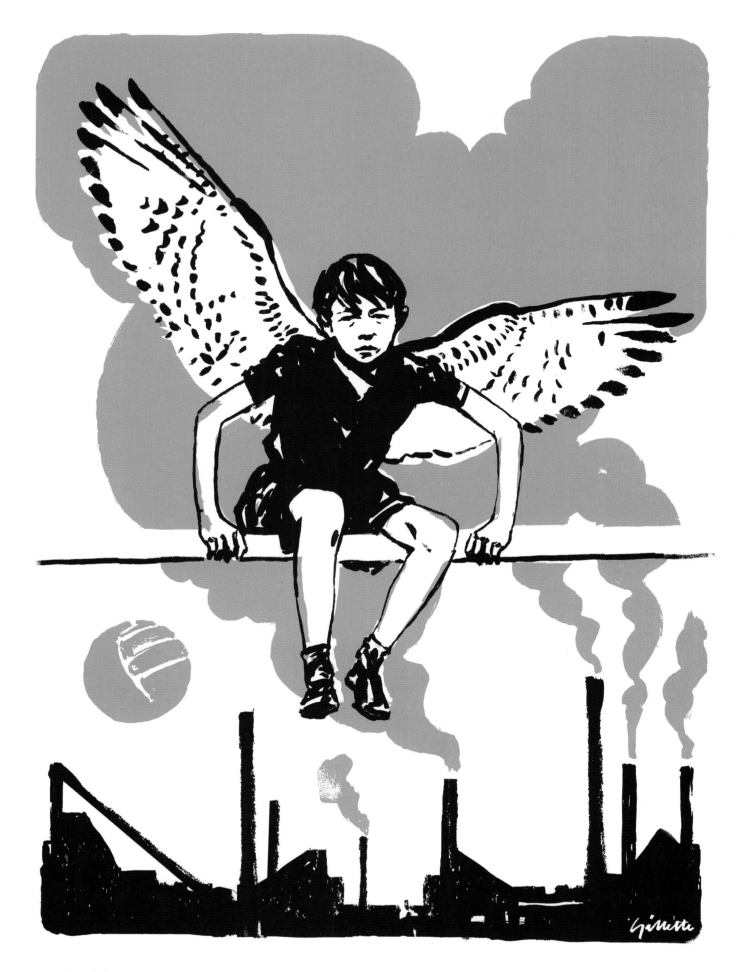

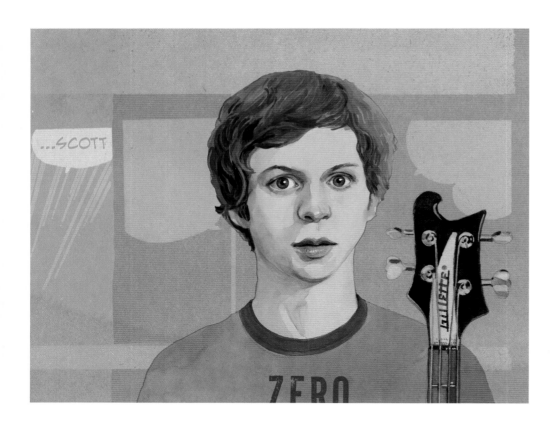

(Left)
Scott Pilgrim vs. the World.
Poster (unused). 2010.

(Below)
Chicken. Poster. 2015.

(Right)
Bedazzled Redux.
Poster. 2008.

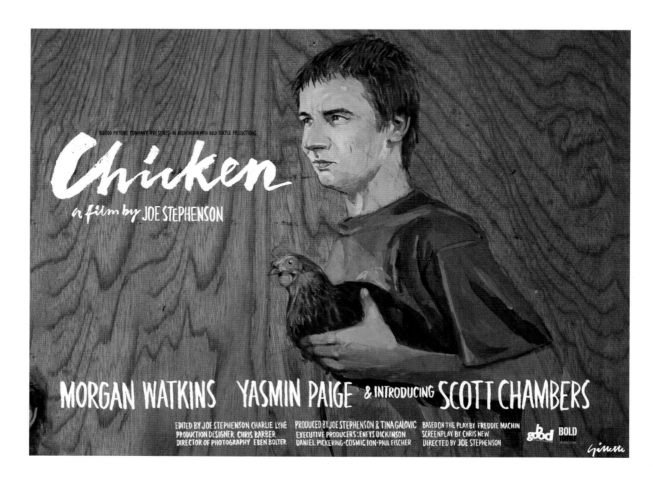

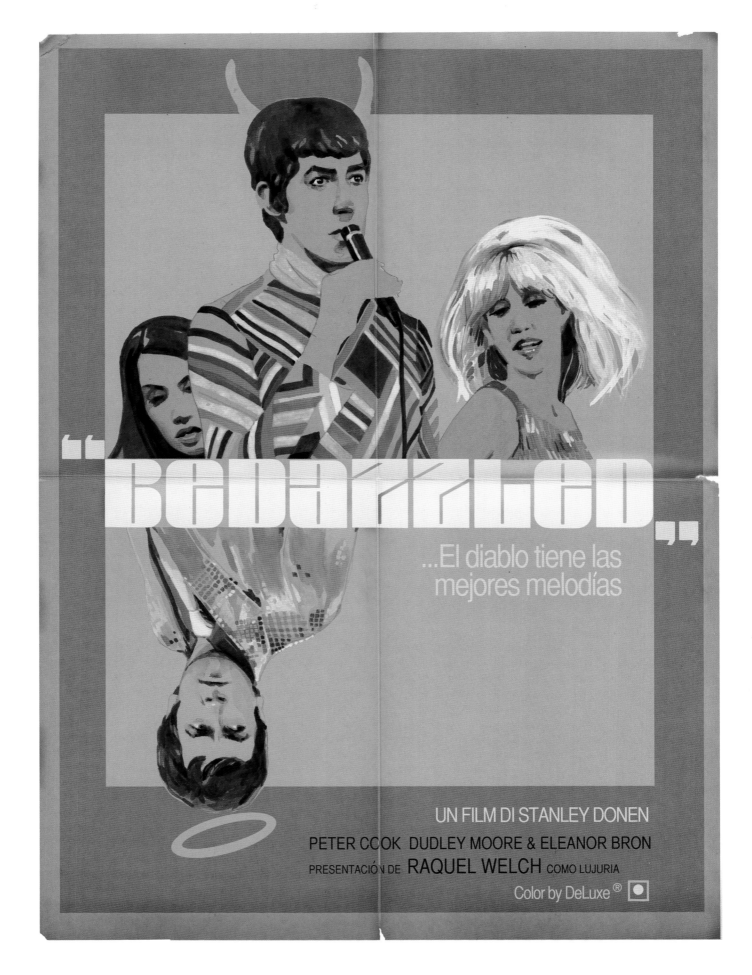

...El diablo tiene las
mejores melodías

UN FILM DI STANLEY DONEN

PETER COOK DUDLEY MOORE & ELEANOR BRON
PRESENTACIÓN DE RAQUEL WELCH COMO LUJURIA
Color by DeLuxe ®

Alongside commissions, I've always made my own work. Experiments lead to new avenues, and when ideas arise, it is best to show willing and encourage the source! Periodically, a show concept arises. Music is sometimes clearly the fuel, as with the *Little Angels*; but other exhibitions have been more oblique. I love my art living in people's homes, and creating tangible work in a digital age is increasingly appealing.

Show-time.

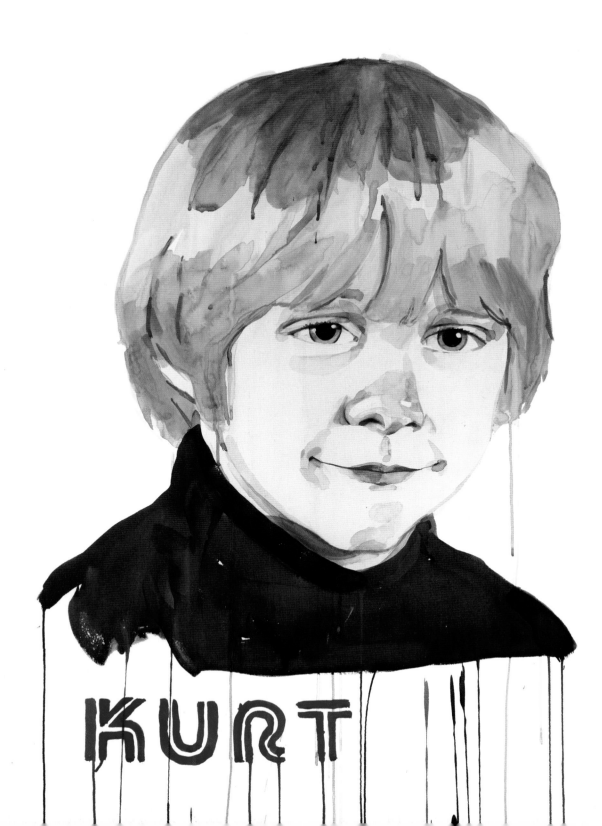

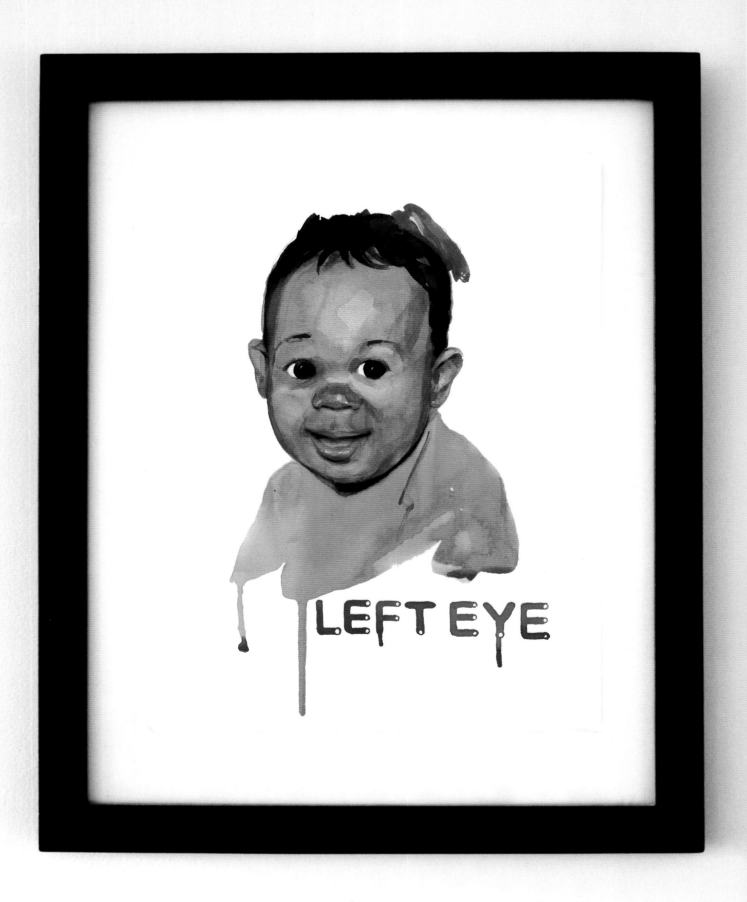

(Above)
Lisa "Left Eye" Lopes.
Little Angels.
2002.

(Right)
Aaliyah.
Little Angels.
2002.

94

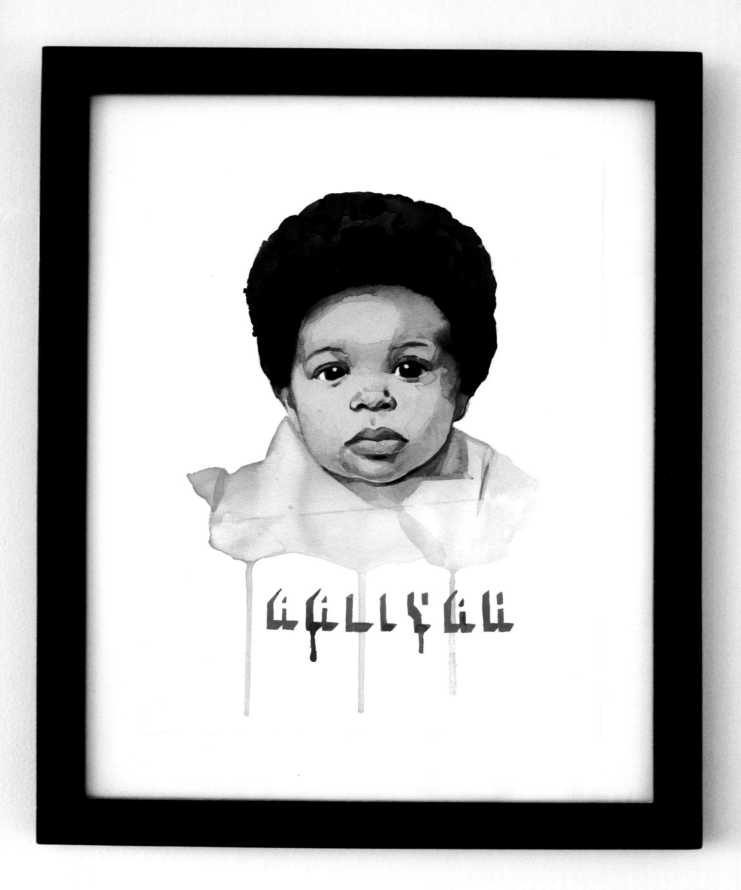

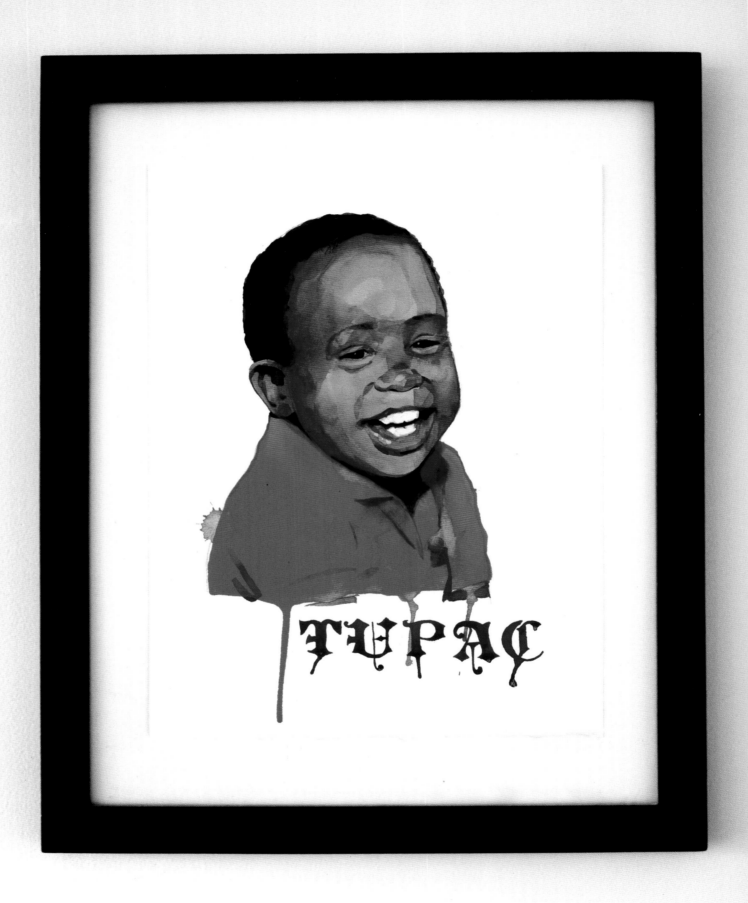

(Above)
Tupac Shakur.
Little Angels.
2002.

(Right)
Biggie Smalls.
Little Angels.
2002.

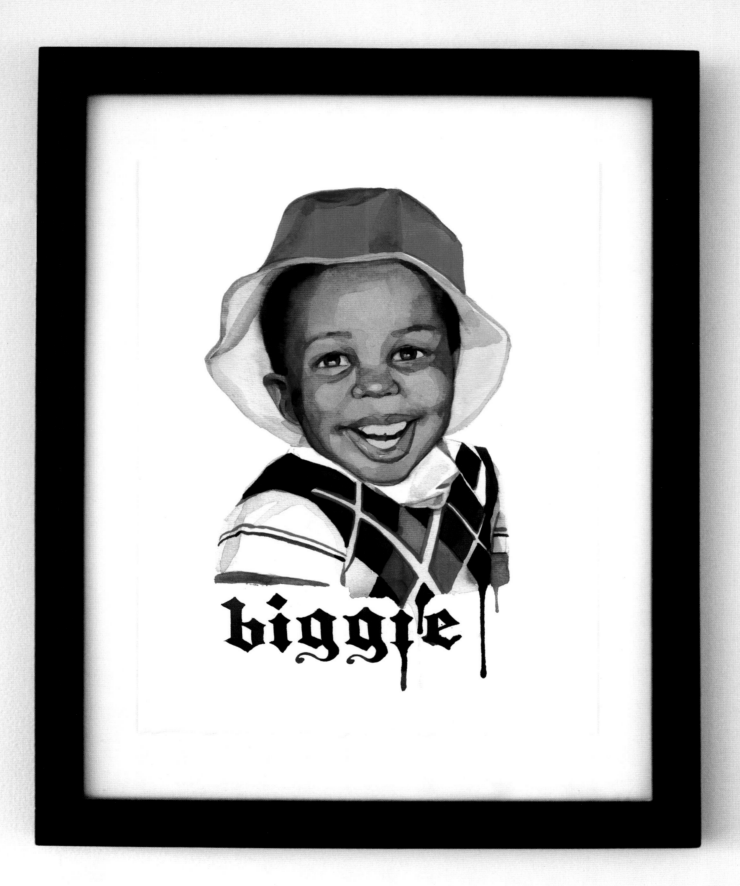

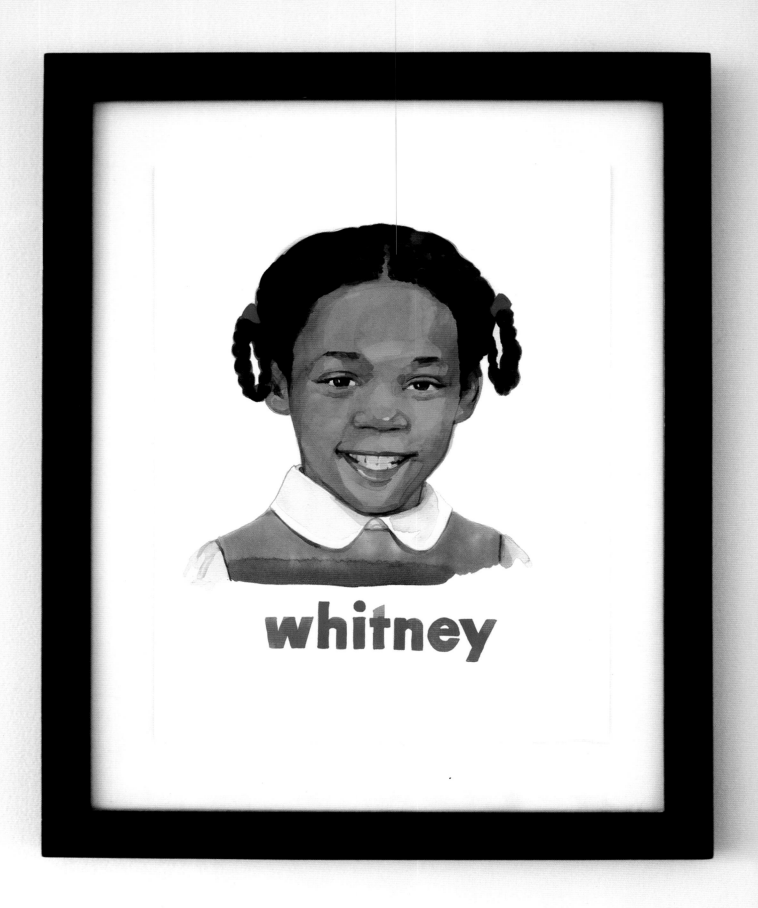

whitney

(Above)
Whitney Houston.
Little Angels.
2012.

(Right)
Amy Winehouse.
Little Angels.
2011.

98

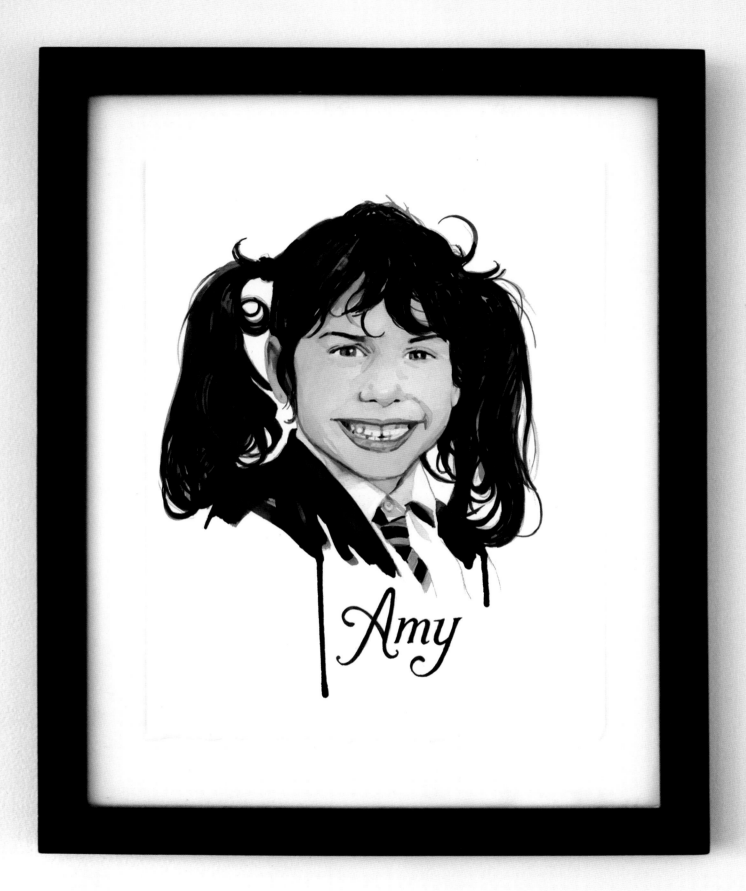

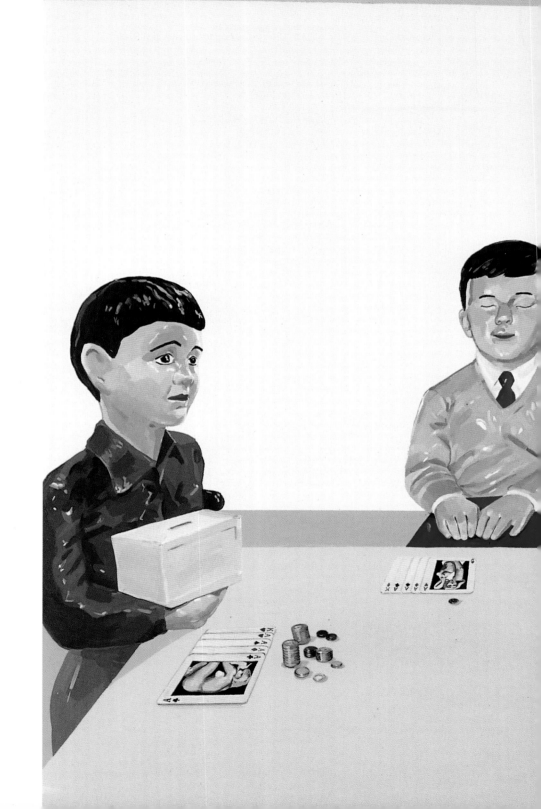

At Home with Charity.
1999.

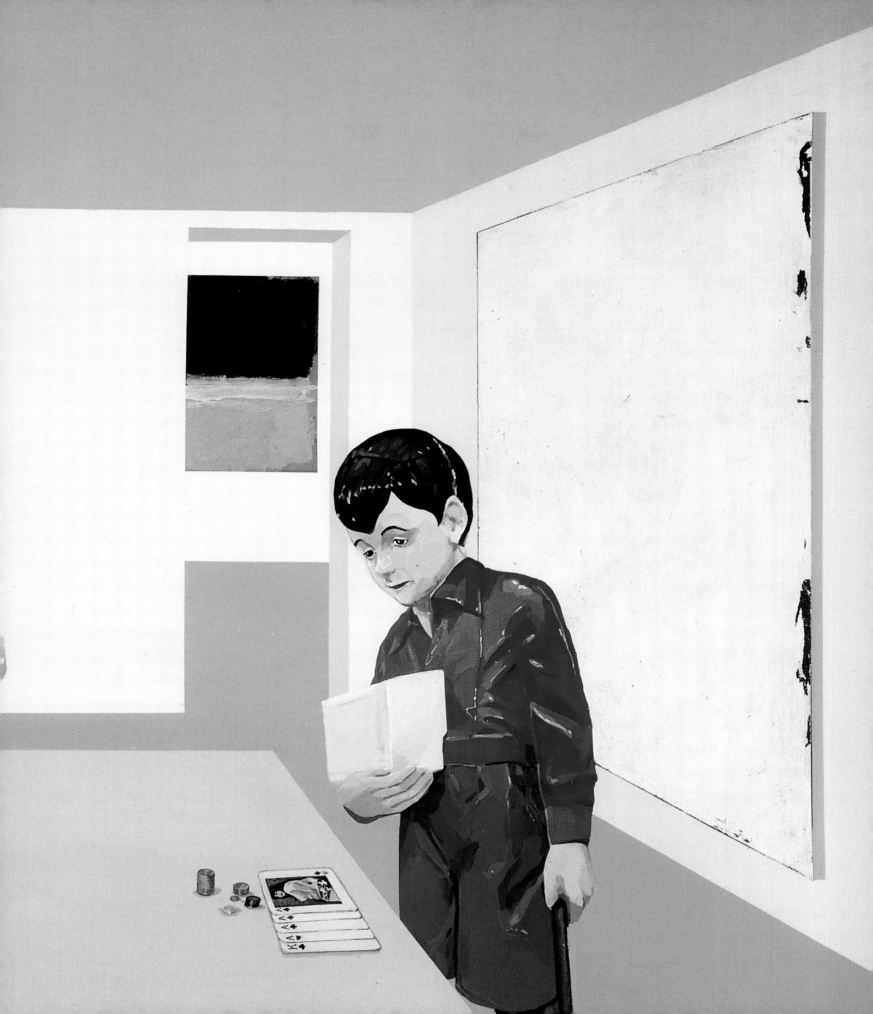

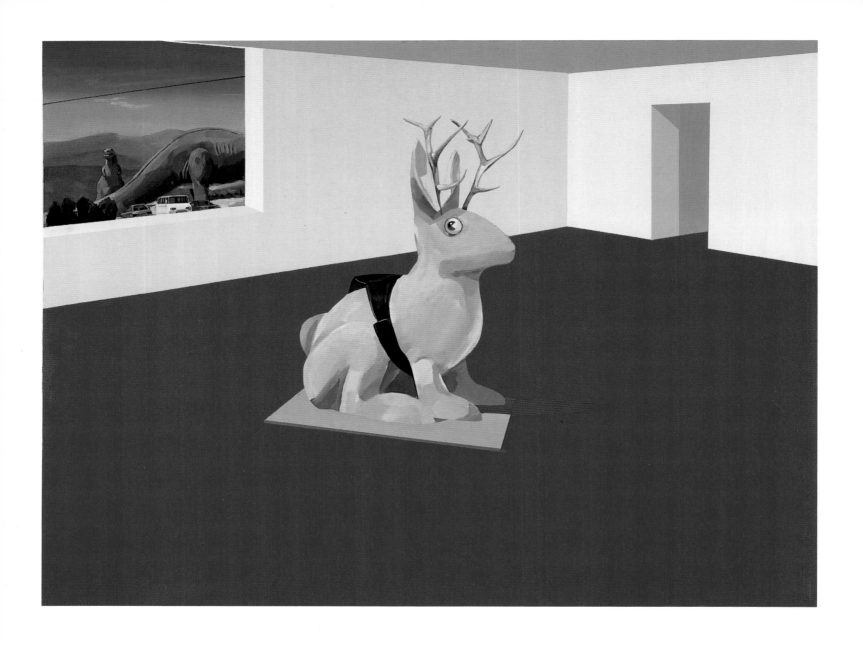

(Above)
The Jackalope.
1999.

(Right)
Nature Is Plastic.
1999.

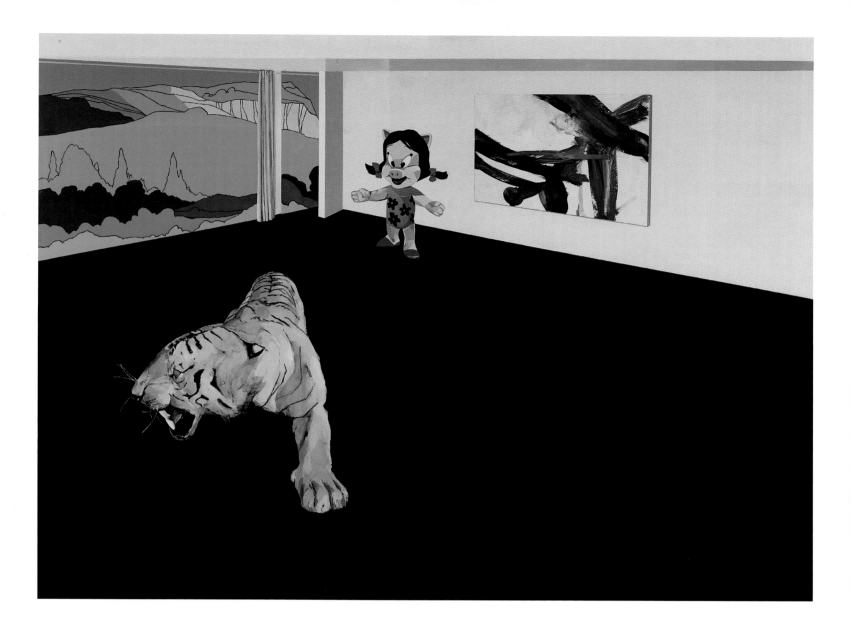

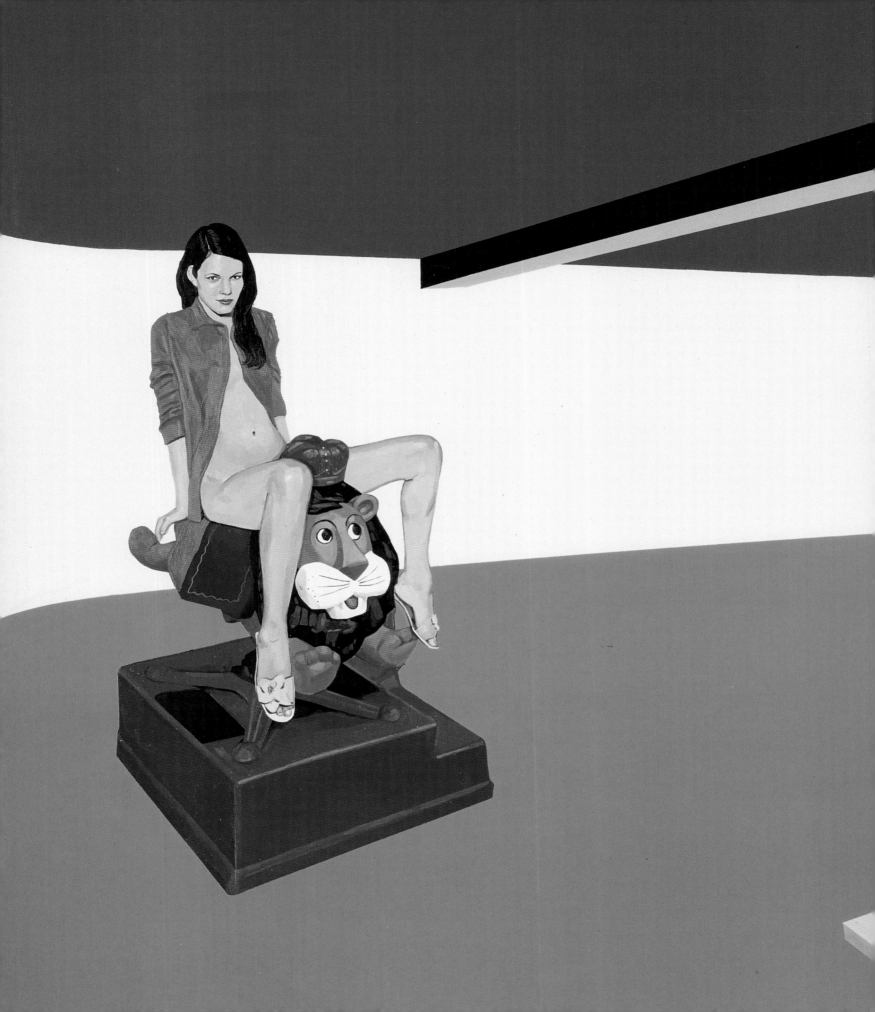

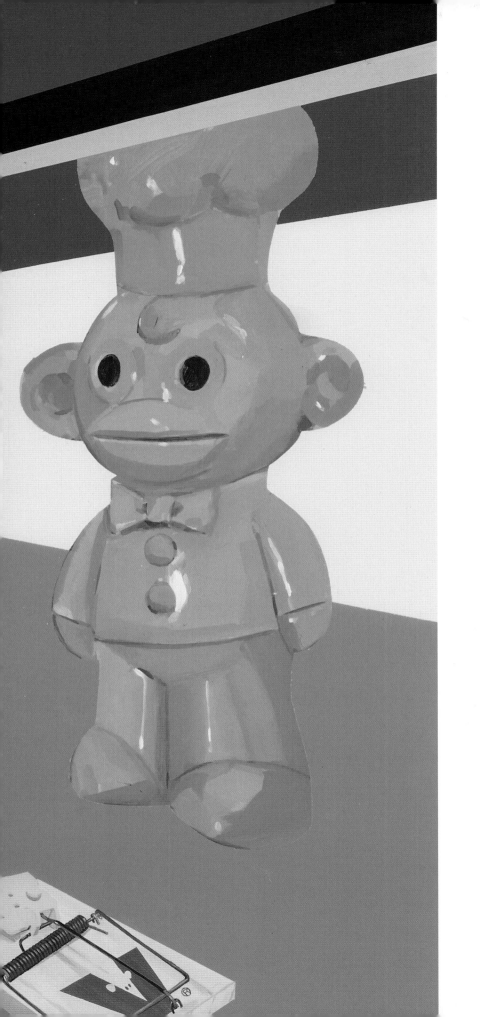

Duplicity and Compliance.
1999.

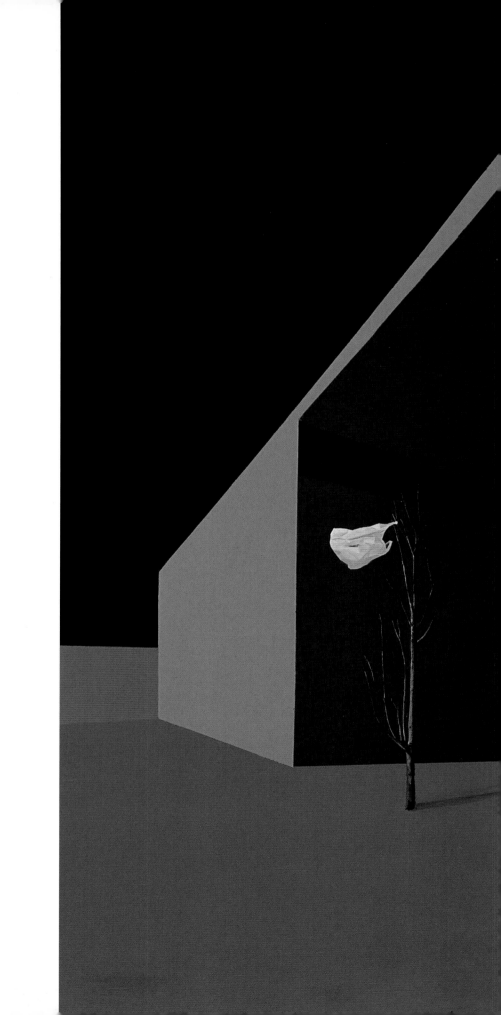

Echoes.
1999.

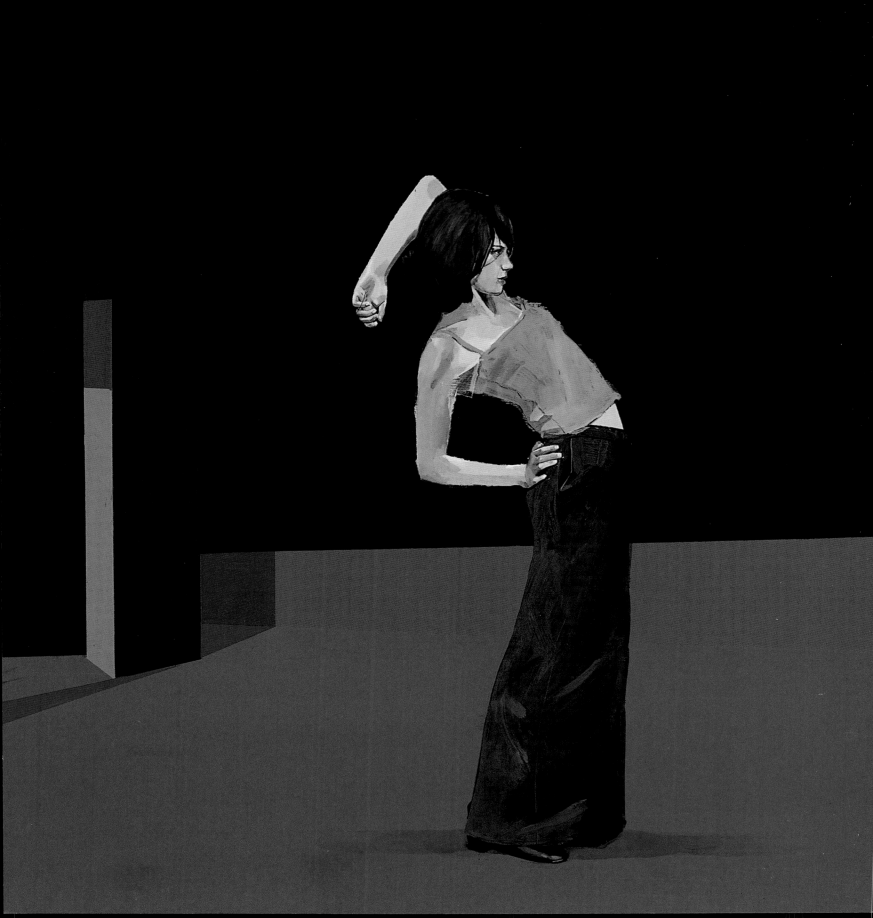

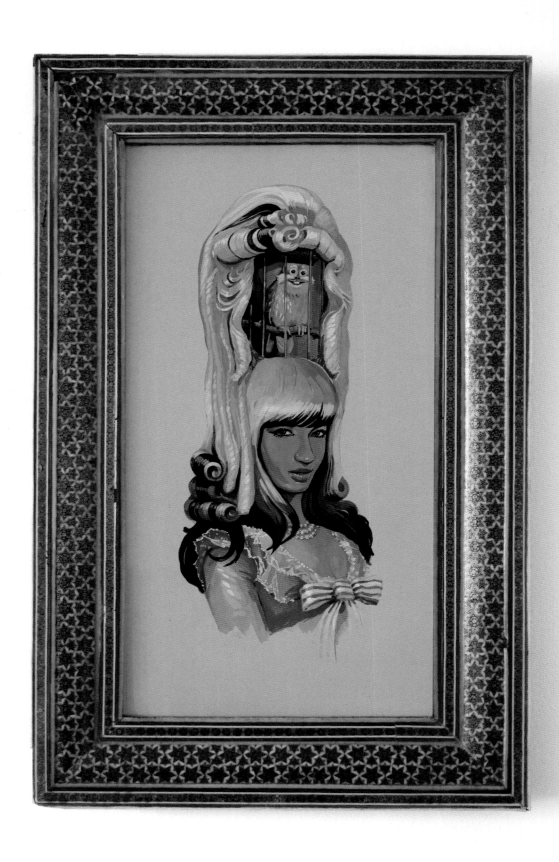

(Above)
Marie Antronnette.
2005.

(Right)
Michael Jackson.
2008.

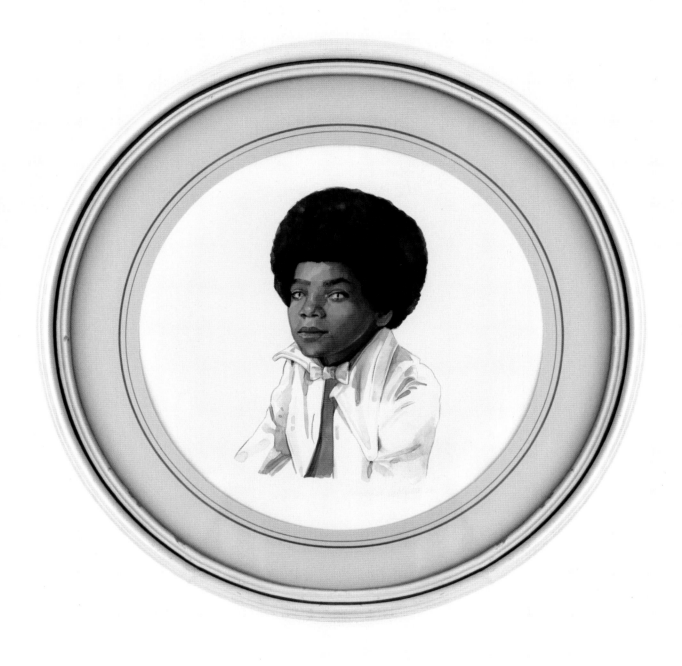

My wife and I went to Kings Canyon one spring break. A freak snowstorm left us holed up in a cabin. I started drawing imaginary bands in pen, letting the lines go where they may. Those drawings were really liberating, like receiving my artistic license back after a long period of work characterized by process and expectancy. In a way, it might be the truest voice in the book, because it relies on nothing but my imagination, a pen, and paper. After a while I started refining the style and attempting likenesses to get commissions. It's proved a welcome break from heavy realism.

Dis-
tor-
tion.

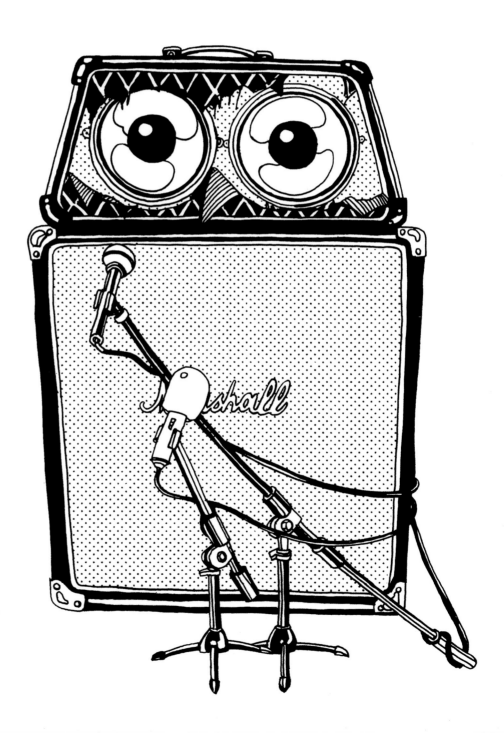

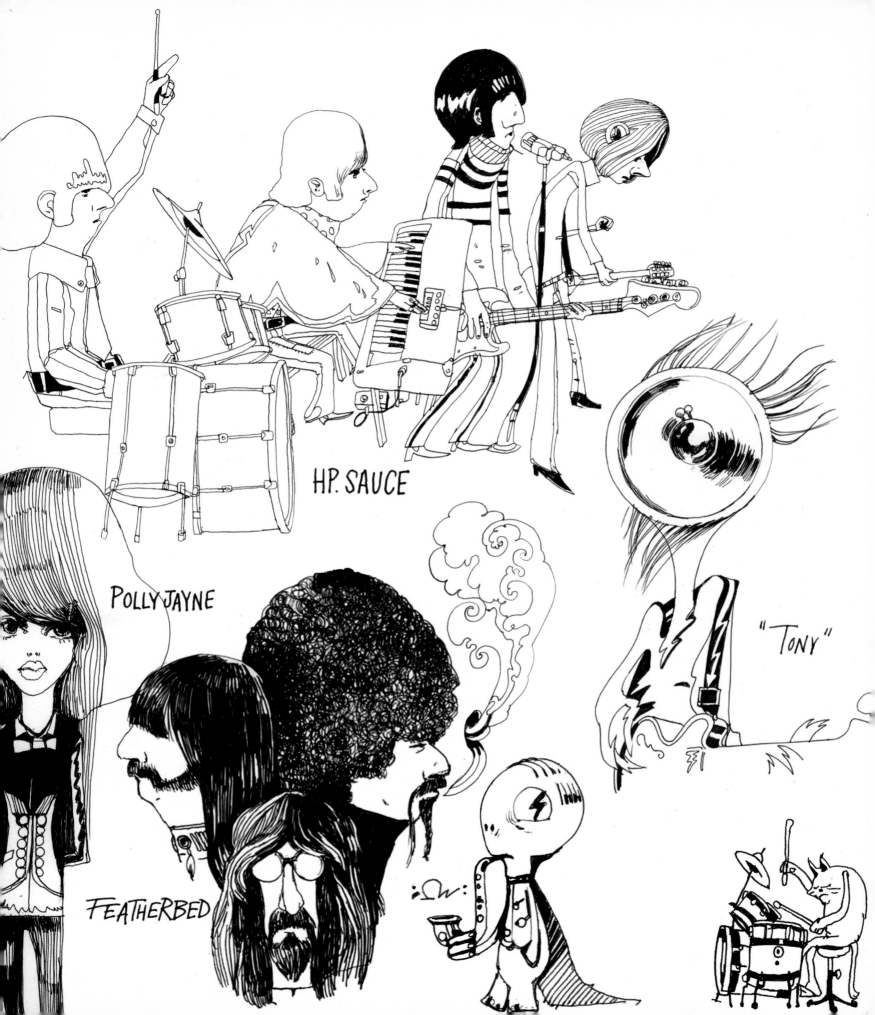

H.P. SAUCE

POLLY JAYNE

"TONY"

FEATHERBED

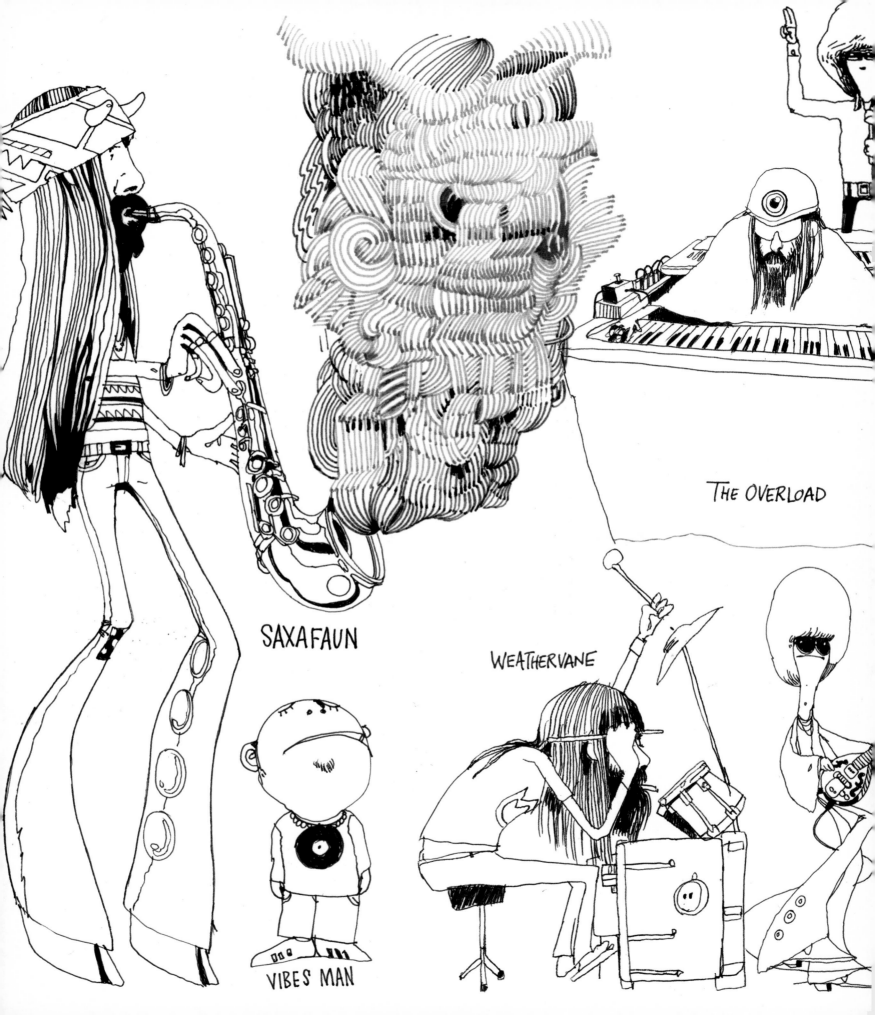

SAXAFAUN

THE OVERLOAD

WEATHERVANE

VIBES MAN

(Previous Spread)
King's Canyon, imaginary
band sketches. 2007.

(Below)
The Horrors. 2012.

(Right)
San Francisco Rockabilly.
Levi's. 2015.

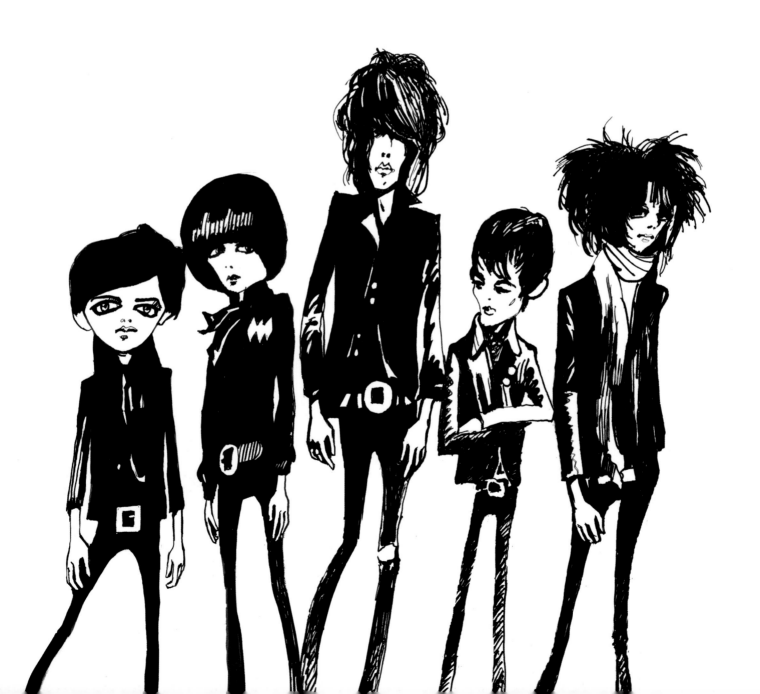

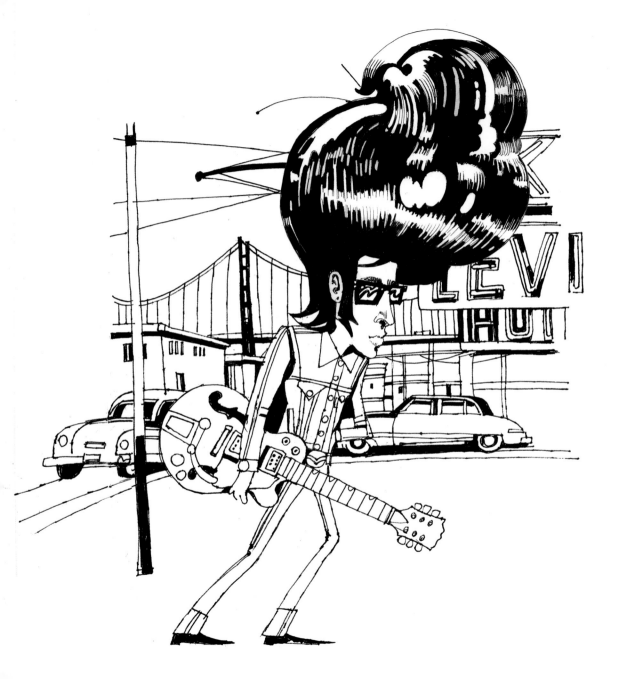

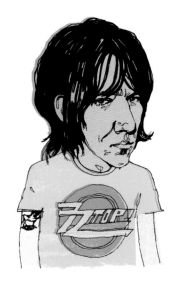
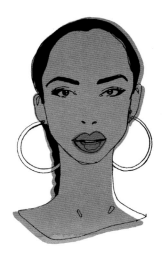
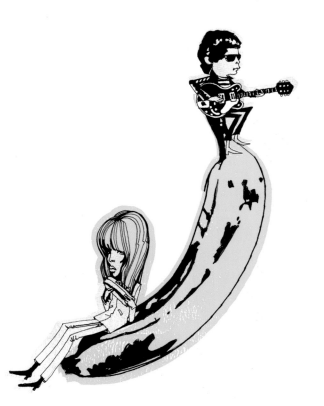
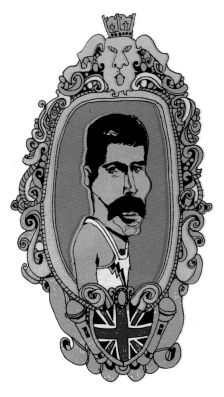
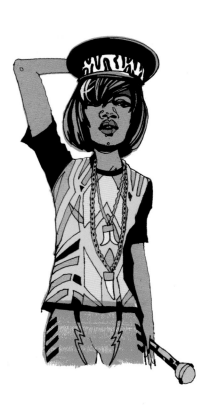

Music Listography.
2008.

I did seventy illustrations
for the book over the
course of two months.

(Above)
Bob Dylan, Elliott Smith,
Sade, Lou Reed and Nico,
Freddie Mercury, and MIA.

(Right)
Kurt Cobain.

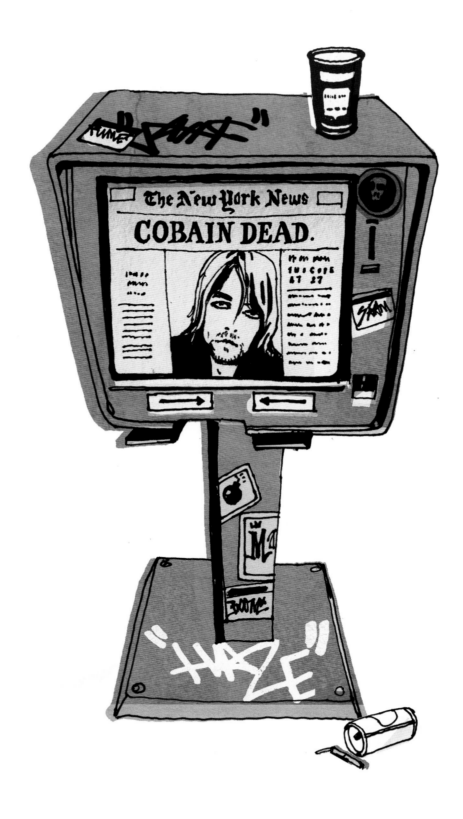

(Below)
Arcade Fire live.
Sketchbook pages.
2008.

(Right)
The Lost Chord.
Sketchbook page.
2015.

(Next Spread)
MGMT at Radio City
Music Hall. Poster.
2010.

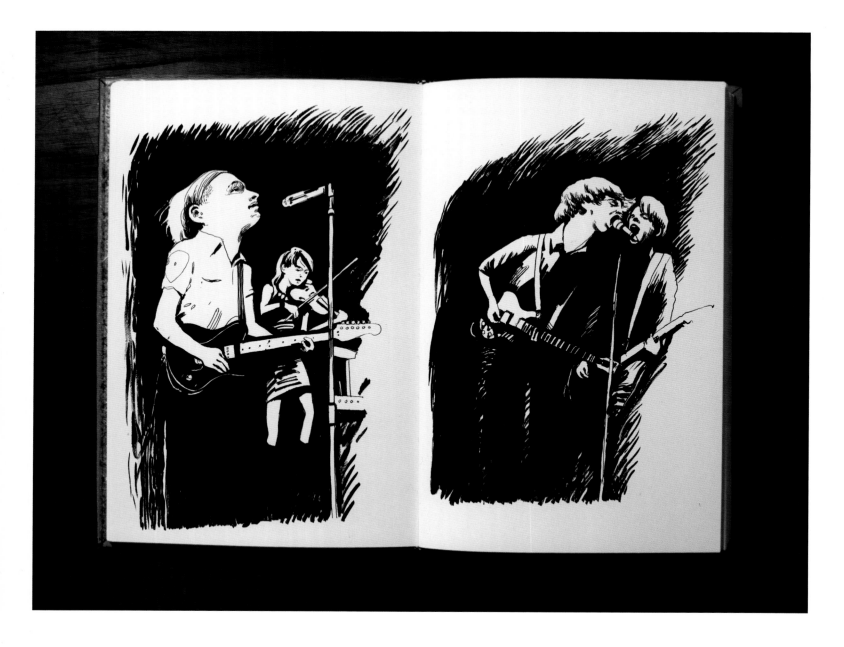

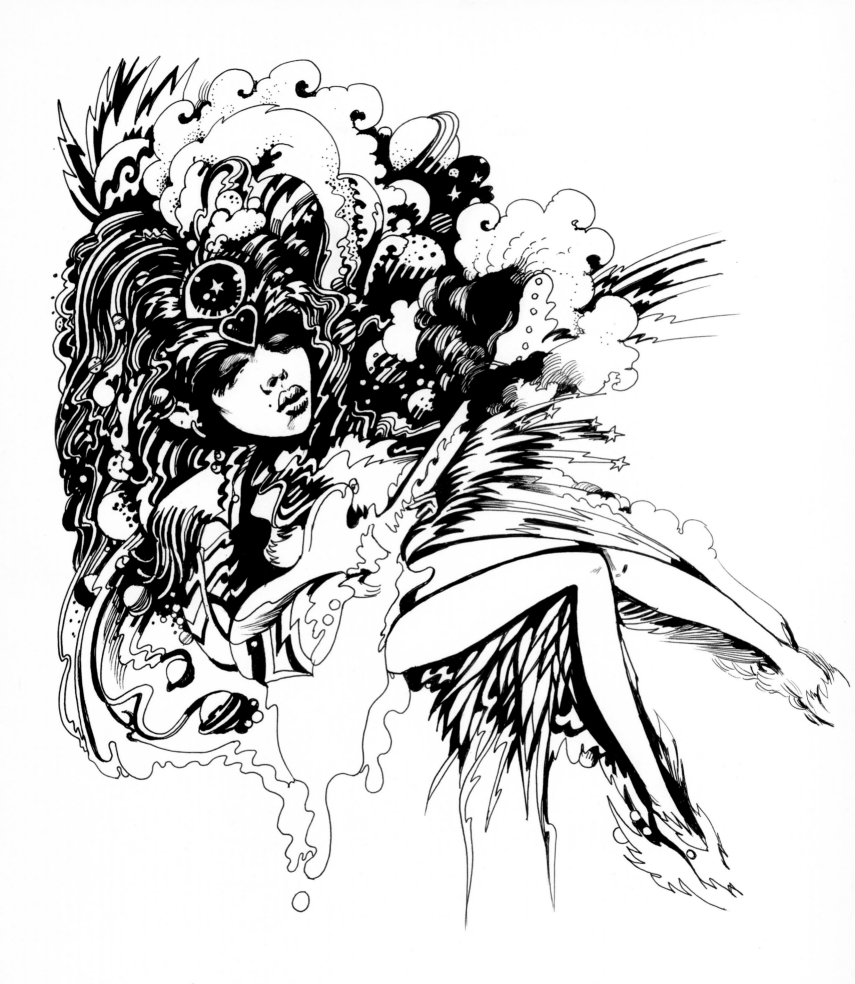

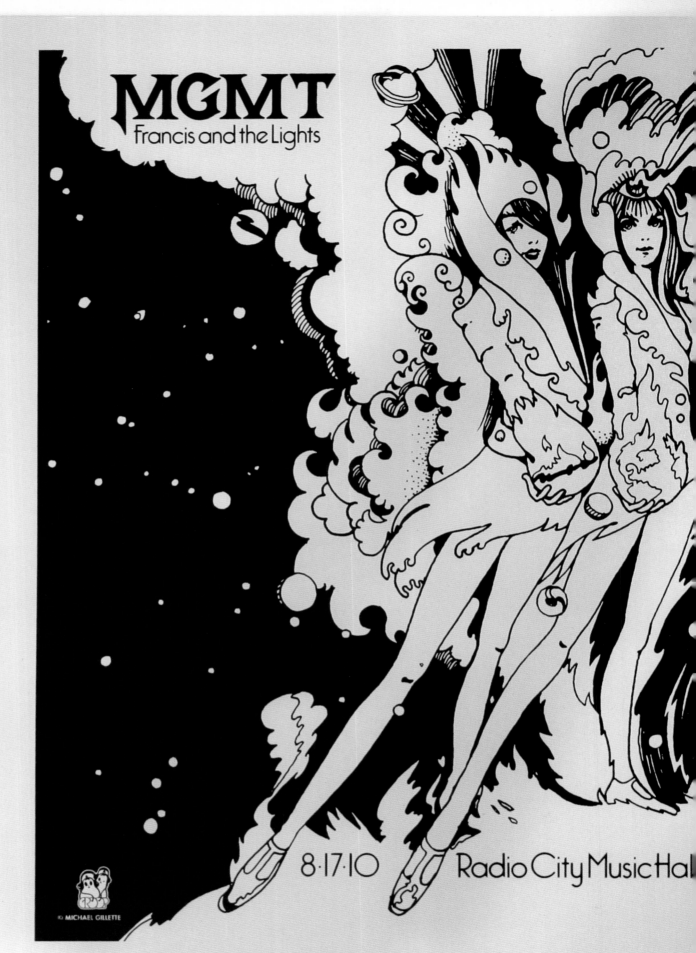

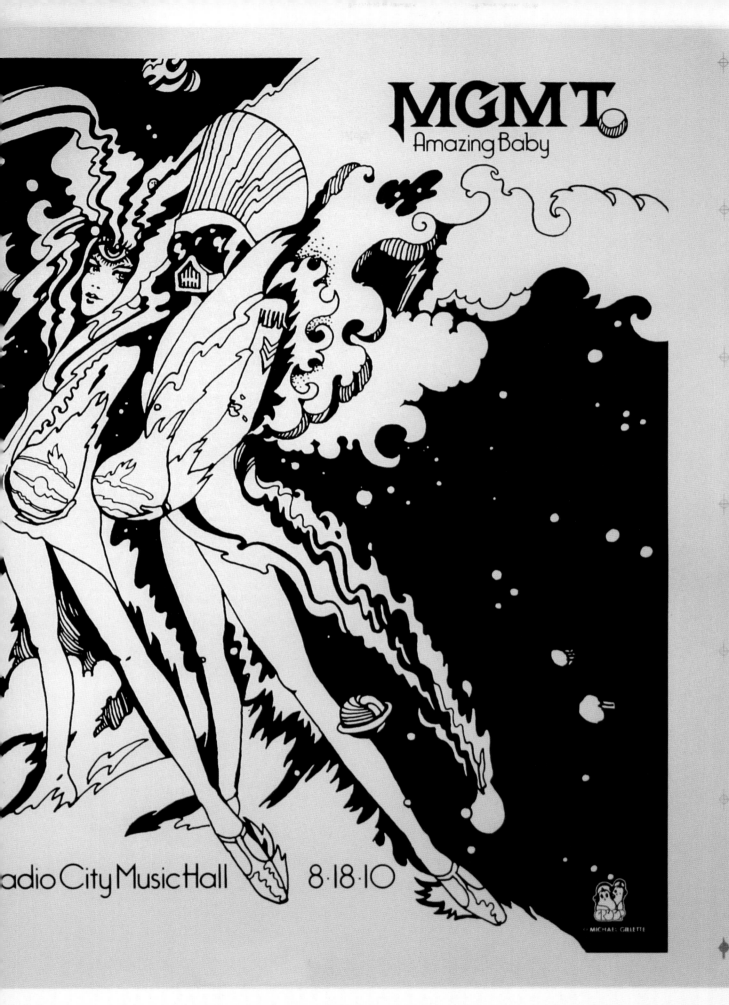

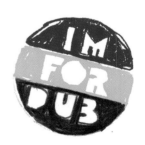

We don't need no stinking badges! 2009.

Half of these designs made it on to T's. My daughters Eleanor and Josephine wear them well.

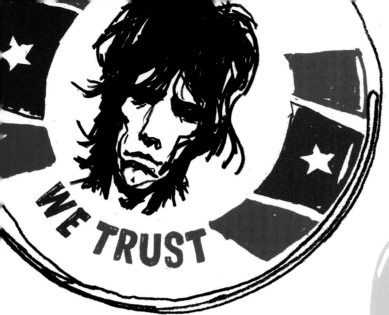

IN WE TRUST

SUPPORT KRAUTROCK

I STILL LOVE POP

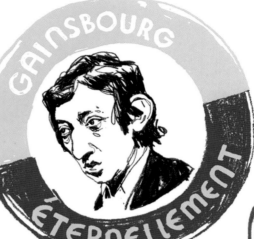

GAINSBOURG ÉTERNELLEMENT

ACID HOUSE NOW

ELECT PATTI SMITH

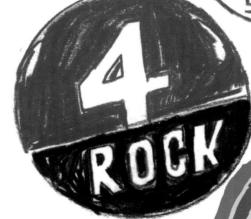

4 ROCK

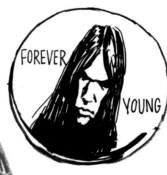

FOREVER YOUNG

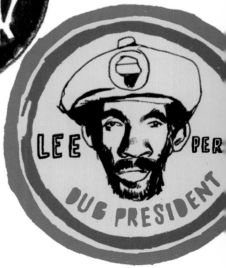

LEE PER DUB PRESIDENT

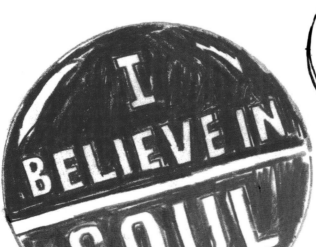

I BELIEVE IN SOUL

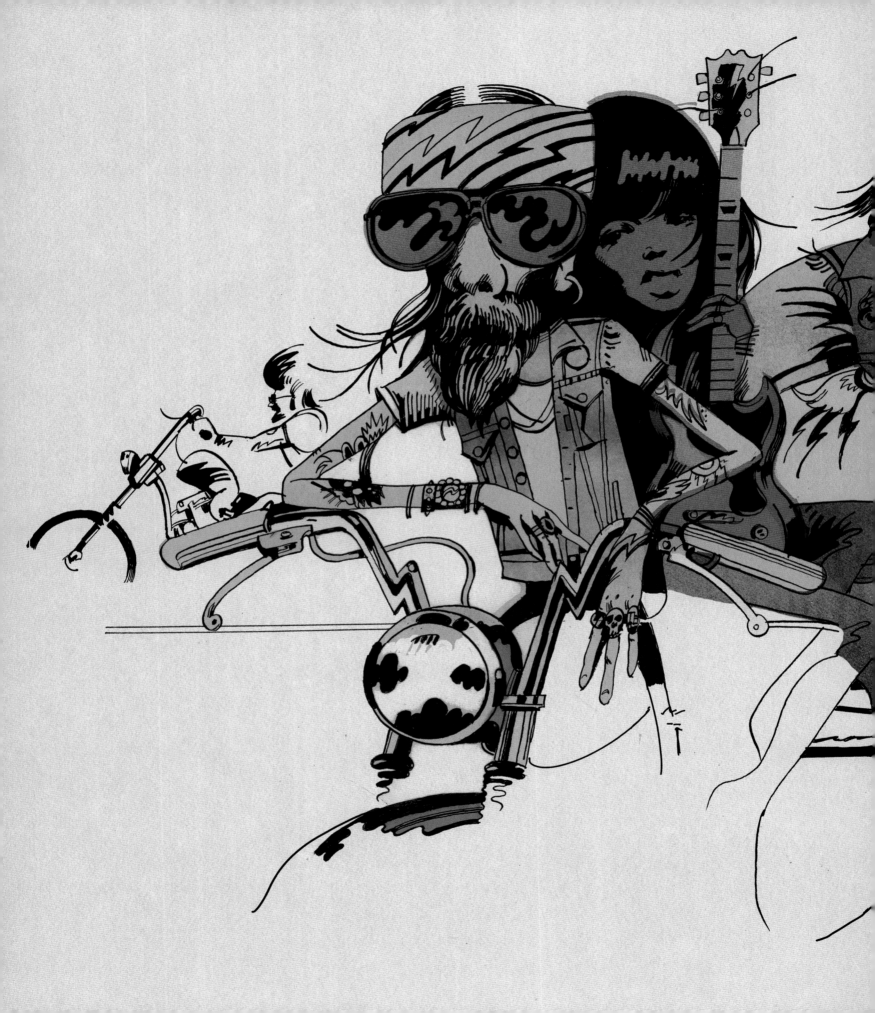

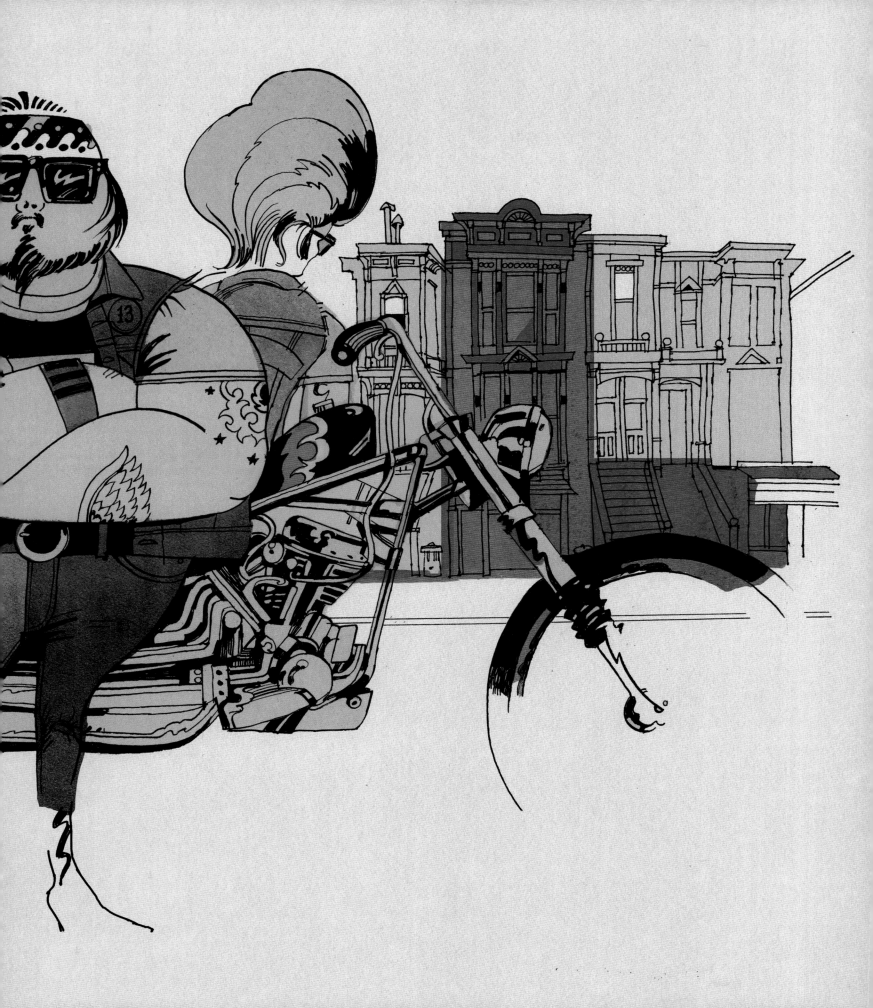

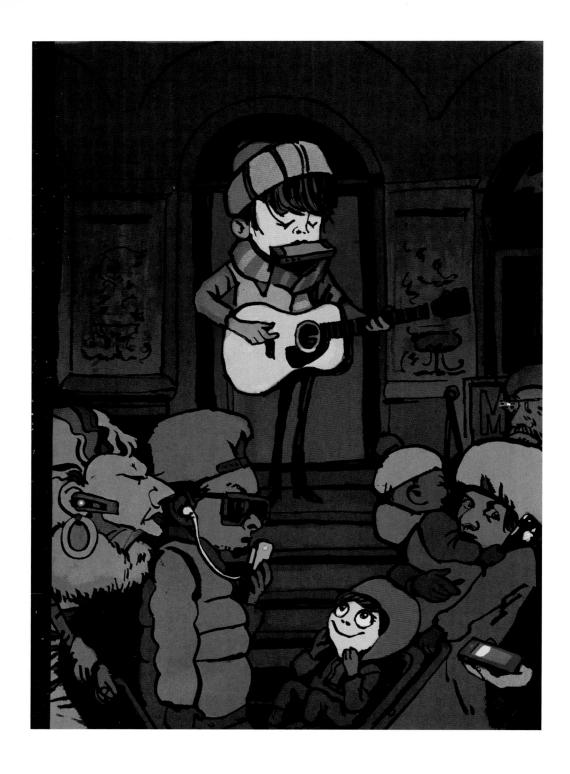

(Above)
ibusk. The New Yorker
magazine. 2014.

A first attempt at doing
a *New Yorker* cover.

(Previous Spread)
Haight Street Angels.
Levi's. 2015.

(Right)
Theophilus London.
The New Yorker
magazine. 2013.

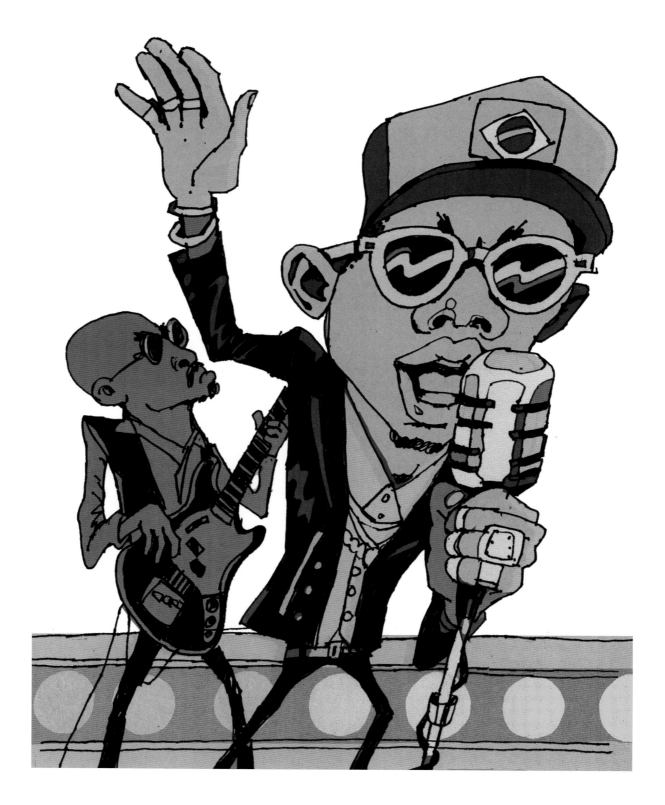

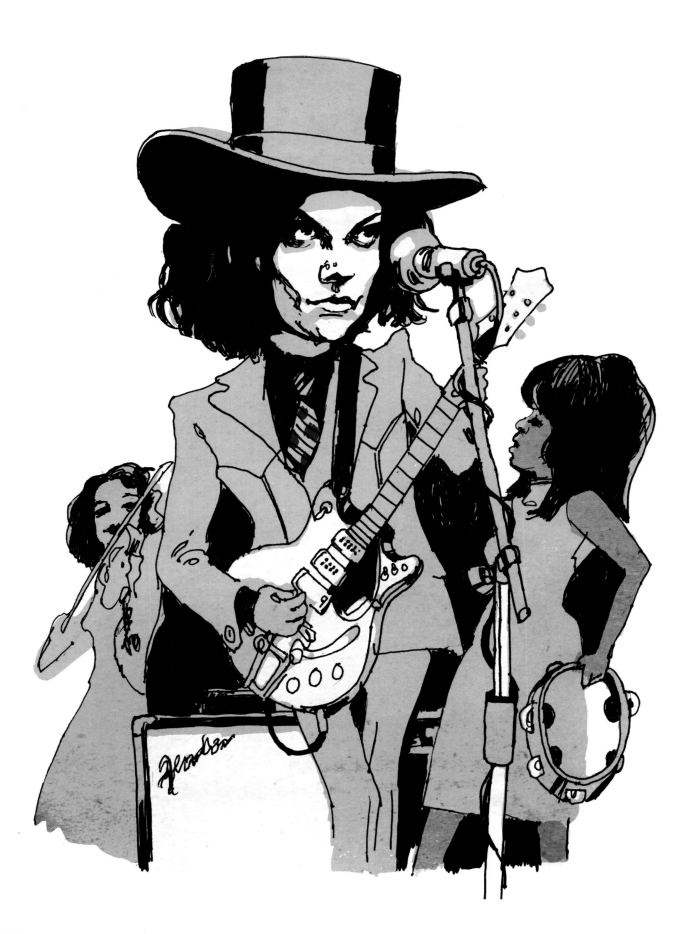

The New Yorker
magazine. 2013.

(Opposite Page)
Jack White.

(Top)
Jonathan Richman.

(Below)
Magnetic Fields.

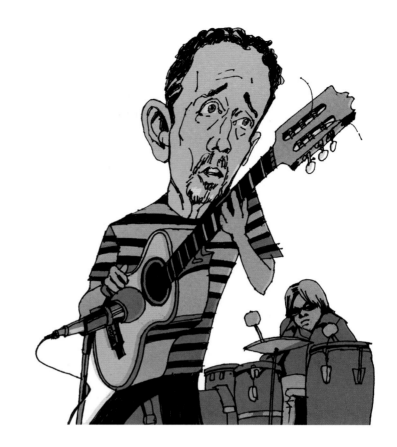

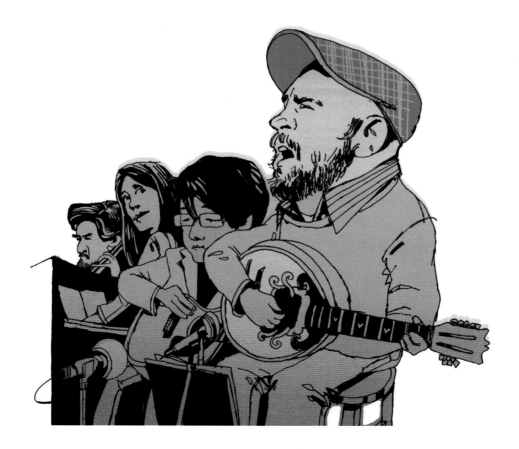

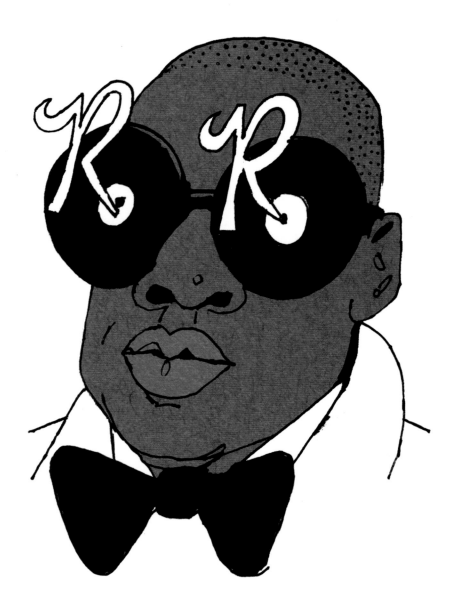

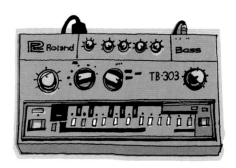

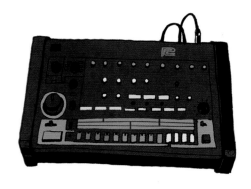

(Above, Top)
Jay-Z.

(Right, Top)
Kanye West.

(Above, Bottom)
TB-303. TR-808.
Spin magazine.
2010.

(Right, Bottom)
TR-909, Autotune.
Spin magazine.
2010.

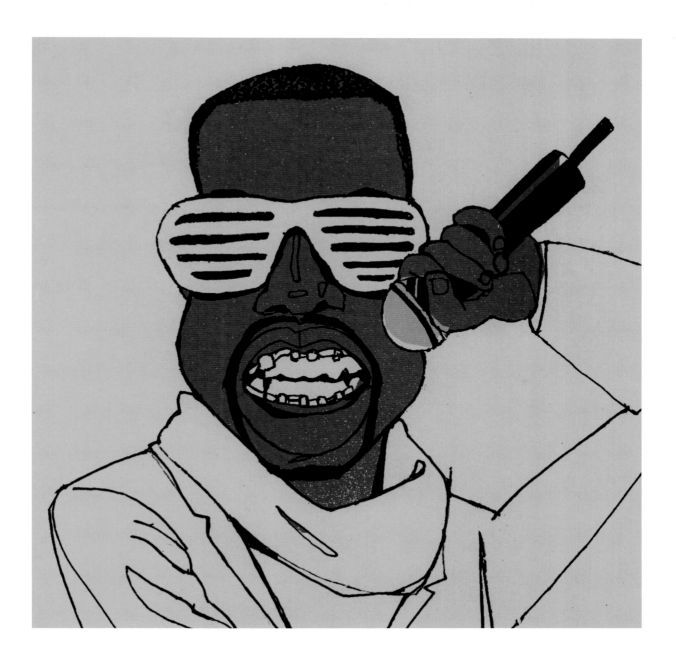

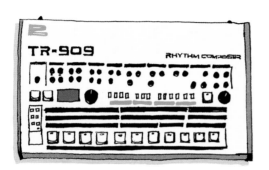 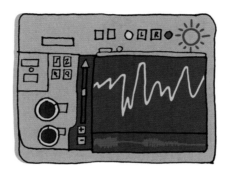

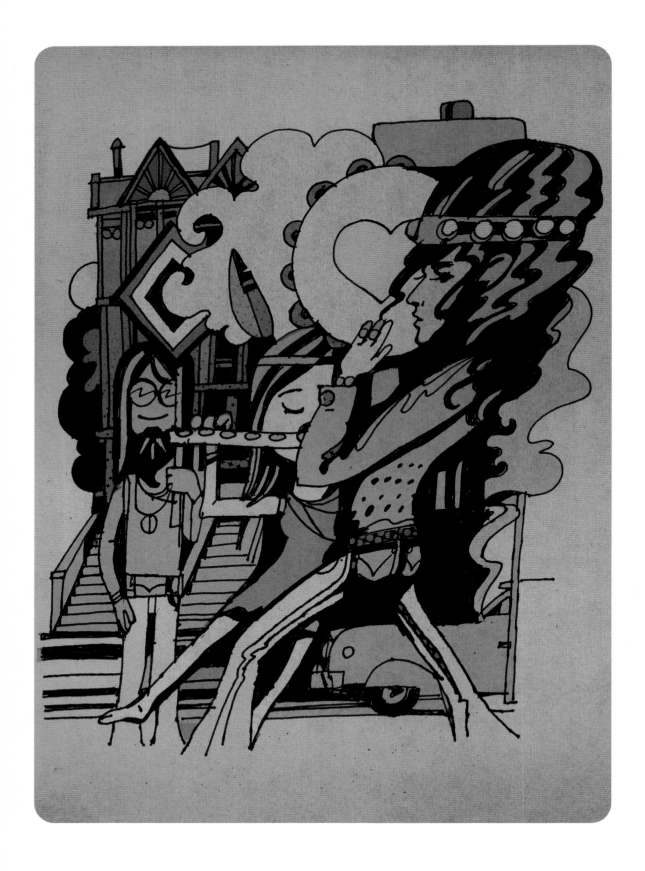

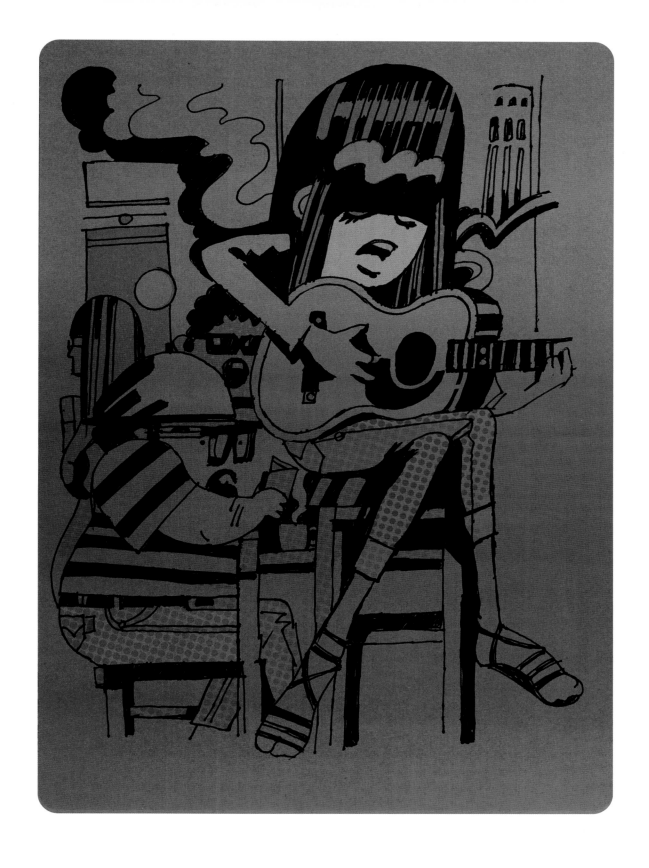

Distortion

(Left)
The Haight 1966.
Levi's. 2015.

(Above)
North Beach 1960.
Levi's. 2015.

My Morning Jacket
"Outta My System" (Video)

In late 2011, the director James Frost asked me to work on a video for My Morning Jacket's "Out of My System," an unapologetic anthem to youthful misdeeds. We located an animation house, and the plan was I'd lead a team of artists.

James directed a live action intro; Jim, the singer, was led to jump into a mysterious hole in the desert, then the animation would begin. I started designing the characters and developing a loose plot. I filled up an entire sketchbook over Christmas. The basic theme was of confronting the fears of life, real and imagined. Plenty of symbolism was ladled in there, metaphors aplenty.

Through January, I designed everything and started feeding the animators. Pretty soon it was evident that we were not all on the same page; they were making it in 3D and it just did not work. We had to cut them loose, leaving me holding up the house, half built and with little money left.

By some miracle, I found an incredibly capable and gifted student—Grant Kolton at the California College of Arts. Over the next three months, we managed to, err ... get it out of our system. It was late May by then. Animation is addictive, all absorbing, and the realm of insanity! Everything had to be puppeted out in Photoshop, a zillion layers. By completion, I could draw in a completely different way; boot camp muscles, where none had existed before, but boy did they ache.

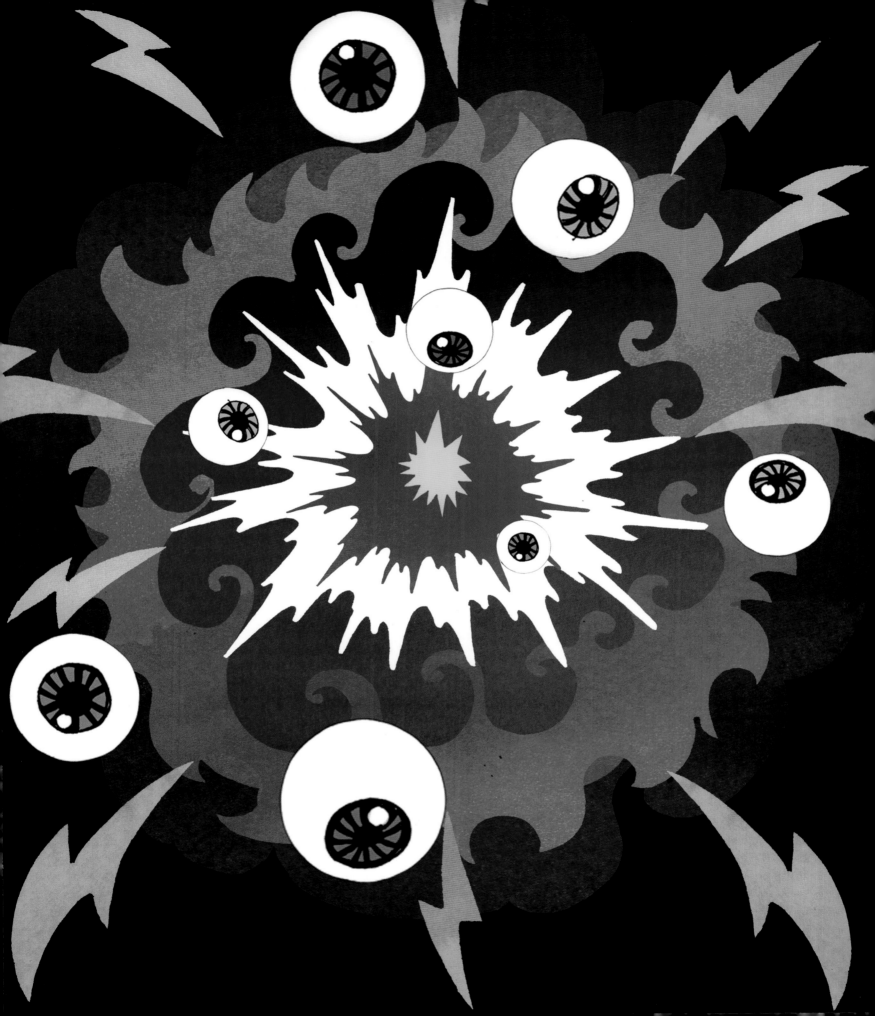

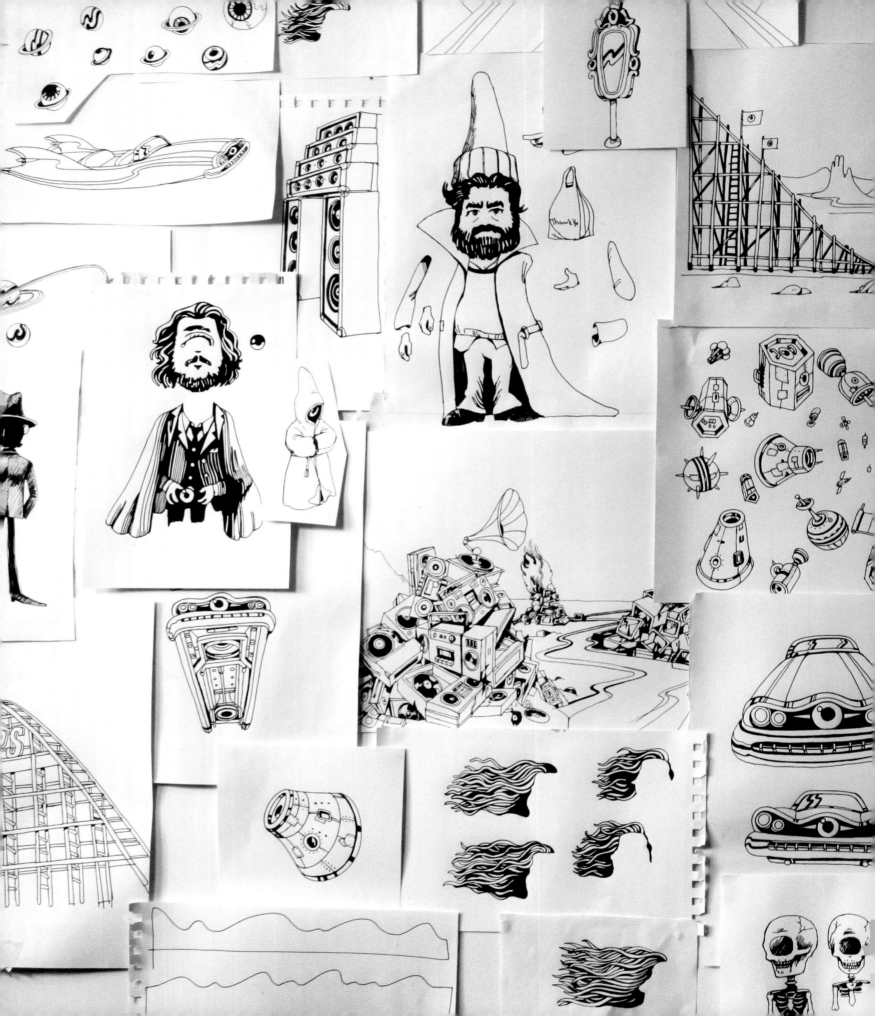

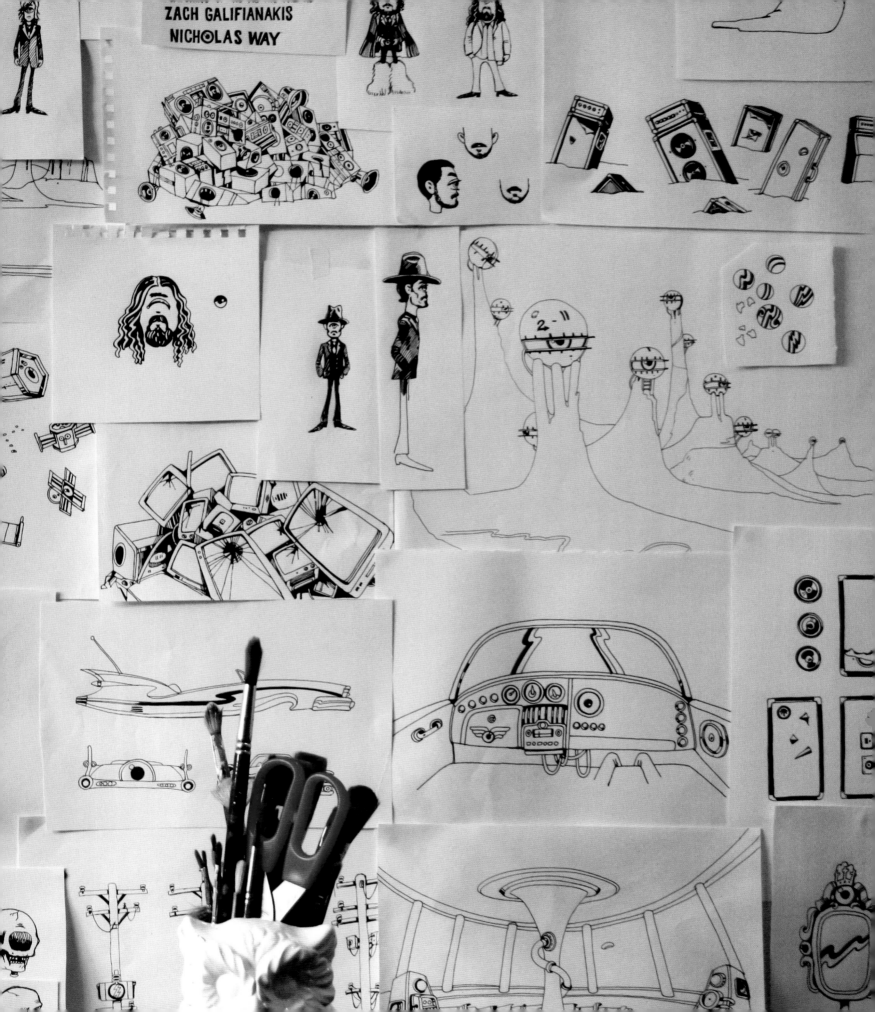

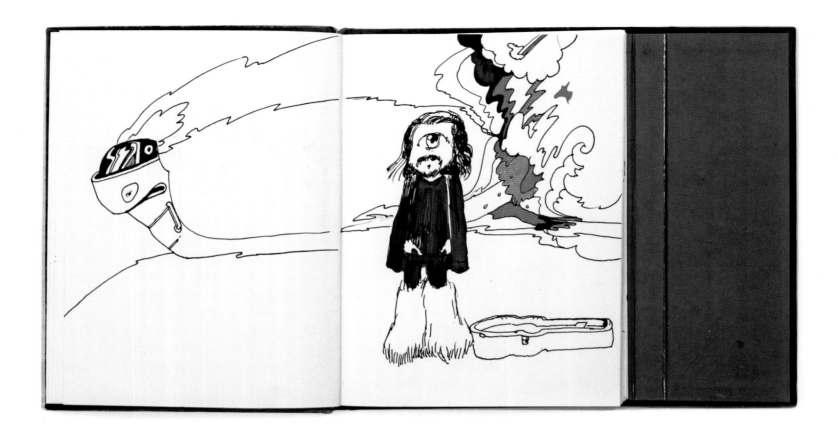

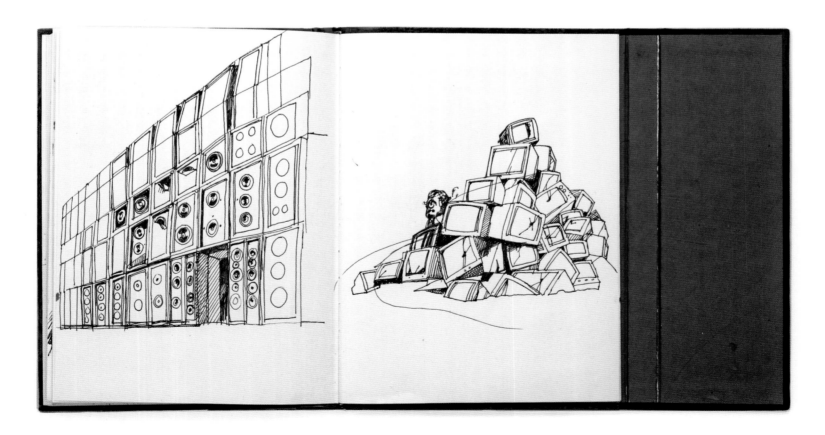

138

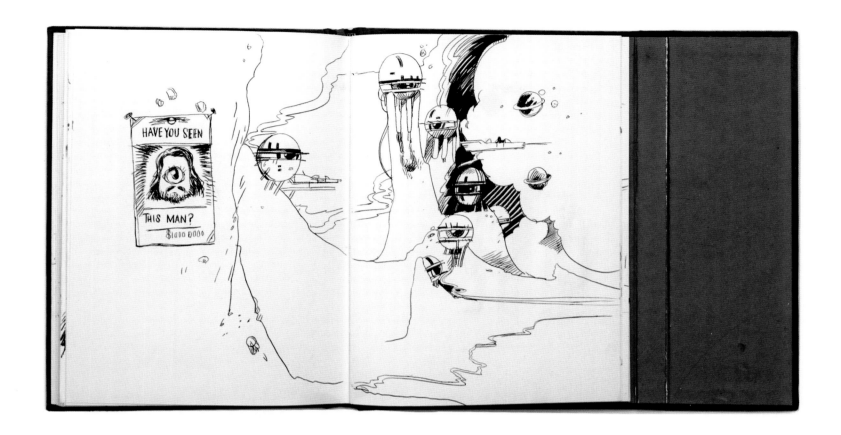

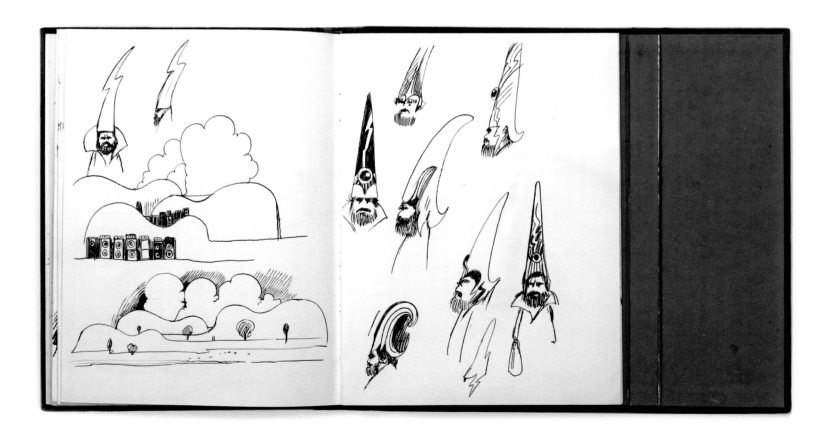

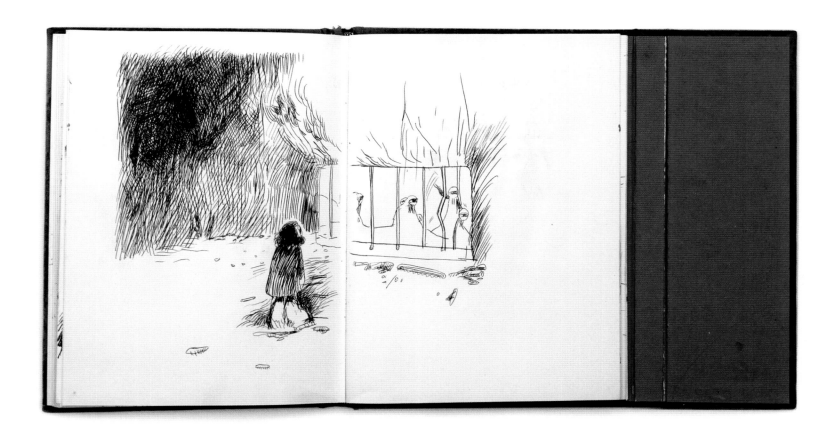

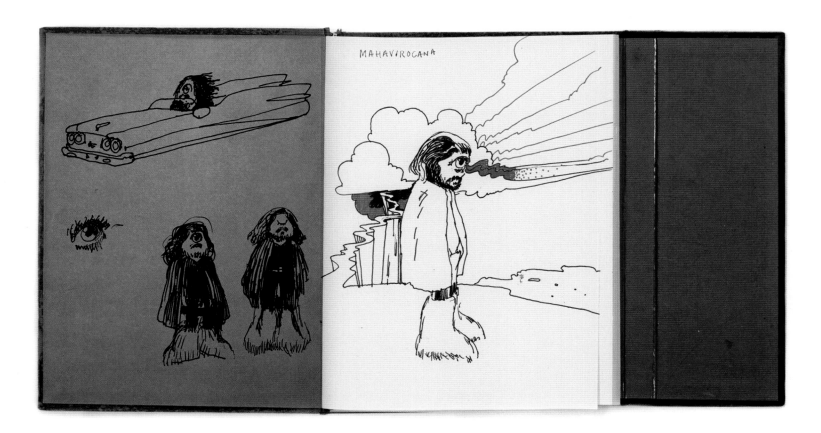

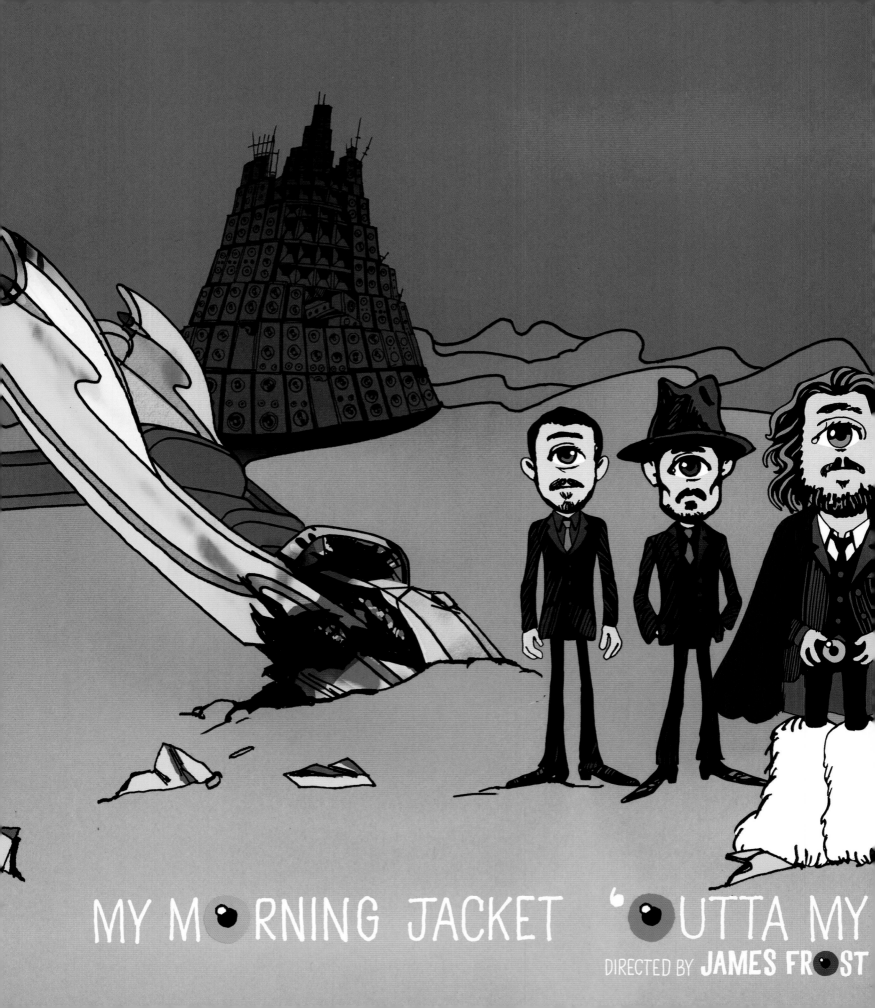

MY M●RNING JACKET '●UTTA MY

DIRECTED BY **JAMES FR●ST**

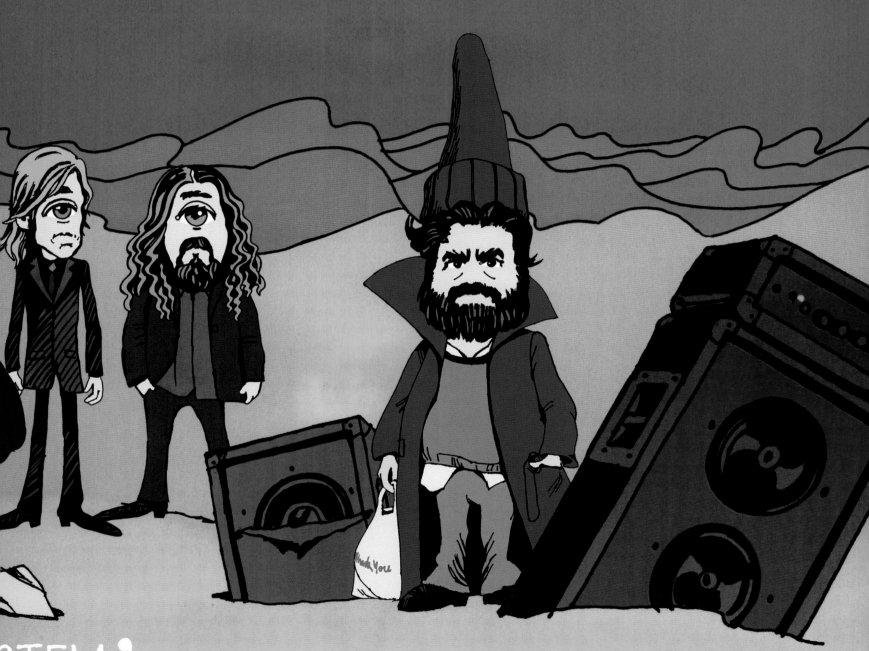

STEM' FEATURING **ZACH GALIFIANAKIS** AS THE WIZARD

TION DIRECTOR & ILLUSTRATIONS BY **MICHAEL GILLETTE** ANIMATION BY **GRANT KOLTON**

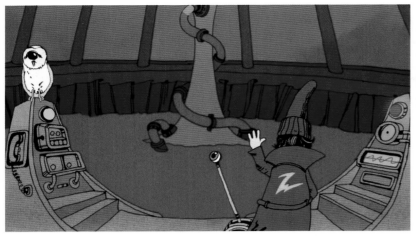
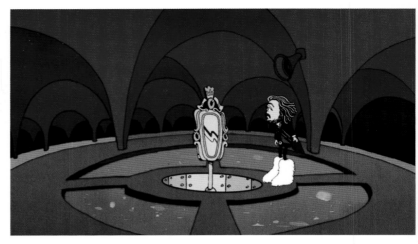
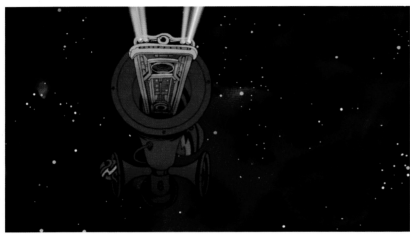
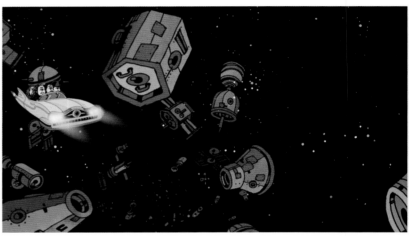
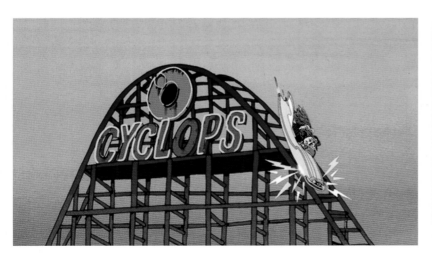
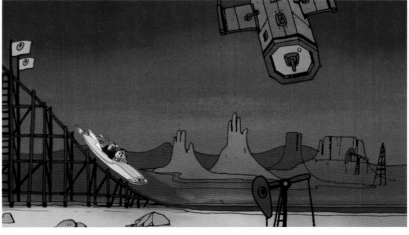

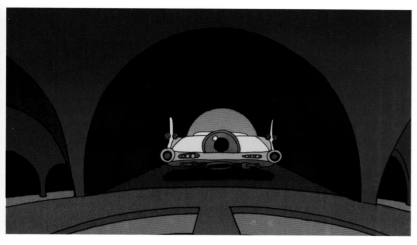
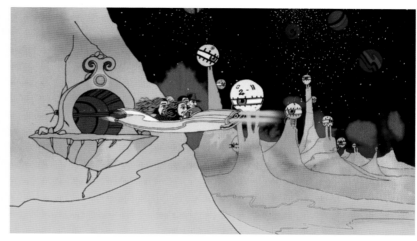
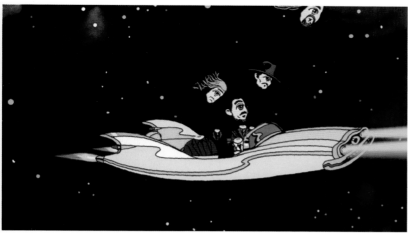
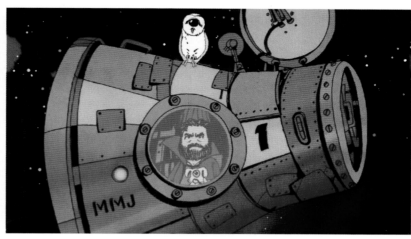
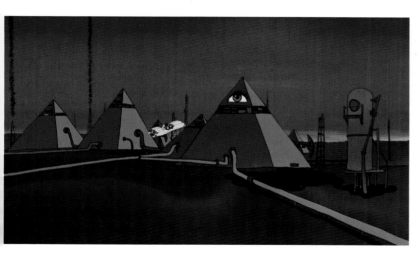

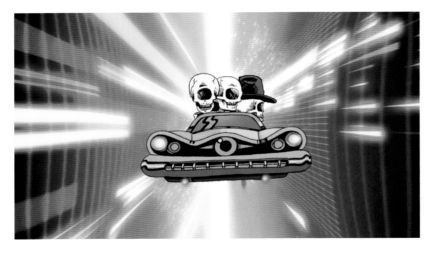
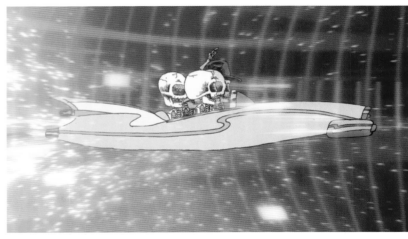
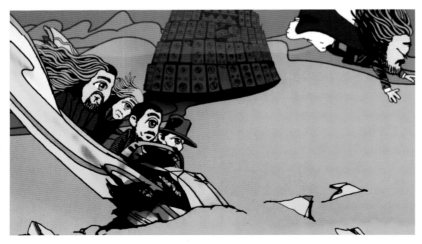
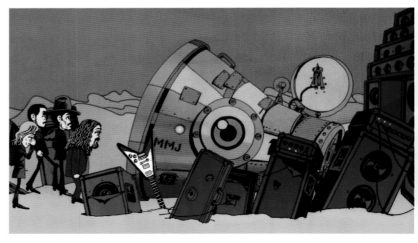
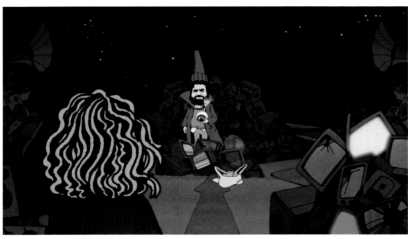
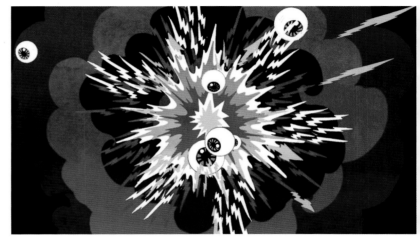

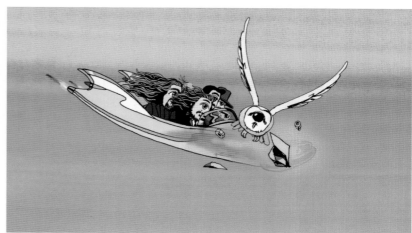
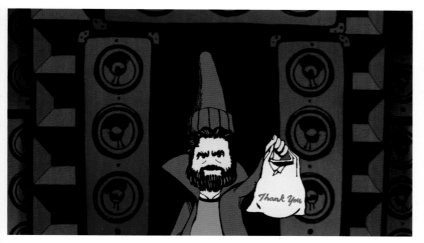
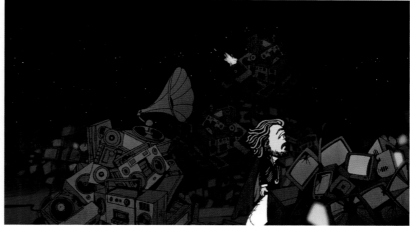
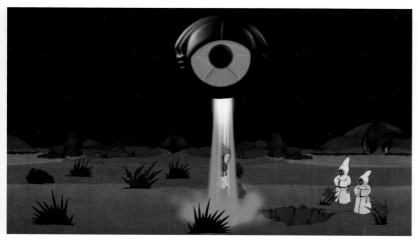
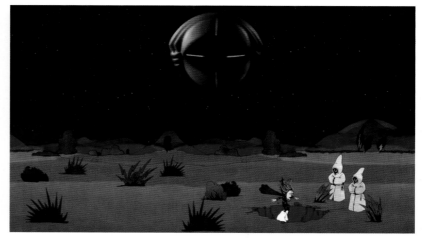

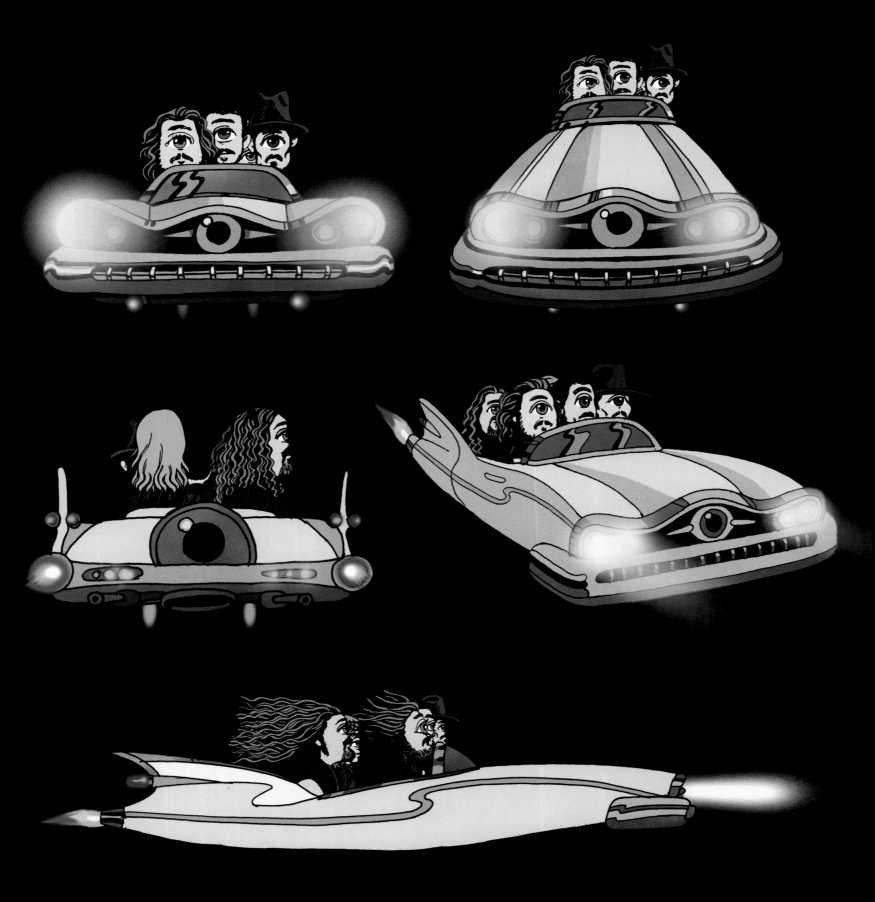

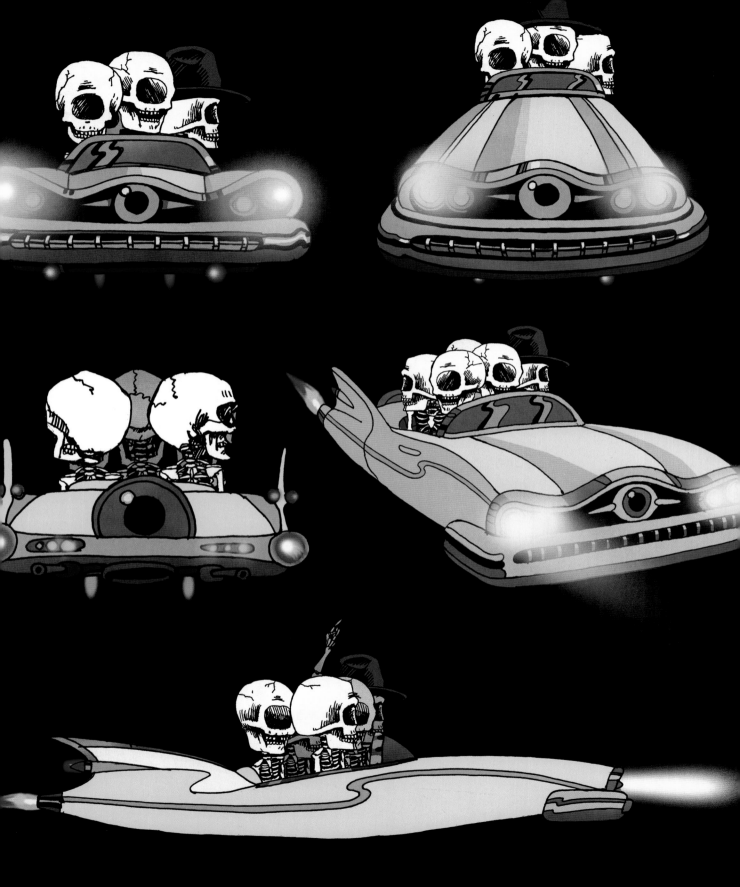

man?" sang The Creation—
a fair question as there are
easier ways to make a mark.
I can't recall a single painting
lesson during my four years
of art college. I started paint-
ing after graduation, learning
acrylic on the fly—at least
I could go over the mistakes.
Later I switched to waterco-
lour, a media that seems to
smell fear on a quantum level.
You have to walk the tightrope
with absolute confidence or
the results will be spiritless,
but when it all flows, there
is nothing more gratifying.
Recently I've taken up Chinese
brush painting and that is also
thrilling in its immediacy, well
after you've spent 10 minutes
grinding the ink.

Paint-
er
Man.

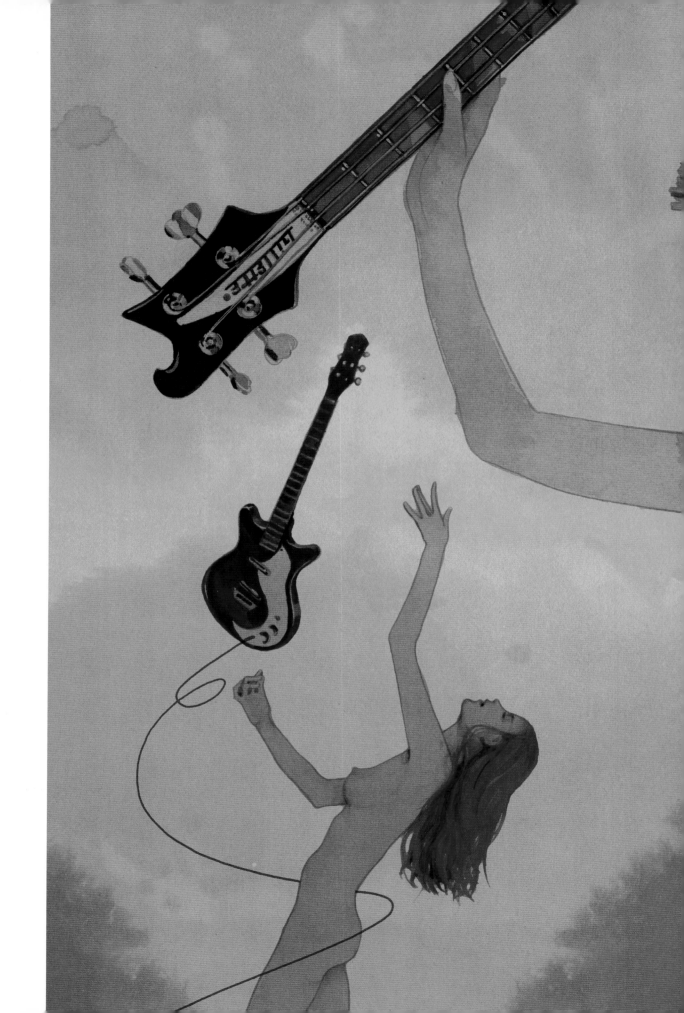

Centrefold magazine.
Wraparound cover.
2010.

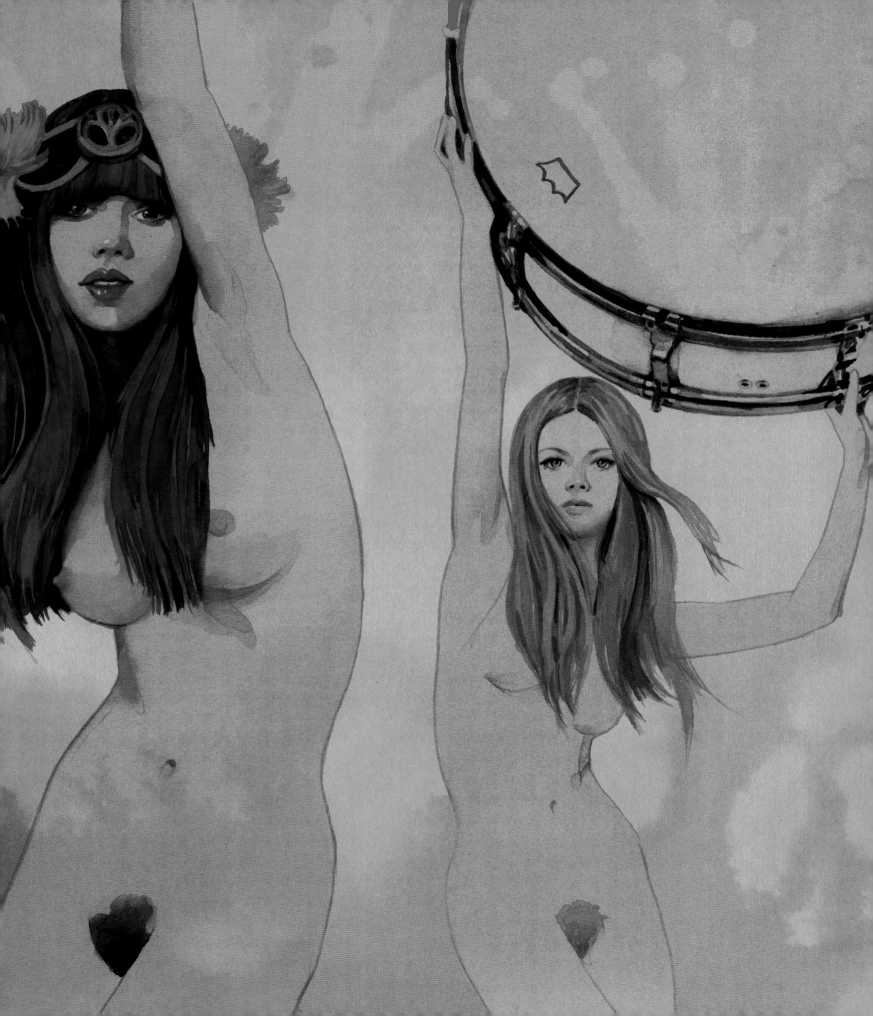

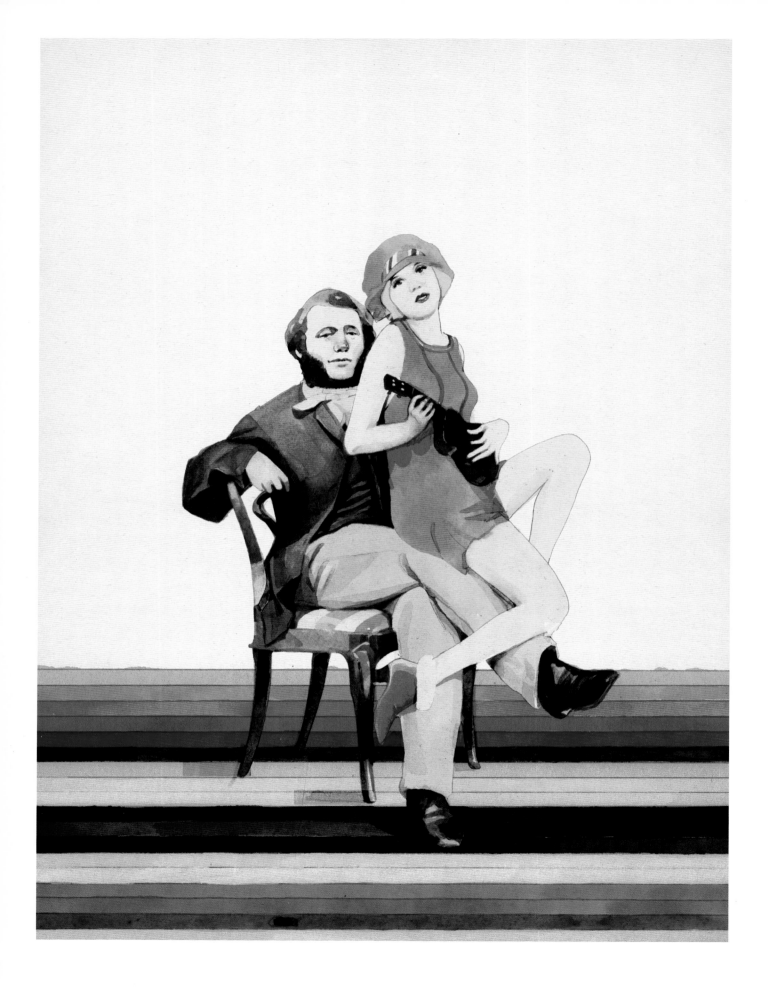

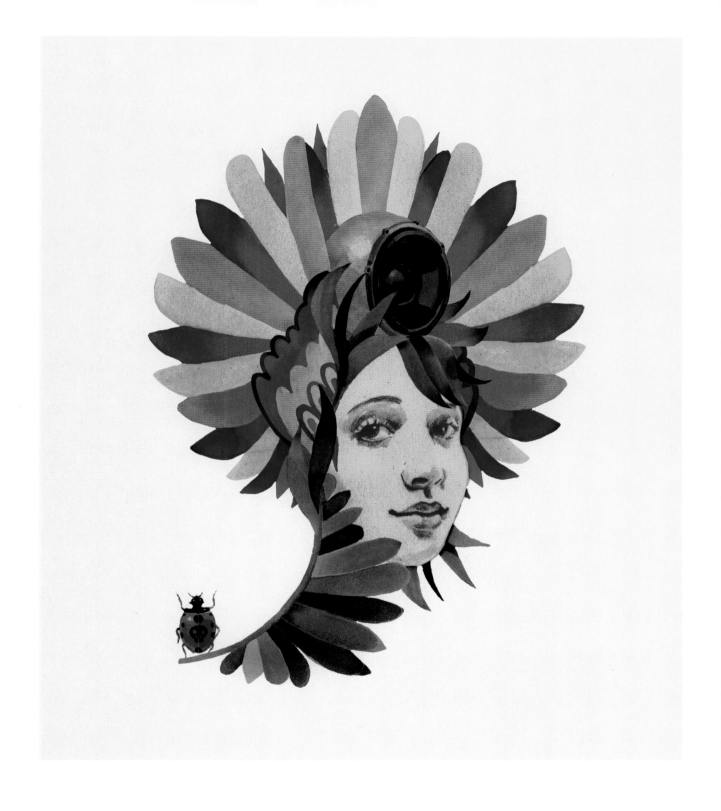

Painter Man

(Left)
Spirit of SF1.
2006.

(Above)
Spirit of SF2.
2007.

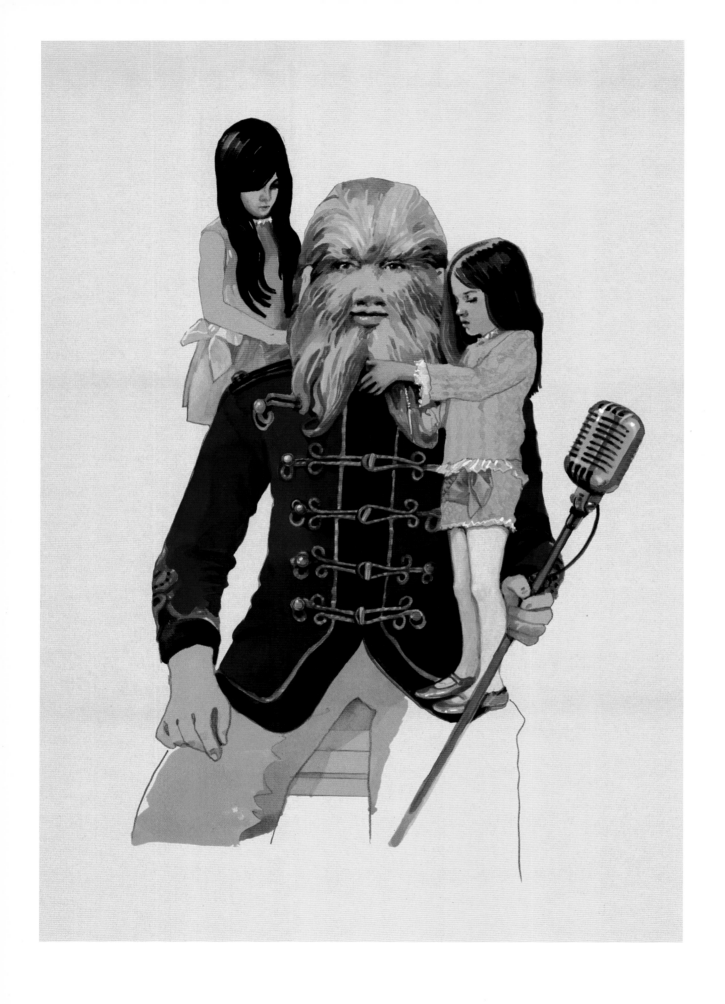

(Left)
The idol.
2009.

(Right)
Macca.
2006.

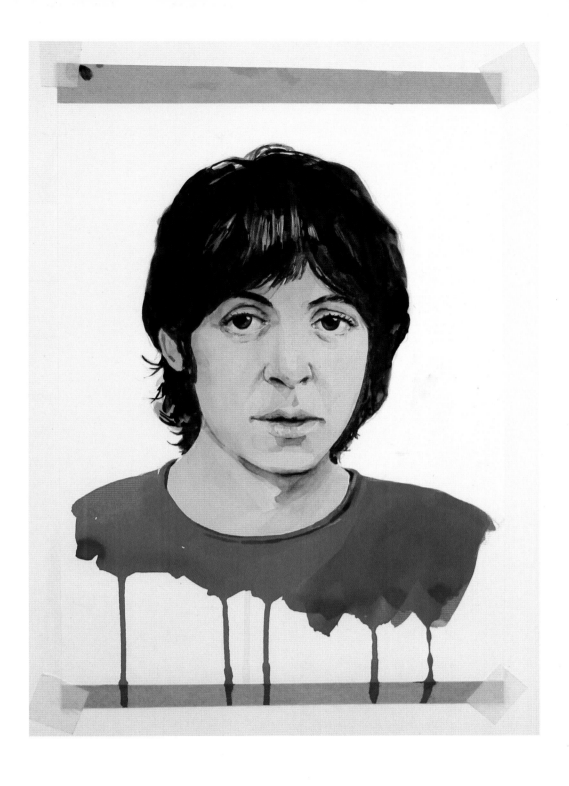

I got a call from Capitol Records one Friday morning: "Could you paint Paul McCartney for a love-themed compilation looking doe-eyed and young?" Yes, HELL YES! He was due in LA on Monday to see artwork. I spent the next day in a state of sheer excitement and confusion. "I am painting MACCA for MACCA?!" Small wonder it's not just a bunch of wobbly scribbles. Come Tuesday, I'm told he loves it but has decided it's not the best time for the album. Next stop divorce! Quite a weekend though.

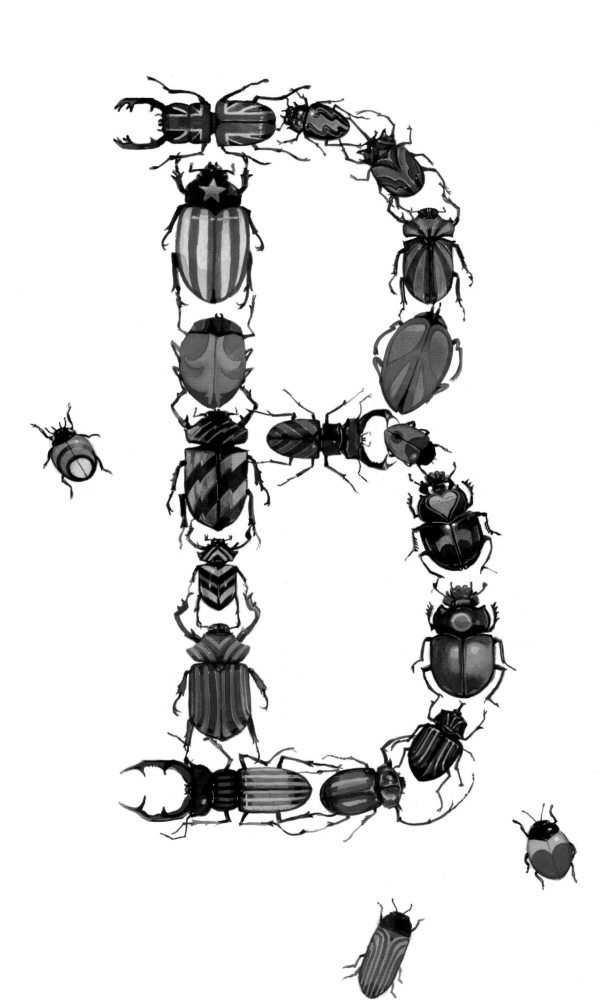

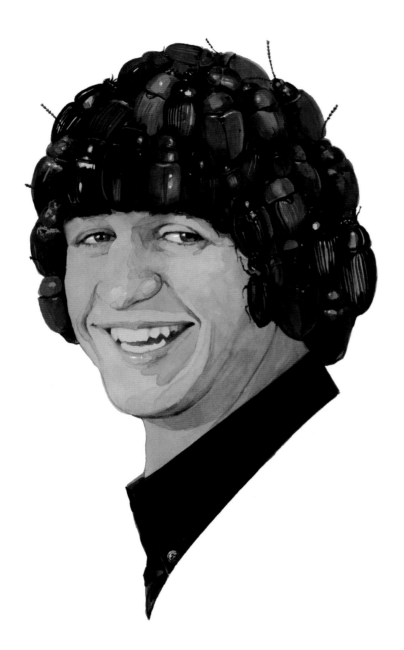

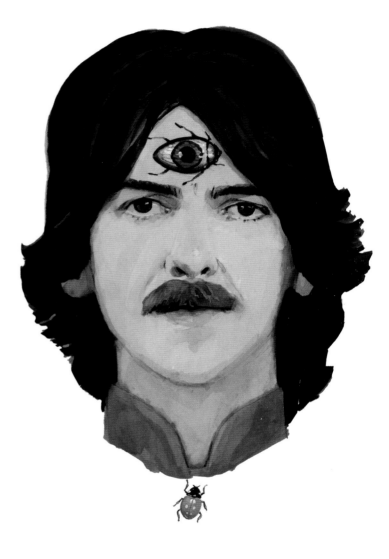

Painter Man *B is for*
 Beatle Bugs.
 2010.

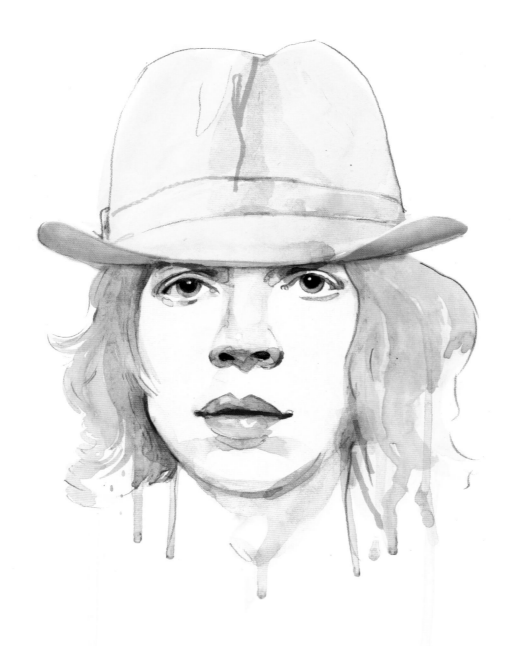

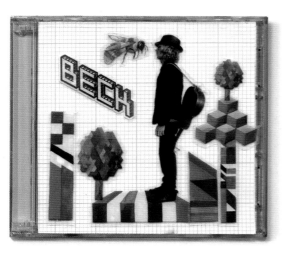

(Above)
Beck.
Information album.
2006.

(Right)
Pink.
Spin magazine.
2002.

160

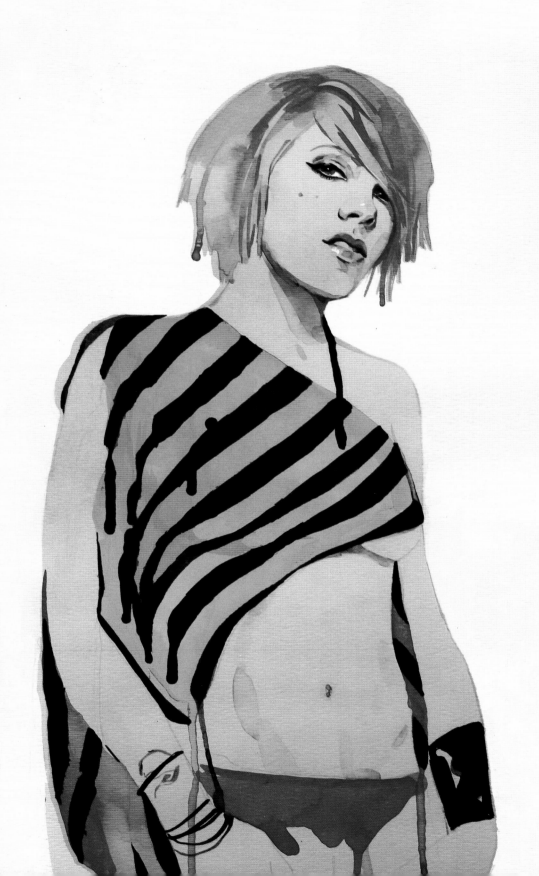

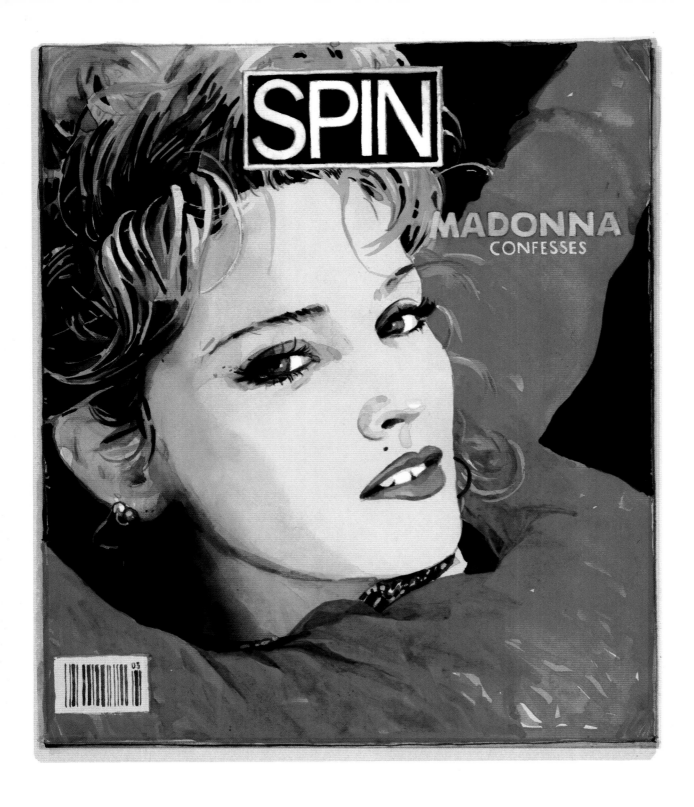

(Above)
Madonna.
Spin magazine.
2010.

(Right)
Tommy Lee Sextape.
Spin magazine.
2010.

Tommy Lee wrote to
me after this appeared:
apparently I'd caught
a good likeness.

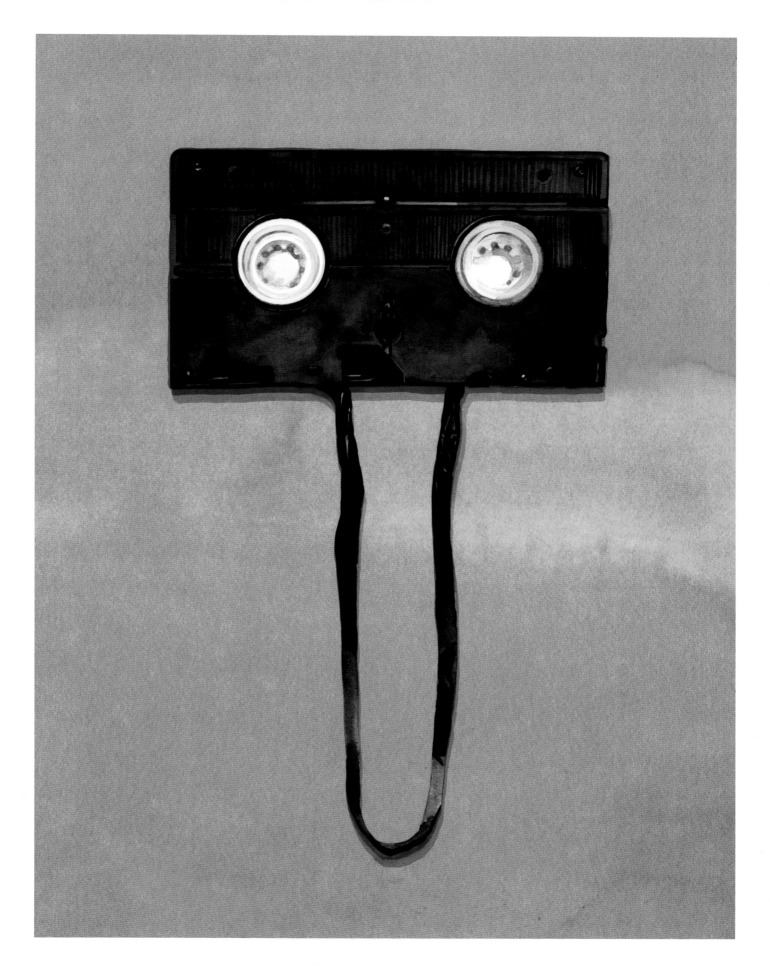

Painter Man

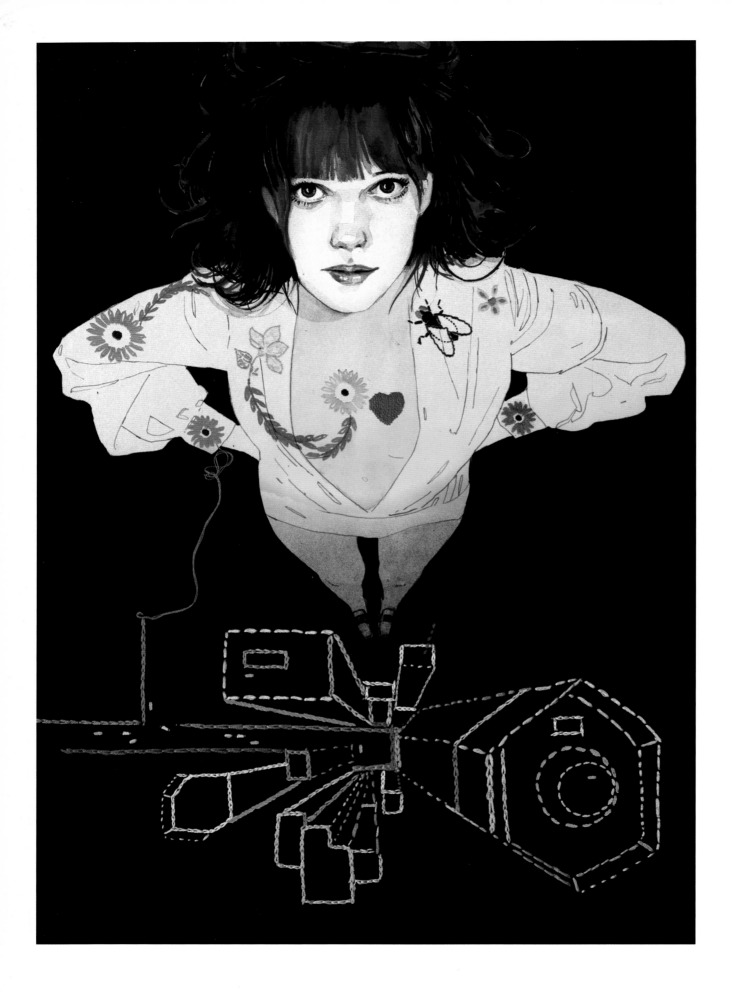

(Left)
Vertigo-go.
2006.

(Right)
Rumer. Mojo.
2010.

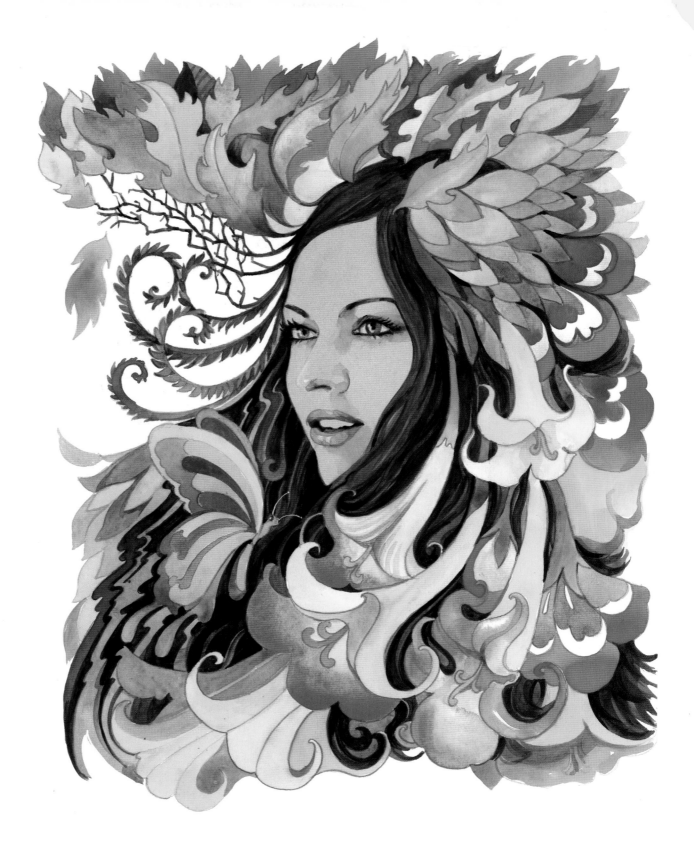

Painter Man

Later reformatted to:
into a 40-foot-wide tour
backdrop for the singer.

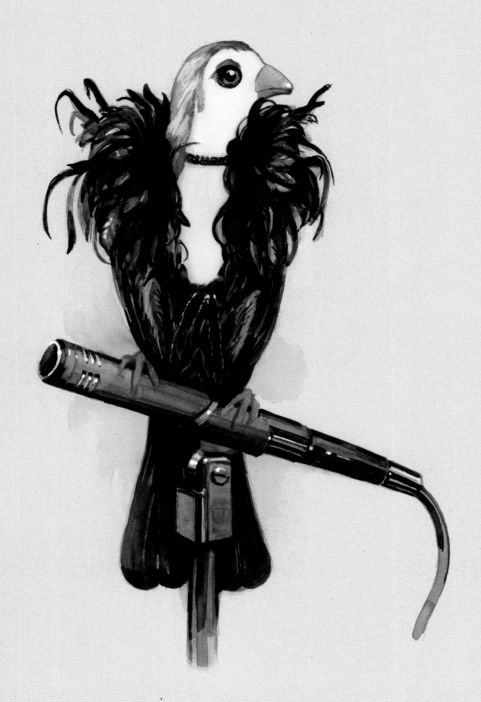

ART ROCK HOPPER (*Artis Moveo Infundibulum*)

Glam Songbirds.
2015.

(Left)
Brian Eno.

(Right)
David Bowie.

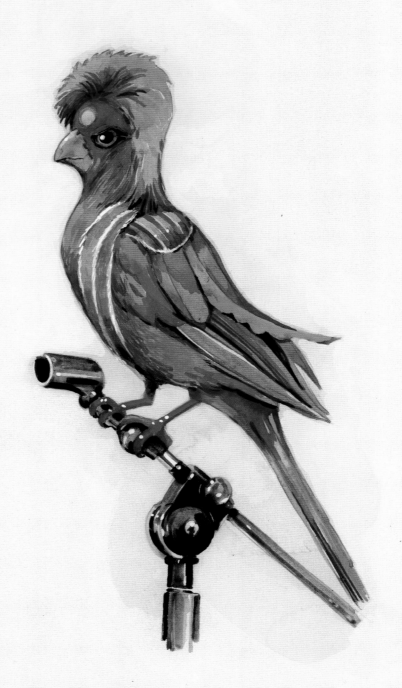

STARDUST WARBLER *(Stellapulvis Cantilo)*

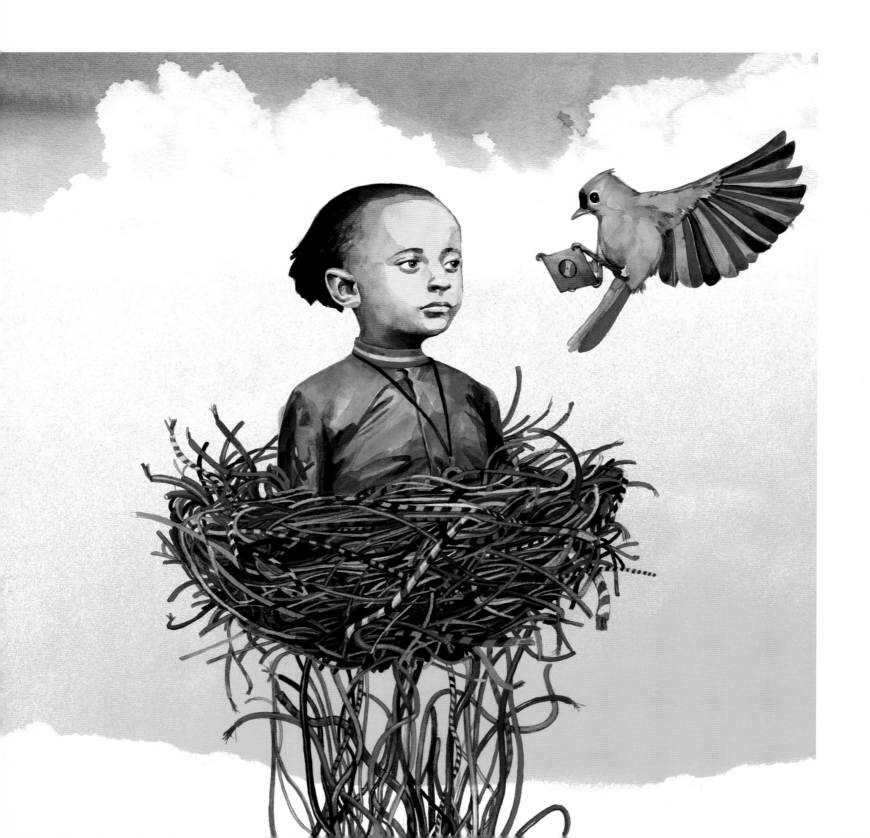

The Birth of Dub.
2004.

I often work to Reggae.
My grandfather once met
Emperor Haile Selassie
(pictured in the nest) at our
local village church in 1939.

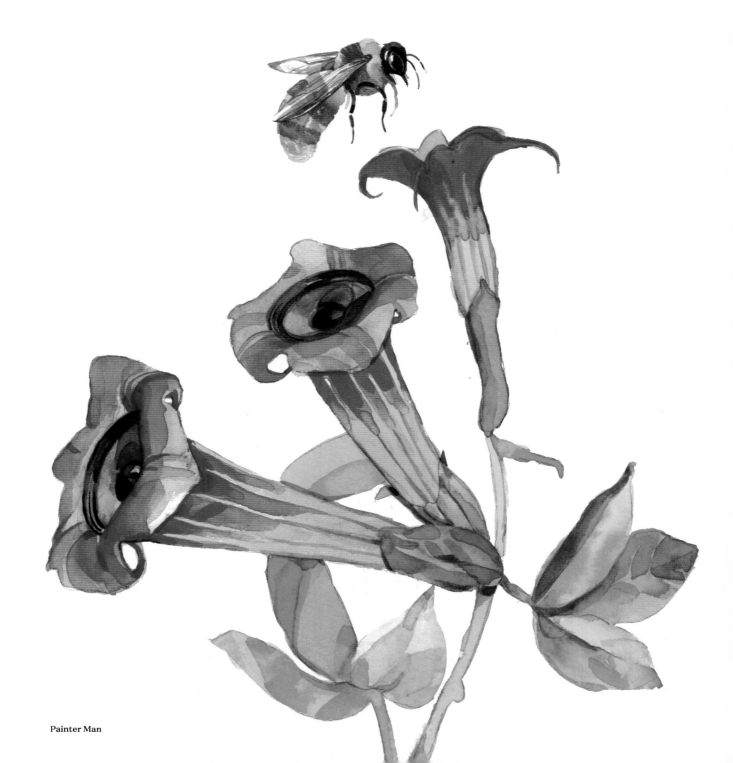

Painter Man

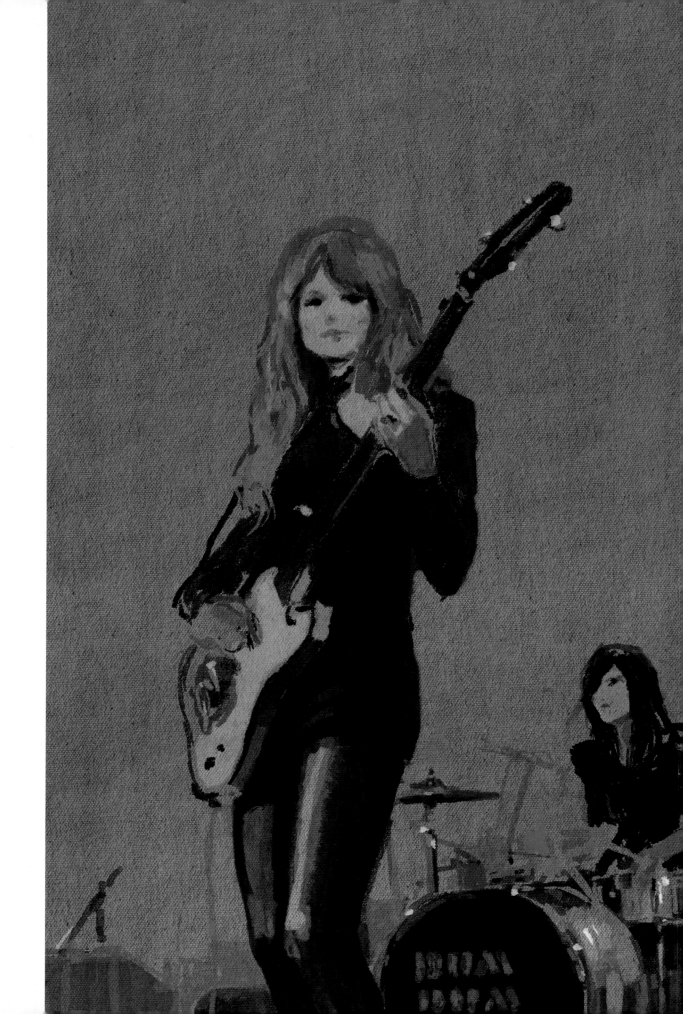

Dum Dum Girls. 2011.
Drawn with a Wacom.

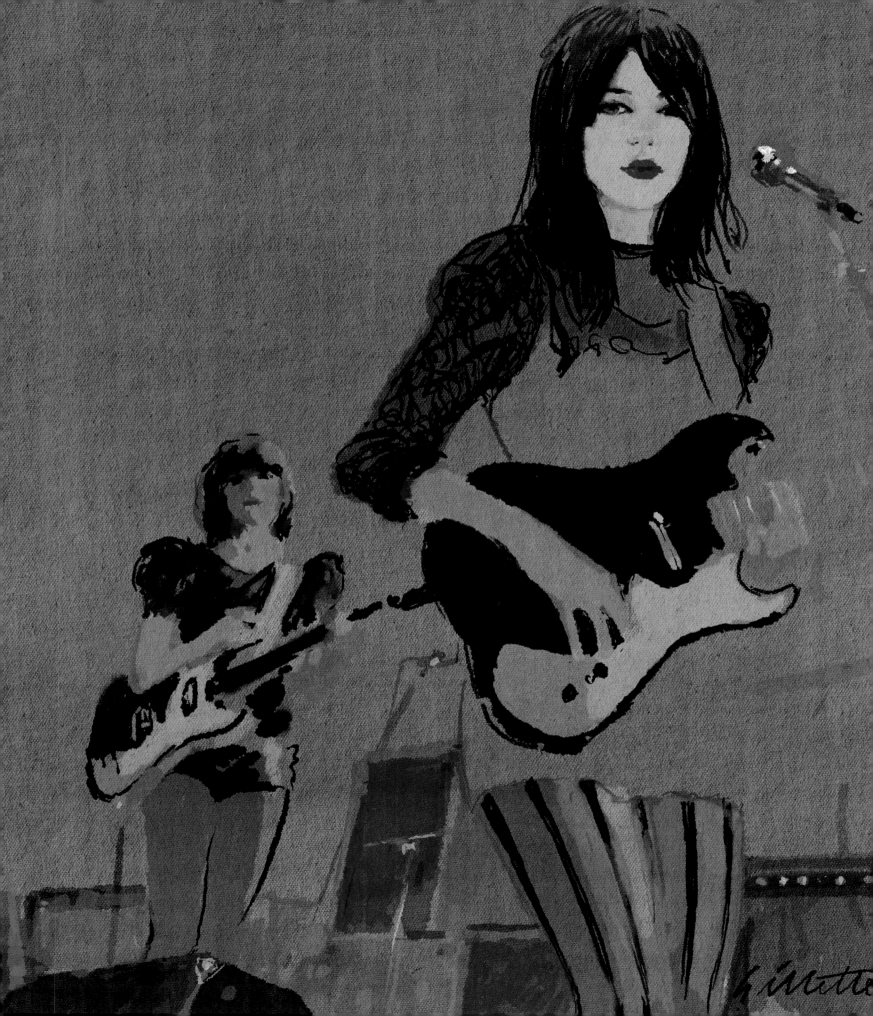

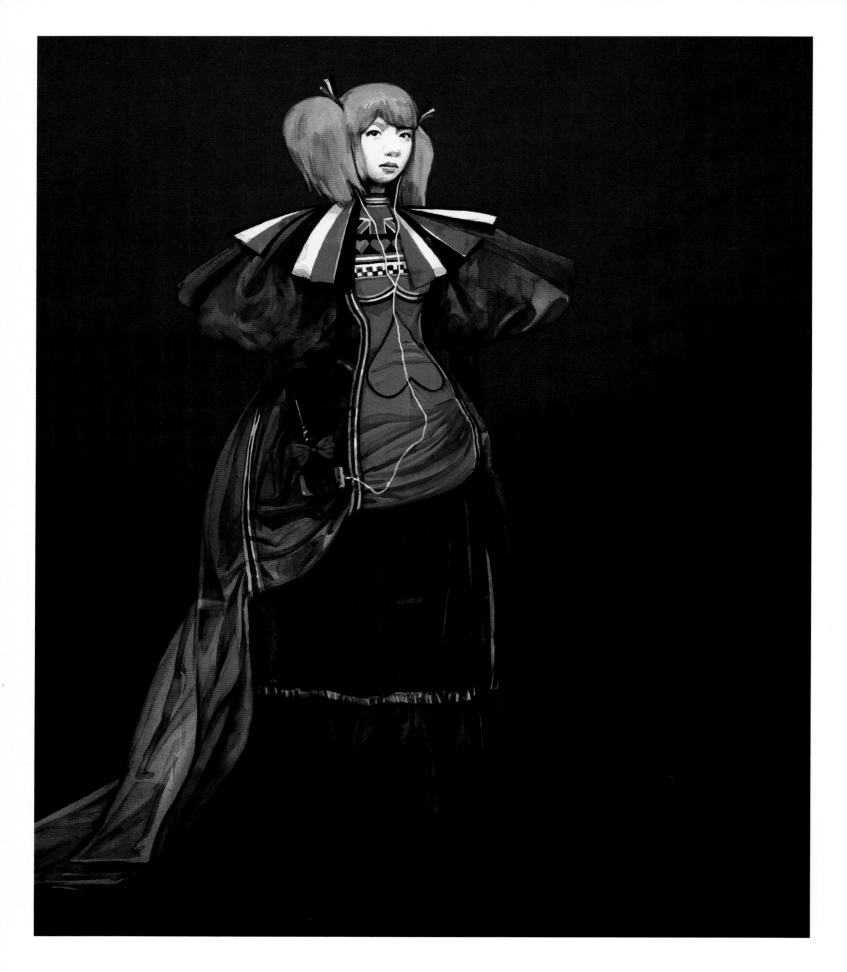

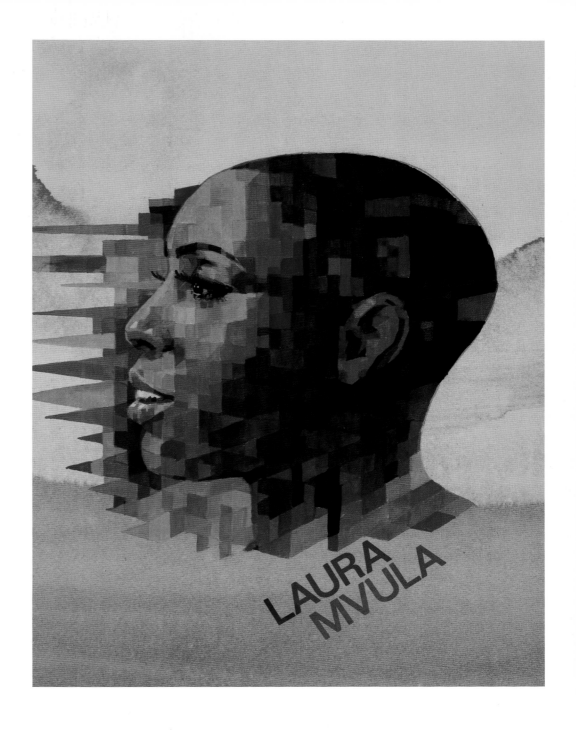

(Left)
*Harajuku girl
with iPod*. 2007.

(Above)
Laura Mvula. 2013.
Unused tour backdrop.

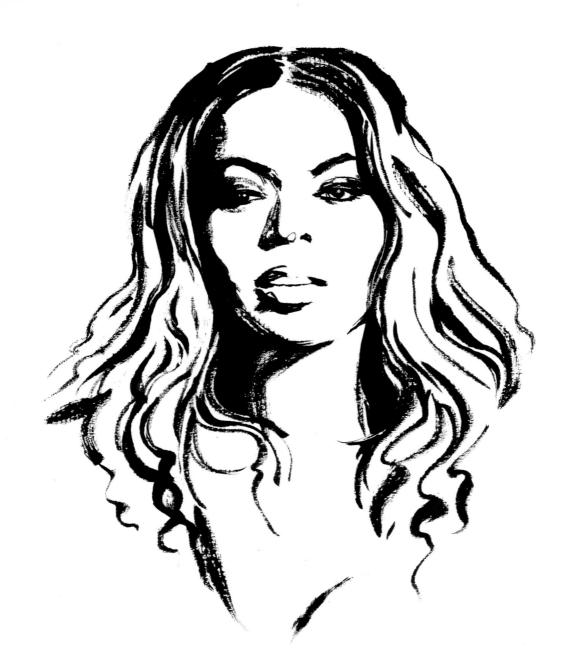

Painted in
Zen brush.

(Left)
Beyonce.
Esquire.
2014.

(Below)
Odd Futures.
Esquire.
2014.

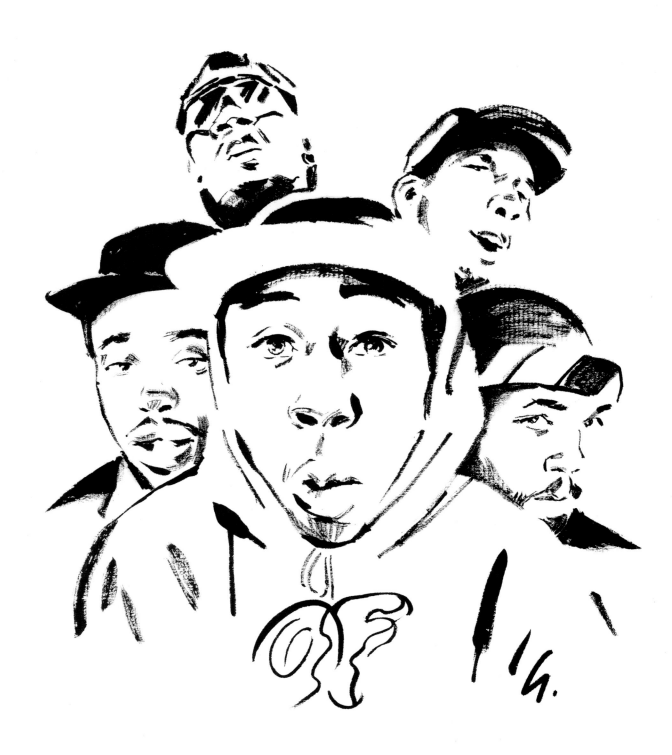

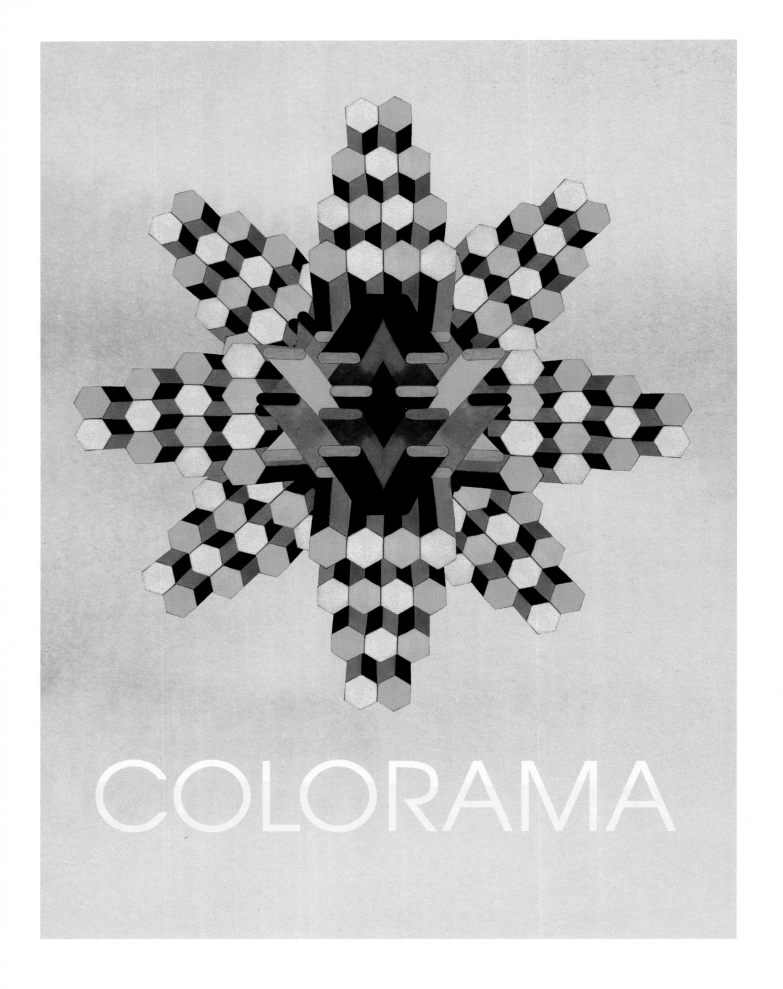

COLORAMA

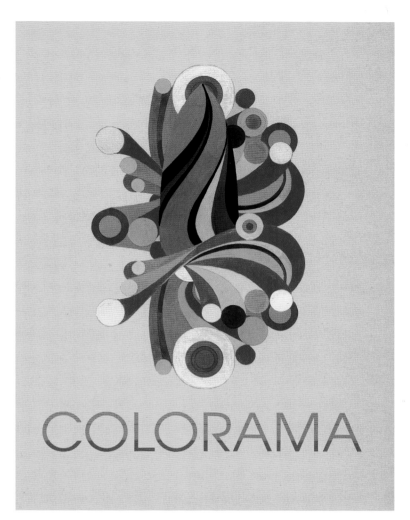

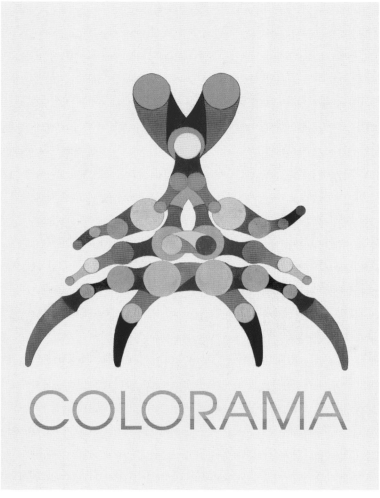

Colorama.
Tour posters.
2015.

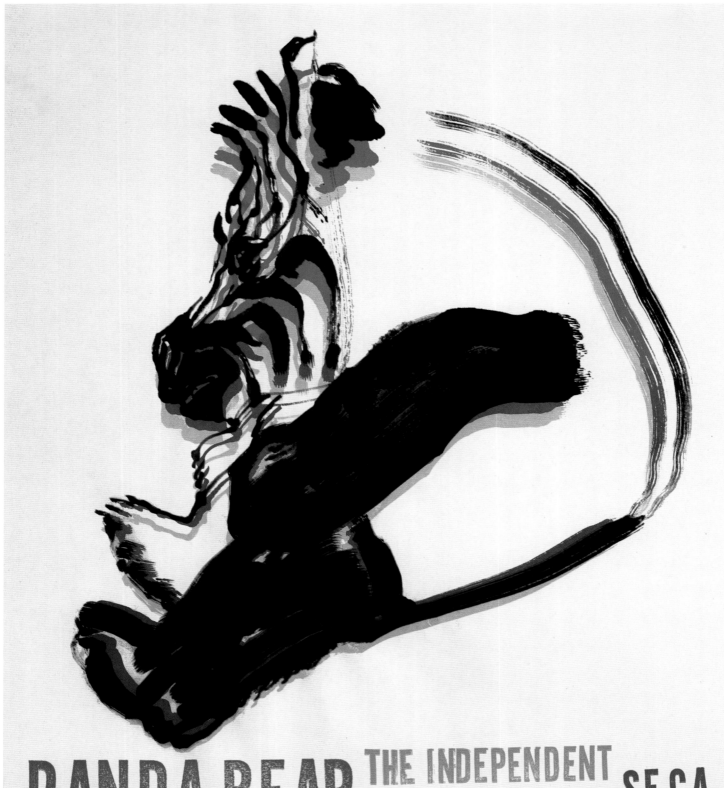

PANDA BEAR THE INDEPENDENT APRIL 14 2015 SF CA

(Left)
Panda Bear.
Poster.
2015.

(Right)
Django Django.
Poster.
2015.

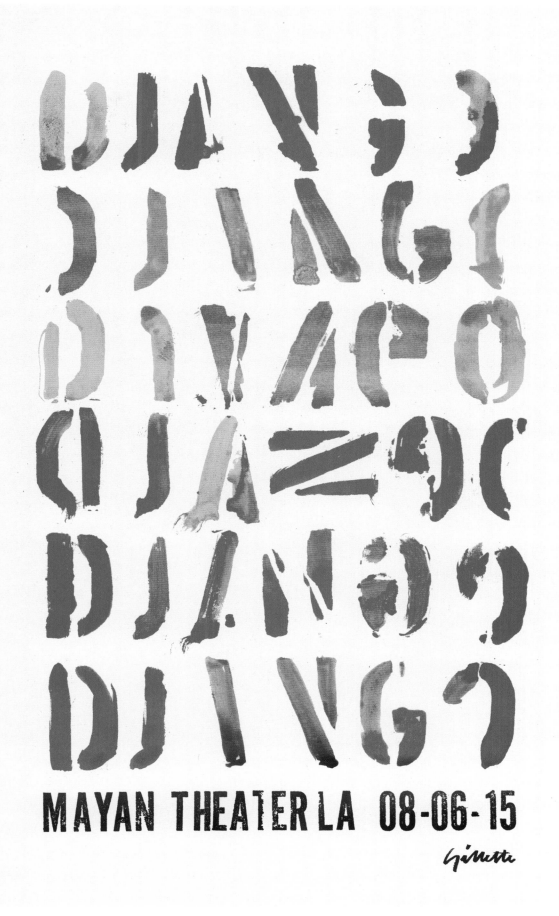

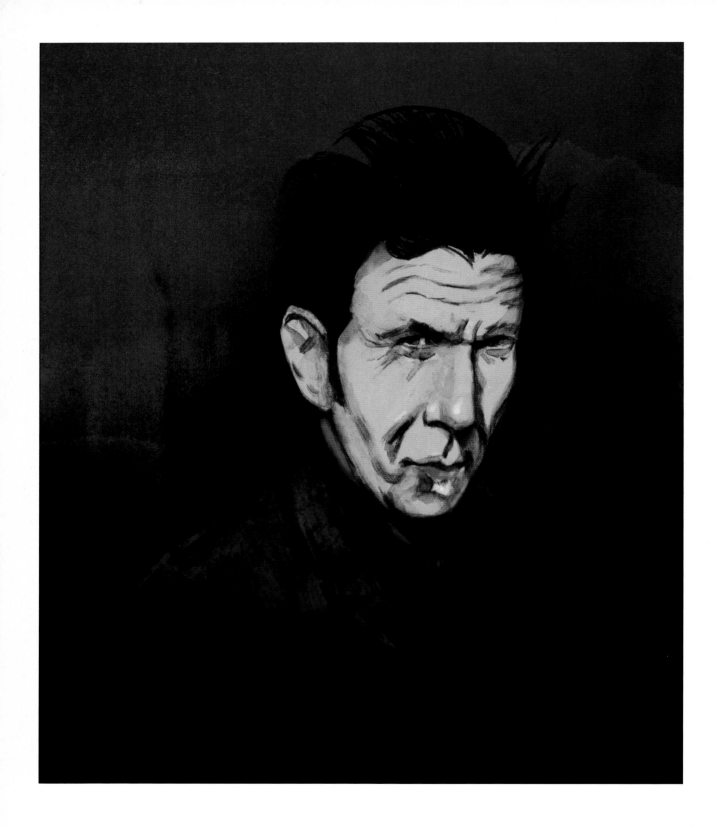

Esquire (US).
2008.

(Left)
Tom Waits.

(Right)
Iggy Pop.

"Be careful to maintain
a spiritual exit. Don't live
by this game, because
it's not worth dying for."
—Iggy Pop, 2014

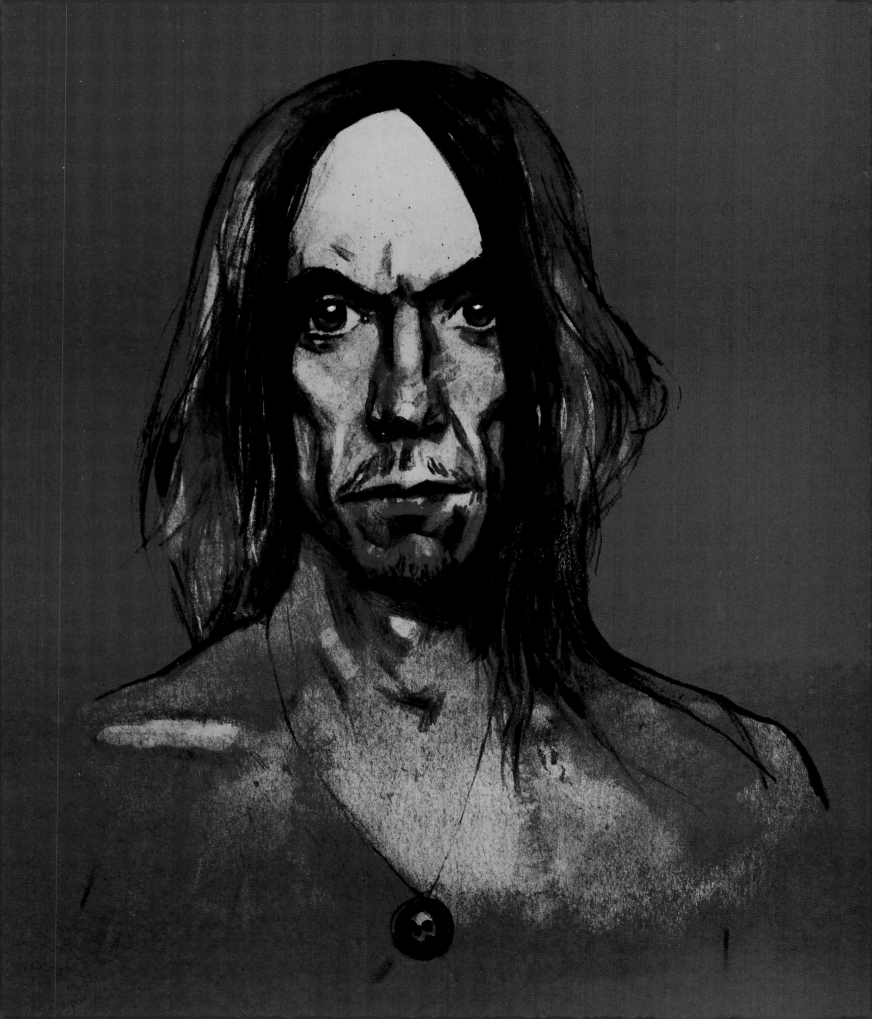

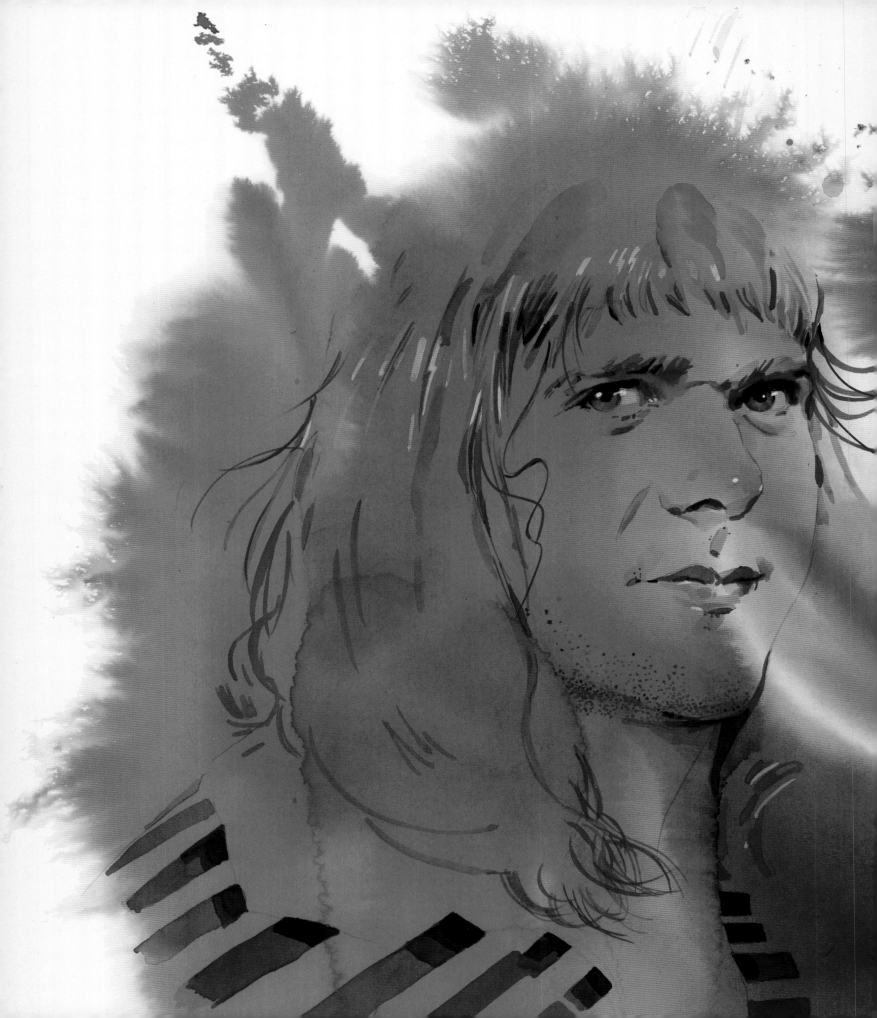

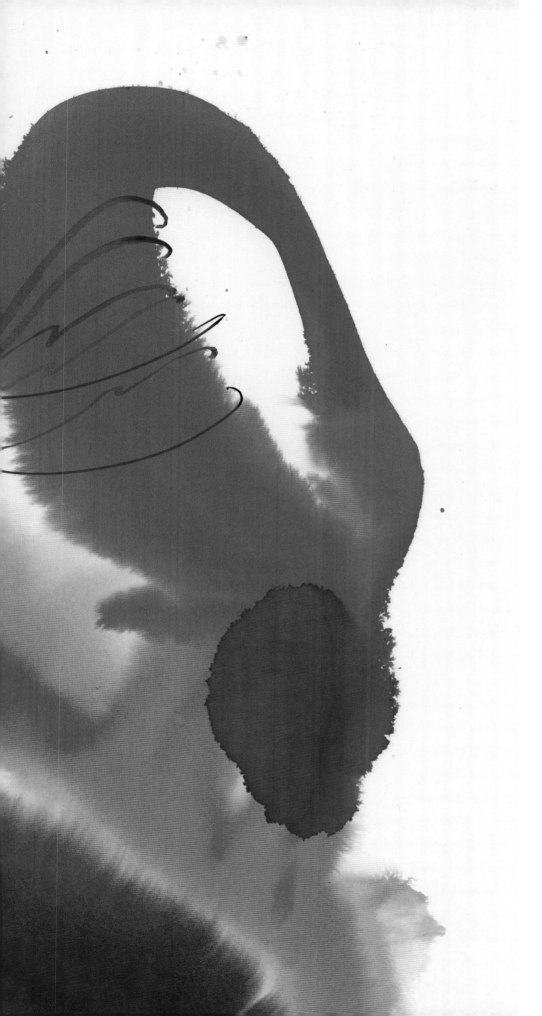

Ariel Pink in ink.
2015.

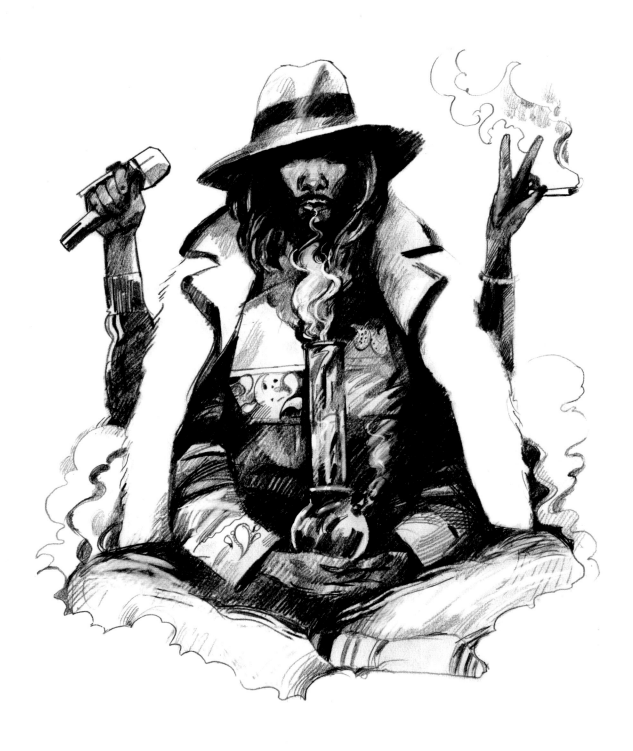

Snoop Dogg's
style evolution.
The Fader.
2014.

(Above)
Initial sketch.

(Right)
Finished Art.

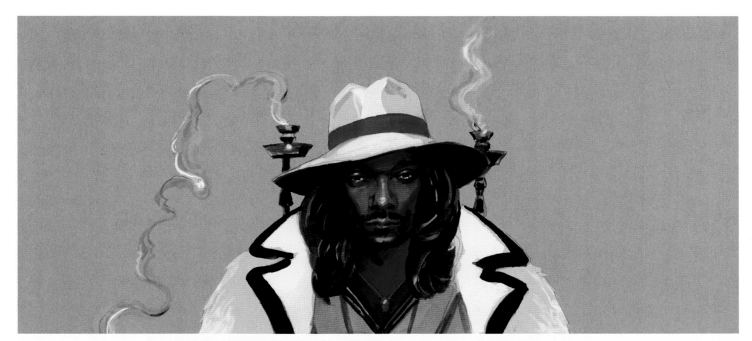
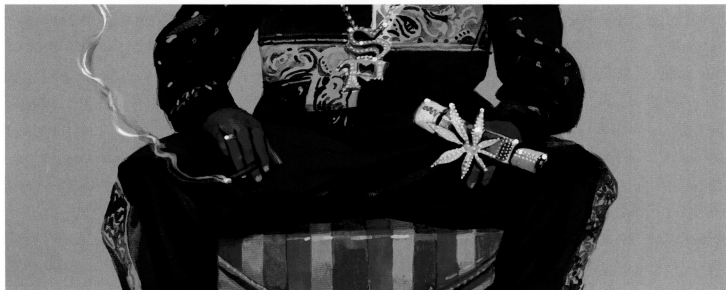
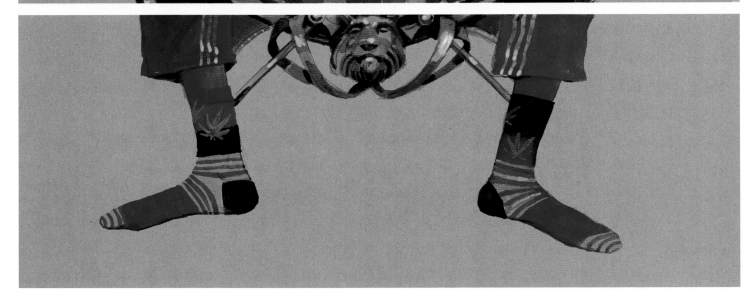

185 Painter Man

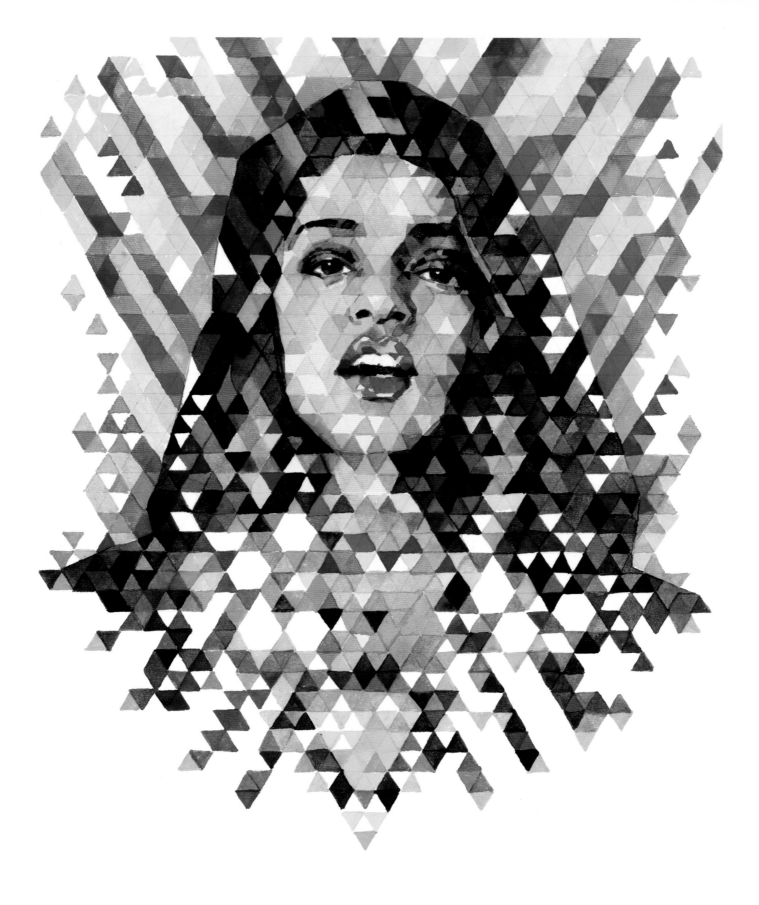

I started painting on various graph papers after my children Eleanor and Josephine were born. It's like doing a jigsaw, allowing me to deal with their needs and return methodically.

(Above)
MIA. 2014.

(right)
Kanye West. 2015.

A big enough ego
to close any book!

186

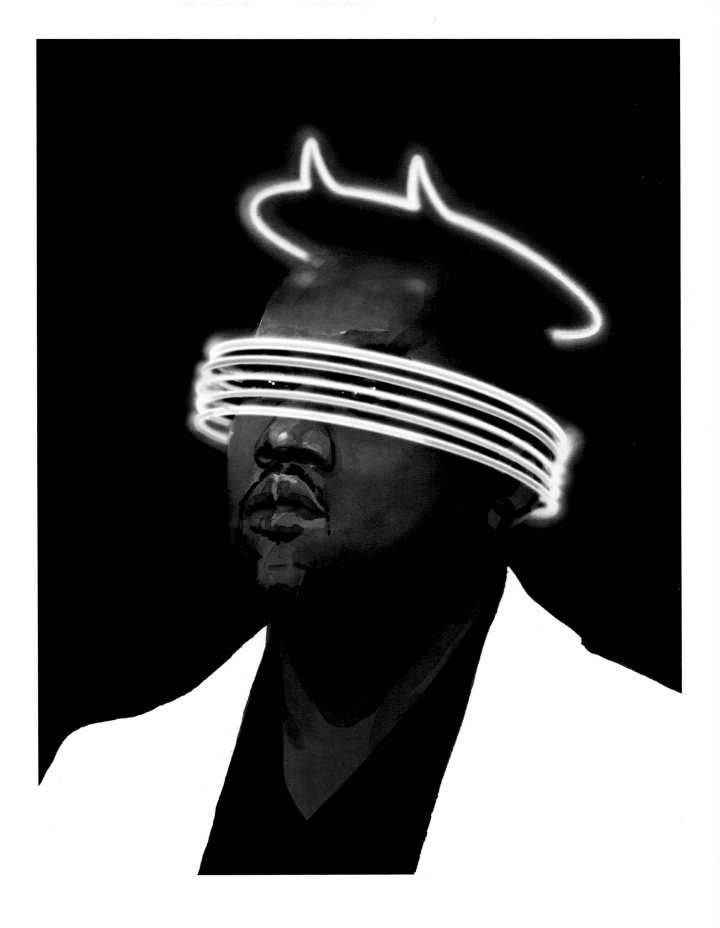

Painter Man

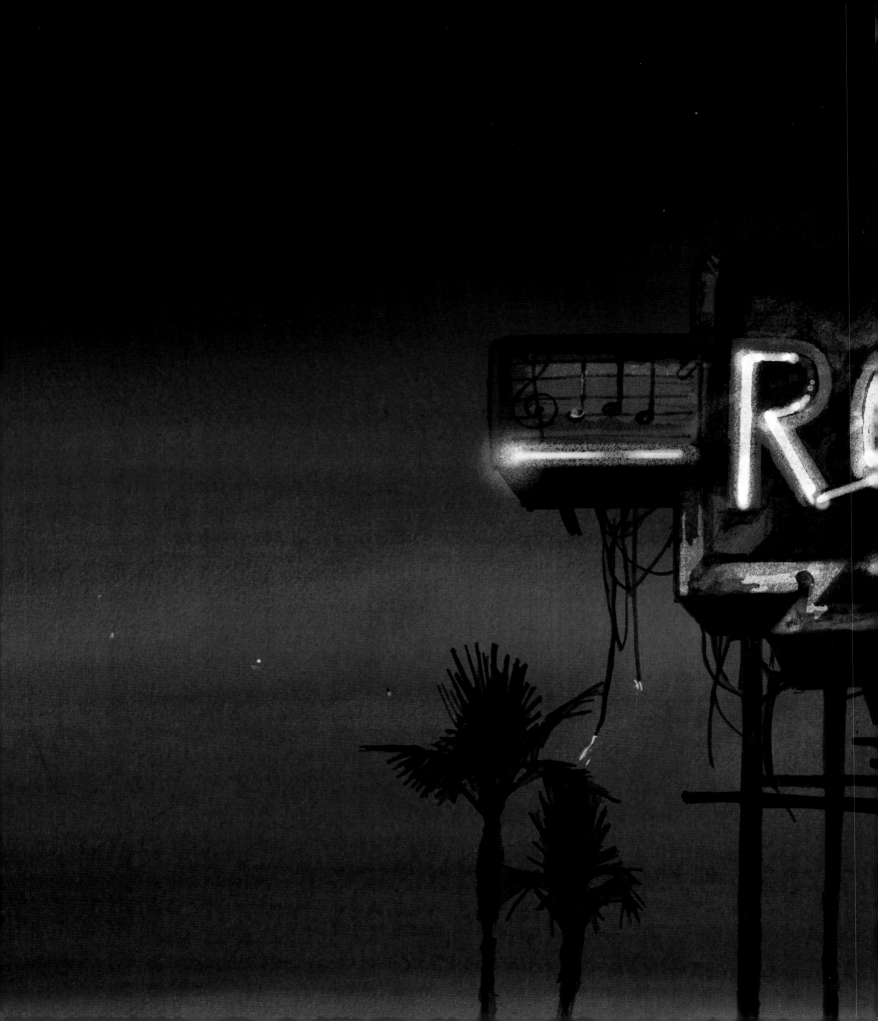

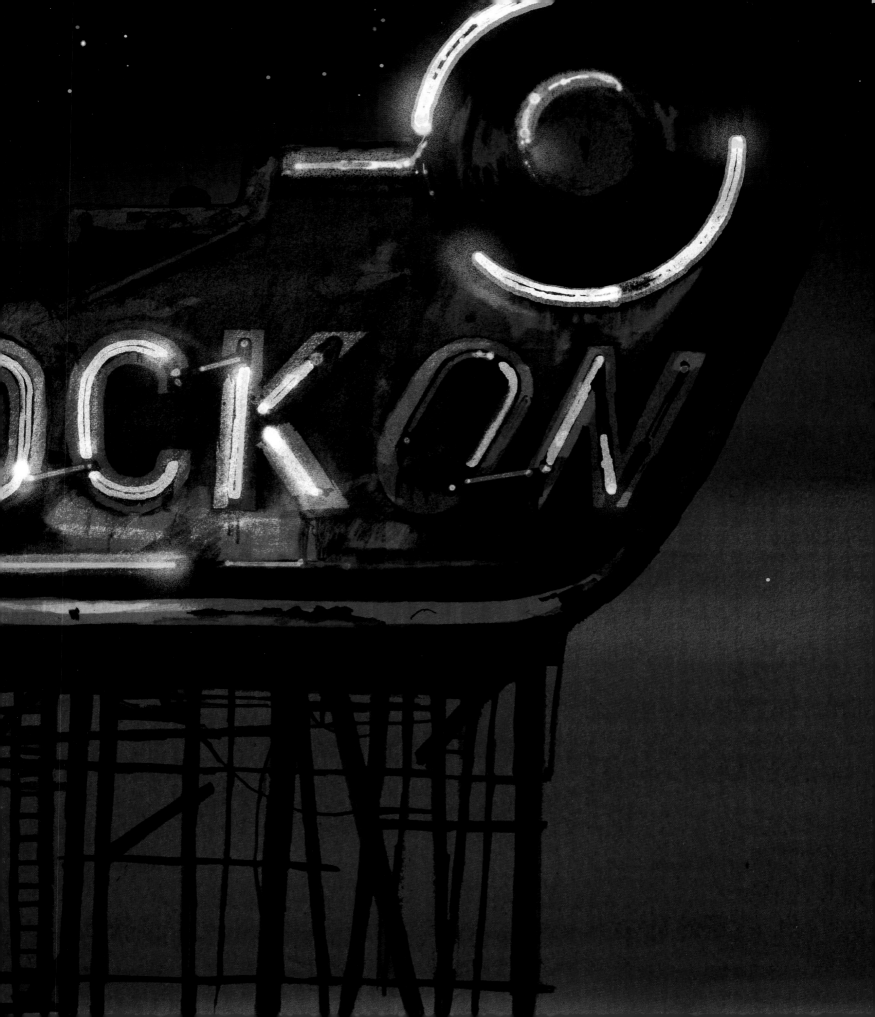

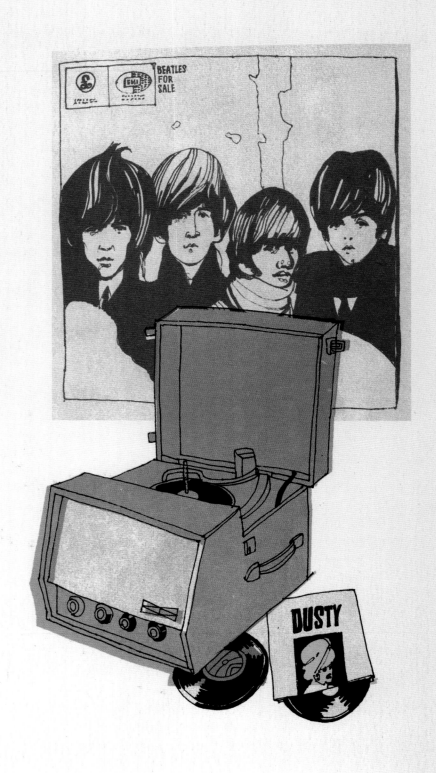

LIST YOUR FAVORITE SONGS

SOME LESSER HEARD GEMS:

THE TENNORS - WEATHER REPORT

The Factory - NO PLACE I'D RATHER BE

PHILAMORE LINCOLN - The North Wind Blew South

THE RECORDS → STARRY EYES

THE MERRY GO ROUND - Time will show the wiser

BUNNY WAILER - Bide Up

GARY McFARLAND - BLOOP BLEEP

COLORAMA - CANDY STREET

DUDLEY MOORE - BEDAZZLED (THEME)

RAVI SHANKAR - ALICE IN WONDERLAND (THEME)

McDonald & Giles - FLIGHT OF THE IBIS

NANCY WILSON - hurts so bad

BLOSSOM TOES - JUST ABOVE THE HOBBY HORSES HEAD

GABOR SZABO - 3 KINGFISHERS

DAVY GRAHAM - SHE MOVED THROUGH THE FAIR

GAIL LAUGHTON - POMPEII 76 A.D.

MICHEL POLNAREFF - DAME DAME

Rosalyn Sweet - BLACKBIRD SINGING

HYPNOTONE - GOD C.P.U.

Acknowledgements

Thanks to: My dear wife Cindy, and beloved
daughters Eleanor and Josephine, Mum,
Dad and Chris, Ken, Marilyn, Jeff and Karen,
Gez Saint, Roger Law, Andrew Davey, Mary
Harding, The Clissold Massive, Richard
Seabrooke, Darrel, Helen, Amanda, Chloe and
Jenny at HEART Agency, Stephanie Pesakoff,
Michael Whitton, Demetri Martin, James
Frost, Roger and Emma, Jon Gray, Noah Lang,
Brian Love, Ian and Tess, Joel and Nicky,
Will and Alice, Chops and Jane, Jo and
Andrew, Janice Taylor, Mark Ulriksen,
Yuri Ono, Thomas Edgar, Jeff Fino, Glen E.
Friedman, Tommy Means, Chad Hinson.
·All at AMMO and Bob Priestley and Tim
Baigent, Mairi Johnson, Paul Willoughby and
Mike Abbink. Gratitude to Fred Deakin,
Justine Frischmann, and Jeanette Abbink
without whom ...

Michael Gillette
Drawn in Stereo

All original artwork ©2015
Michael Gillette.
michaelgillette.com

All Rights Reserved.

Foreword by Fred Deakin
Interview by
Justine Frischmann

Design: Rational Beauty,
Jeanette Abbink
Copy Edit: Sara Richmond

Typeset in Domaine Display
and Domaine Text, designed
by Kris Sowersby

ISBN: 9781623260378

Library of Congress Control
Number: 2015937103

© 2015 AMMO Books, LLC.
All Rights Reserved.

Printed in China.

To enjoy the wonderful world
of AMMO Books, please visit
us at ammobooks.com.